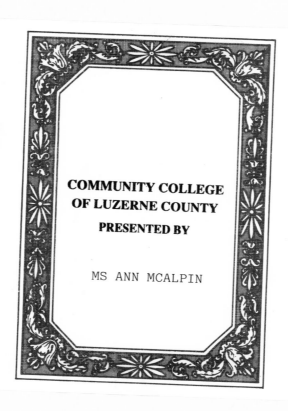

Affective Development and the Creative Arts

A PROCESS APPROACH TO EARLY CHILDHOOD EDUCATION

LINDA CAROL EDWARDS
The College of Charleston

Merrill Publishing Company
A Bell & Howell Information Company
Columbus Toronto London Melbourne

Cover Photo: Joanne Hendrick

Published by Merrill Publishing Company
A Bell & Howell Information Company
Columbus, Ohio 43216

This book was set in Palatino.

Administrative Editor: David Faherty
Production Editor: Ben Ko
Cover Designer: Brian Deep
Photo Editor: Gail Meese

Photo credits: pp. 2, 5, 169, 173 by Gail Zucker; p. 14 by Doug Martin/Merrill Publishing; p. 16 by David Herbert; p. 29 by Blair Seitz/Photo Agora; pp. 66, 92 by Charles Wolfgang/Merrill Publishing; p. 68 by Paul Conklin; pp. 75, 77, 86 by David Strickler; p. 101 by Lloyd Lemmerman/Merrill Publishing; p. 117 by Frank May/Merrill Publishing; pp. 121, 128 by David Strickler; p. 145 by Ben Chandler/Merrill Publishing; p. 146 by Gail Meese/Merrill Publishing; p. 147 by Andy Brunk/Merrill Publishing; p. 152 by Jean Greenwald; p. 201 by Ron A. Rocz.

Library of Congress Catalog Card Number: 89–85102
International Standard Book Number: 0–675–21023–2
Printed in the United States of America
1 2 3 4 5 6 7 8 9—94 93 92 91 90

To Don Schulte, Roberta Collard, Meg Cline, and Annette Godow

Preface

Affective Development and the Creative Arts: A Process Approach to Early Childhood Education is a teacher training text designed to involve college and university students of early childhood education, practicing preschool teachers, and other child-care professionals in a *process* approach to creative arts exploration. The theme of the book is self-expression and self-exploration. It interweaves the creative arts and the affective elements of learning and knowing and encourages you to let go of the notion that innate talent is a prerequisite for finding joy and wonder in the creative arts. It also helps you discover that in our own personal and professional ways we are all creative. The text links the concepts of creative development and information-processing theory and research to classroom application. It is both a unique theoretical and practical approach to creative arts exploration and a collection of techniques that focus on the affective component of the creative process. Quite often, teaching about creativity can be a difficult task, especially in programs that address the creative arts as a product-oriented activity in the classroom. The experiential and exploratory nature of this text will help you gain new understandings of yourself and your children. As you allow yourself to become more involved in the *process* of creativity, you will begin to feel more personally secure and professionally confident when inviting young children to explore the creative arts in these same or parallel ways.

 This text is based on the strong conviction that the creative arts are intrinsically related to the affective domain and that teachers must express and experiment

with both their own creative potential *and* affective development. It is through both of these processes of internalization that we gain the skill and confidence to open the doors to creativity and self-awareness to our young children enthusiastically and without hesitation.

The text is divided into eight chapters, each of which focuses on a major component of a creative arts curriculum and a specific aspect of the continuum of affective development. Affective development through the creative arts is a process we experience as we move from simply attending to the creative arts as a necessary and vital part of a total educational experience to integrating the creative arts into all aspects of our lives.

Chapter 1, "An Introduction," develops a rationale for blending the streams of creative arts education and affective development into a holistic or gestalt approach to teacher education.

Chapter 2, "Exploring Guided Fantasy," stresses the need for receiving the gifts our imagination gives us and for using them to increase our awareness and sensitivity to our own creative potential.

Chapter 3, "Music and Movement," takes a broad look at the value of singing, dancing, and action-oriented experiences for young children and encourages us to *respond* to the content by actively involving ourselves in the music and movement experiences.

Chapter 4, "Basic Art Materials and Methods," introduces a variety of art media you and your children can use for experimentation. Also included in this chapter is an experienced-based activity focusing on communication and communicative behaviors.

Chapter 5, "Creative Drama," is filled with "seeds" that serve as a starting point for introducing creative drama to young children. The affective content examines *valuing,* the next major category on the continuum of affective development, and how we view our own participation in the creative arts process.

Chapter 6, "Three-Dimensional Art," considers the importance of art that can be seen, touched, and felt, and presents several ways for you and your children to explore art in three dimensions. A special section, "Conditions that Encourage Creative Expression," serves as a reminder of the importance of establishing a classroom environment based on trust and respect. There is also an experiential activity designed to assist you in evaluating your current personal and professional support system.

Chapter 7, "Literature," contains many ideas for using literature with children, such as flannel board stories, storytelling techniques, and poetry. A categorical bibliography of children's literature will help you select books to meet the special needs of your children. You will also be spending some time identifying your personal and professional strengths and understanding your limitations.

Chapter 8, "Beginning a New Adventure," concentrates on the continuation of your journey into the creative arts by challenging you to shape your own personal philosophy of creative arts education. This process will help you to clarify your attitudes and your beliefs and bring some closure to this journey as you and your children begin a new adventure with greater insight, sensitivity, and awareness.

Acknowledgments

I am indebted to several individuals for their assistance and support in producing this project. In particular, three people deserve special recognition: Peggy Fitzgerald, who drew the illustrations with her sensitive pen and her understanding of young children; John Steedman, who spent countless hours reviewing individual chapters and who patiently revised my first musical notations; and Nickie Kopacka, who gave me her technical assistance and encouragement.

My thanks go to those colleagues and friends who so willingly shared their ideas and experiences with me: Norma Jean Anderson, Helen Gorini, Marge Humphreys, JoAnn O'Neill, Ann Whittemore, Jenny Rose, Peter Yaun, Camee Davidson, Jane Schuler, Becky Mahaffey, and Harriet Magrath. I also am grateful to all the students and teachers who made my job challenging and who stimulated my thinking. To you I am most grateful.

Sincere appreciation is expressed to the reviewers who provided insight and suggestions into the development of this text: Thomas Yawkey, Pennsylvania State University; Jerry Bigner, University of Colorado; Nancy MacGregor, Ohio State University; Meg Cline, University of Massachusetts; Shirley Oliver, University of Maine; and Eleanor Cook, University of Maine.

The team effort and professionalism of the staff of Merrill Publishing Company, especially David Faherty, Jeff Johnston, Nancy Mitchell, Gail Meese, and Ben Ko, brought this book to completion.

Finally, my appreciation goes to my parents, Sarah and Wilbur Edwards, who opened my first window to creativity; Scott Davidson, who helped me develop my own philosophy of creative arts education; Cavas Gobhai, for his unswerving friendship; and my family, for their patience and love.

Linda Carol Edwards

To the Student

This text is written for you, a unique, dedicated individual who has chosen early childhood education as a profession. The creative arts and affective development are two of the most important areas of your teacher education. This text is an invitation to you to begin a journey to explore your own creativity and your own personal ways of knowing and learning. It will provide experiences that will touch you, heighten your awareness, excite you, and give you insight into the wonder and magic the creative arts hold for all of us. I urge you to attend to the beauty of your own affective development and find ways of teaching that reflect your own special personality. Your participation in the creative arts and the affective-based, experiential activities is essential. When you enter into these experiences with enjoyment, your own uniqueness, and a good measure of sensitivity, you can learn to integrate the creative arts and affective development into all aspects of your lives.

Contents

1

An Introduction 1

Teacher Education and the Creative Arts 4
An Overview of the Text 6

2

Exploring Guided Fantasy 9

Affective Domain: Receiving 10
Guided Fantasy and the Creative Process 11
Teaching Strategies 13
Guided Fantasy for the College Student and Classroom Teacher 17
Guided Fantasies for Children 21
Ideas to Extend Learning 24

3
Music and Movement 27

Music and Movement: Enjoyment and Value for the Young Child 28
Fundamentals of Music and Movement 31
Basic Stages of Early Musical Development 36
Affective Domain: Responding 38
Music and Movement for the College Student and Classroom Teacher 39
Teaching Strategies for Music and Movement 47

4
Basic Art 61

How Important is Your Role, Teacher? 62
Children and the Artistic Process 67
Teacher Communication 69
Teaching Strategies for Basic Art 72
Art Activities for the College Student or Classroom Teacher 82
Image Awareness Art Activities for Children 85
Ideas to Extend Learning 89

5
Creative Drama 91

Understanding Creative Drama 92
Affective Domain: Valuing 94
Guided Fantasy for the College Student and Classroom Teacher 96
Guided Drama for the College Student and Classroom Teacher 98
Teaching Strategies for Creative Drama 104
Ideas to Extend Learning 112

6
Three-Dimensional Art 115

Young Children Explore Three-Dimensional Art 116
Conditions that Encourage Creative Expression 121
Teaching Strategies for Three-Dimensional Art 122
Three-Dimensional Art for the College Student
 and the Classroom Teacher 130
Developing a Personal and Professional Support System 137
Ideas to Extend Learning 140

7
Literature 143

Selecting Literature for Children	144
Arranging an Environment for Literature	148
Storytelling with the Flannel Board	150
How to Make and Use Quiz Cards	153
Poetry for the College Student and Classroom Teacher	155
Affective Domain: Organizing	160
Ideas to Extend Learning	163

8
Beginning a New Adventure 165

Creative Arts: Carry Them On!	166
Affective Domain: Characterization of a Value or Value Complex	167
Developing a Philosophy of Creative Arts Education	167

Appendix 1
Fingerplays 175

Appendix 2
Music 183

Appendix 3
Bibliography of Children's Literature 187

Index 197

About the Author 201

1
An Introduction

There are, besides the gifts of the head, also gifts of the heart, which are no whit less important, although they may be easily overlooked because in such cases the head is often the weaker organ.

—Jung

A five-year-old captures her favorite activity, "swimming in the lake," by moving her paint-filled brush across the flat surface of the paper. A few days later, she creates her lake from a formless lump of clay. In each case, she is using the creative arts to explore ways of expressing her feelings and sensory experiences in tangible, symbolic form.

Expression, feelings, and sensory exploration are central to the artistic development of children *and* to the creative process. Young children, in particular, are drawn to the arts because "messing about" with creative arts material is both natural and satisfying. Children represent their thoughts and feelings as they become involved in the sensory pleasures of drawing and painting. They discover power, pride, and feelings of accomplishment as they pound and push a lump of clay into a form that is uniquely theirs. As children express themselves through creative movement and dance, they feel the joy and pleasure that come from discovering new and different ways of moving their bodies.

Affective expression is very important to young children, and it is through the process of self-discovery that they enter the world of the creative arts. In the past three decades, scholars such as Dimondstein, Gardner, and Lowenfeld and Brittain have made tremendous contributions to the literature regarding the expres-

sive, affective, and sensory elements of the creative arts process. Their writings have had a profound influence in helping us understand the intimate relationship between the arts, creativity, and affective development. Dimondstein sees the creative arts as being especially relevant to young children because they permit a child not only to perceive and experience feelings but to gain an understanding of those feelings as they are expressed in concrete form. The process is a transformation of each child's personal experience, resulting in the material reflection of such symbolic transformations.[1]

Gardner views the affect, or feeling states, of a child as being an important component of the artistic process. He tells us that the experiences and feelings of the child are of crucial importance to any art encounter. A deep, meaningful, affect-rich life seems essential for exploring and developing the creative process.

> A child's immersion in affective states while encountering the arts has a positive dimension. . . . Because of its unity and potency, an affect may well have an integrating and structuring effect on the child's experiences, influencing both his perception and his creation of objects.[2]

Sensory exploration is essential for the developing young child, and the creative arts are a virtual storehouse of sensory experiences. Creative arts are filled with textures, forms, colors, shapes, rhythms, melodies, dance, and action—all of which help young children to express important aspects of themselves that their limited expressive and receptive language may not allow. Expression, feelings, and sensory exploration are all part of the marvelous, magical nature of young

children. The creative arts *process* provides a pathway for children to reach into new creative unfoldings and understandings of themselves.[3]

As children experience the arts, they discover new ways of representing their world in ways that can be seen, felt, and heard. We need only to sit back and watch children creating to see that they bring their own personal feelings, experiences, sensory impressions, and imaginations to the artistic experience. They also enter into the process in ways that are unique, different, and right for them. This process is a transformation of each child's inherent artistic potential, and the result is a wonderful, exciting, and significant reflection of the child as artist.

As children manipulate and explore the properties of paint, clay, music, or movement, they begin to develop concepts about their experiences. Through the creative arts they discover the hardness and plasticity of clay, the smoothness and roughness of different textures, the soft and sustaining bell-tone of a suspended triangle, and the floating weightlessness of a silk scarf. Touching, seeing, and hearing are all intricately intertwined in these experiences of the creating child. The very intimate involvement of children with sensory exploration heightens sensory awareness and provides a solid base for future artistic creation.

Feelings are the descriptors given to emotional states, descriptions of the personal meaning of an emotion. Very often, young children cannot pinpoint a feeling much less put that feeling into words. They can, however, express and represent feelings through the creative arts. When children make art, they are going about the serious business of learning about their world—the external environment of things, people, and happenings. They are also learning about their own inner, affective world of feelings and emotions. Children involved in the process of creating and discovering the creative arts are probably closer to touching both of these worlds than at any other time. Delight and spontaneity can be communicated through singing, clapping, and moving to music. Young children can express strong feelings such as anger or frustration by pounding clay or vigorously smearing finger paint. For young children, especially, involvement in the creative arts provides an acceptable outlet and offers a legitimate method for handling and expressing strong or confusing feelings.

Young children are just beginning to learn about the world, and because they are still amateurs they make mistakes, they get confused, and they don't always get things "right." The creative arts process is wonderfully inviting to young children because the process does not require that they "know" how to draw a house or that they understand the techniques involved in dance. In creative and artistic expression, there is no one correct response and no right or wrong way to be creative. The creative process is a *safe* way for young children to try out, explore, experiment, and (as you will soon observe) fumble about with ways of learning about themselves and the world of creativity. The creative arts process gives them *time*, the much-needed time that is necessary for them to discover, firsthand, how to represent their experiences, feelings, and sensory impressions in a form that they can see, hold, and touch. More importantly, the creative arts help children to give order and structure to their experiences in a symbolic and creative manner.

Intellectual and physical development are strengthened as children respond to the creative arts. Young children become problem solvers as they learn which

side of the cutout picture to put the glue on. They construct valuable knowledge while working with different shapes, colors, textures, and sizes. Language development and the acquisition of communication skills is enhanced as children talk about their art experiences and express their ideas to others. Expressive and receptive vocabulary is increased as they hear and use new words such as tempera, artist, pastels, and potter's clay. Physical development, eye-hand coordination, and fine- and large-muscle coordination are strengthened as children scribble with crayons, push and mold clay, cut things with small scissors, or finger paint. Children develop the strength and dexterity that will be needed later on for handwriting.

The creative arts naturally fit the needs of young children. They want to do it "their way!" They want to take the initiative, do what they want to do, and express themselves in ways that are right and satisfying to them. The creative arts give them this freedom, and as teachers we can open the doors to the creative arts "storehouse" and provide opportunities for them to explore the richness of the treasures.

TEACHER EDUCATION AND THE CREATIVE ARTS

Current interest in teaching the "whole" child (which includes both the affective and psychomotor domains, as well as cognition) and in teaching the child as artist have provided varied viewpoints on the importance of creative arts education. The National Education Association has passed a resolution that says "that artistic expression is basic to an individual's intellectual, aesthetic, and emotional development and therefore must be included as a component of all education" (NEA Resolution: B–28). Dr. Ernest L. Boyer, of the Carnegie Foundation for the Advancement of Teaching, began his keynote address to the Getty Center for Education in the Arts Invitational Conference by expressing his "deep conviction" about art education. The arts, Boyer says, are "one of mankind's most visual and essential forms of language, and if we do not educate our children in the symbol system called the arts, we will lose not only our culture and civility, but our humanity as well."[4] As early childhood educators, we believe these words too, and we know that the creative arts are essential to the education of all young children.

During this same address, Boyer presented three essential reasons why we need arts education in our schools. First, arts education "[helps] children express feelings and ideas words cannot convey." There are human experiences that require a "more sensitive set of symbols we call the arts." Second, "through the langauge of the arts we can help integrate our splintered academic world." Boyer said college students are accumulating units "but they are not gaining insight or perspective or a sense of wholeness." They "urgently need to see connections, and finding patterns in the disciplines can be accomplished through the arts." Boyer suggested that the arts provide us with a language "that cuts across all disciplines and brings a more coherent meaning to our world." Lastly, arts

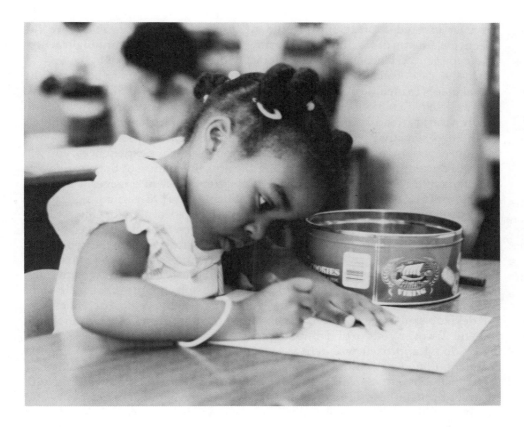

education is necessary because the arts "provide the child with a language that is universal." Dance, music, painting, sculpture are languages that are universal, languages that can be understood all around the world.

Among the many questions that we as educators must address, two seem especially important. Where do we start and how do we insure the inclusion of creative arts education in the education of young children? A first step for professional teacher education programs is to recognize the primary importance of providing activities that encourage teachers to enter into the creative arts process and to express these experiences through their own exploratory and creative behaviors. The creative arts, with their intrinsic relationship to subjective, affective experiences, can help you investigate and develop confidence in using a variety of media, exercise skills in imagery and fantasy, construct symbolic representations, and deepen your understanding and appreciation for the creative efforts of young children in the process.

There is an increasing awareness among educators that the development of instructional approaches that integrate the student's affect and unique personal experiences with course content can increase student motivation, participation, and learning. You, as a teacher of children, are certainly no exception. Feelings, emotions, concerns, attitudes, and values surface in every preservice teacher who

has ever entered a practicum or student teaching experience. These are the affective elements of teaching and learning, and they arise as beginning teachers (and experienced teachers as well!) interact with children in school.

In this case, college courses in creative arts education seem to be one of the logical places to include information on affective education. Teaching is a creative form in itself. Experiences that lead to teaching the creative arts effectively to children can also lead *you* toward increased understanding of creative arts content, heightened sensitivity to the affective elements of teaching and learning, and freedom of your own expressive potential. Through affective experiences, you will begin to develop skills in understanding the affective nature of the creative arts and transmitting your understanding to children. As you engage in affective experiences that are healthy and growth producing, you are learning skills to use when designing environments that will foster affective learning for children.

The creative arts encounters in this book are written to be experienced by you. They are carefully designed to encourage you to refresh or rekindle the impact that the creative arts have had or can have on you both professionally and personally. You will be actively involved in the process as you practice using the creative arts materials, and you will also begin to develop those techniques that seem to fit naturally into your own syle of teaching. As you participate in these activities, you will develop skill in using and manipulating various art forms. At the same time, you will discover your own natural capacity for creativeness. The in-class, learning-by-doing approach will help you to be more open to exploration and experimentation; fears, inhibitions, and the old notion that innate talent is a prerequisite for success will begin to disappear; excitement about working with creative arts materials will emerge; and you will discover your own expressive and creative abilities. When this happens, you will feel more personally secure and professionally confident.

Allow yourself to be open to the joy and wonder the creative arts hold. If you give yourself permission and are willing to explore beyond the realm of what you already know, you will open many magical doors both for yourself and for your children. I read something a long time ago about magic doors and the creative arts process. I don't remember the exact wording but it went something like this: "of magic doors there is this; you do not see them, even as you are passing through." In many ways the door to the world of creative arts is indeed a magic one. You and your children are beginning a journey into the richness and beauty of the arts. Who knows, you may just pass through a magic door of your own without even realizing it!

AN OVERVIEW OF THE TEXT

Creative Arts Education

This text includes a wide range of creative arts, including the visual arts, the expressive forms of dance, the sounds and rhythms of music and song, the organization of words we call poetry, and the thought, feeling, physical movement, and vocalization of drama. These are represented in singing, creative

movement, writing, painting, storytelling, creative dramatics, and sculpting. Included in these broad areas are rhythm and beat, action songs and movement, guided fantasies, finger plays, instrumentation, basic art materials, three-dimensional art, children's literature, and poetic form.

Affective Education

This text is based in part on three basic assumptions.

1. The creative arts are intrinsically related to the affective domain.
2. Learning involves cognitive and affective development.
3. Increased consciousness of experiencing is related to enhanced learning.

As a guide to affective development, you will be offered many opportunities to focus on the continuum of development in the affective domain. The affective-based guidelines provide numerous learning activities and exercises designed to provide a structure through which you can attend to your own affective development. These activities range from inviting you to become involved in basic human interaction encounters to integrating personal creative expression into your own professional life. As you follow this instructional guide, you will begin to understand the impact that consciously attending to your own affective development can have on your personal and professional growth as a teacher.

These learning experiences are based, in part, on the idea that self-knowledge, how you make sense of your affective parts of being, developing, and learning, are a vital component of the "worthwhile" knowledge you will need to become a teacher.

This approach to creative arts education and affective development is experiential, and you will have the opportunity to be directly involved in the process. The format of each chapter is structured to encourage active participation on the part of your leader or teacher *and* you. I believe that a journey to explore the creative arts and affective development is much more than a designated set of objectives and procedures to be followed rigorously. It is, rather, an orchestral score with room for improvisation, interpretation, and an endless range of dynamic potential. This text provides a framework, ideas, and exercises that must be extended, modified, and developed to meet the needs of your particular group. I can provide the score . . . it's up to you to make the music!

The following definitions should be helpful to you as you prepare for your adventure in the creative arts and your own affective development:

Affective refers to the feeling or emotional aspect of experiencing and learning, including wishes, desires, joys, fears, concerns, values, and attitudes.

Emotions are nonverbal states of consciousness in response to an individual's environment, internal state, or experience.

Feelings are descriptors given to emotional states, descriptions of the personal meaning of something to the person experiencing an emotion.

Domain means belonging to something contained within certain limits, a sphere of activity, or dominion.

Creativity refers to the proactive, purposeful impulse to extend beyond the present, characterized by originality, imagination, and fantasy.

Learning is the differentiation, integration, and generalization of experience.

Creative Arts include the visual arts, music, dance, poetry, drama, and other aesthetic modes of creative representation.

Each chapter follows a consistent format, which includes an overview and objectives. At the end of each chapter you will find ideas for extending what you have learned by translating this knowledge into practical classroom application. References and suggestions for additional reading are included at the end of each chapter.

Before you move on to Chapter 2, read Robert Alexander's very powerful and poetic description of the creative process as it relates to the creative arts:

> as children journey amid the creative splendor of the mind-heart-soul, their imaginations are constantly opening new doors and windows, showing new avenues of approach and hinting at mysteries which lie beyond what they can see. . . . In the act of creation, children are closer to their truth than at any other time Thoughts and feelings are experienced with magnificient clarity, crystal sharpness and control. All of life's bewildering chaos is transformed into harmony and truth."[5]

The creative arts await you. The next chapter begins with you and the brilliance of your own imagination!

ENDNOTES

1. Dimondstein, G. *Exploring the Arts with Children*. New York: Macmillan, 1974.
2. Gardner, H. *The Arts and Human Development*. New York: John Wiley and Sons, 1973, p. 173.
3. Gardner, H. *The Arts and Human Development*. New York: John Wiley and Sons, 1973, p. 1.
4. Boyer, E. Keynote address to the National Invitational Conference, sponsored by the Getty Center for Education in the Arts, Los Angeles, California, January, 1987.
5. Alexander, R. "What Are Children Doing When They Create?" *PTA Today*, March 1985.

2
Exploring Guided Fantasy

This chapter begins with some general guidelines for working in the affective domain. The guidelines are followed by a discussion about guided fantasy and by research findings related to the creative process and fantasy activity. Before planning guided fantasies to use with children, it is important that *you* experience the process yourself. Experiential learning for you is included in the guided fantasies designed for adults. One guided fantasy will take you on a journey to look for a very special teacher. Another will encourage you to become aware of your own creative potential. Suggestions for teaching strategies when introducing guided fantasy to children are provided to assist you in planning and implementation.

Objectives

This chapter will provide the information and opportunity for you to

- describe the relationship between guided fantasy and the creative arts process
- attend to your own creative potential
- experience a guided fantasy
- identify strategies and methods for introducing guided fantasy to young children
- identify and describe the characteristics of an effective teacher

AFFECTIVE DOMAIN: RECEIVING

Many of you have probably not considered that learning about yourself is a valuable part of your teacher preparation. Few opportunities for affective exploration are available to preservice teachers, although the field of affective education is rich with ideas and techniques to facilitate such learning. As an initial step toward exploring the creative arts from an affective perspective, this chapter will introduce the technique of *guided fantasy* to encourage you to experience the first major category on the continuum of development in the affective domain: receiving.[1] *Receiving* (or *attending*) refers to your willingness to attend to the existence of certain phenomena or stimuli. Receiving implies that you will listen attentively and be aware of what you are experiencing. An important goal for the work you will be doing throughout this chapter is to develop an increasing awareness and sensitivity to your imaginative and creative potential.

An important component of the learning-by-doing process is supporting each other, laughing often, and being serious sometimes. This approach to exploring the creative arts helps to build a sense of community, which is an important step in confidence building and in understanding our own creative abilities. This chapter is concerned with creating a positive learning atmosphere in which you can relax and enjoy the pleasurable aspects of the creative arts. At the same time, you will be experimenting with some new behaviors, trying to lay down new tracks of thought on which the imagination can run.

You are just coming together as a group and may be feeling some anxiety as you anticipate a class in creative arts education. The activities in this chapter will elicit laughter, encourage establishing an informal learning environment, and help you to feel free from threat so that you can actively participate in the creative arts experience. An atmosphere of trust and acceptance is necessary for learners of all ages to freely exercise their imaginations, to explore their own creativity, to develop spontaneity, and to discover personally meaningful ways to enter into the world of creative expression. The creative arts classroom must be relaxed and informal, high in levels of trust, and low in competition. These are essential elements for a positive learning experience. Use this arena for experimenting, discovering, and recognizing your own talent for creative self-expression.

The importance of active participation is to

- exercise our own imaginations
- explore our own creativity
- enhance spontaneity
- overcome fears of "performing"
- reduce inhibitions
- and support each other while learning creative arts content and exhibiting our own creativity in a nonjudgmental atmosphere

GUIDED FANTASY AND THE
CREATIVE PROCESS

Guided fantasies are planned experiences, read or spoken by an individual or individuals and usually centered on a particular subject or idea. Guided fantasies often focus on the internal, creative, and imaginative potential of the participants. Fantasy is a process of using the imagination to create mental images. It can be used as a tool for creativity, for mentally rehearsing an anticipated act or behavior, or for experimenting in a relatively safe way with different uses of the imagination. By giving yourself the opportunity to explore your inner resources of imagination and creativity, you can broaden your perspective on your own creative possibilities. Stretching and exercising your imagination in this way is a first step in realizing your ability to be creative.

The term *creativity* remains largely undefined. A great deal of literature is available on the subject, and while very useful, the main question in its research is unanswered: what *is* creativity? Is it a creative product, a means of original expression, or a process of development and change? Paul Torrance,[2] a pioneer in the study of creativity, identified four characteristics of creativity: fluency, flexibility, originality, and elaboration. Torrance's findings suggest that creativity is the ability to produce something novel, something with a different stamp on it.

Creative people are fluent and flexible in thought and can use their imagination to construct, elaborate, and embellish original works.

Guided fantasy provides adults and children with opportunities to create symbols and images that are flexible and original in thought. Guided fantasies are fluent and ever-changing: In the process of pretending and imagining, people can invent and elaborate on images that are as original and individual to them as their fingerprints.

A person's fantasy life does not, however, meet the requirements Torrance proposed for creative *production*. An image is not a product; it is an original perspective, a free flowing of ideas that includes flexible reception of images. Because guided fantasies are a process and not product, attention must be given to the *process* if it is to be developed.

Singer[3] reported that there are two major systems for coding and storing material, a verbal-linguistic code and an imagery code. Throughout our own educational process, most of us became proficient in learning the verbal-linguistic system. However, the imagery system of coding provides us with a means of reflecting experiences in more detail. A classic example of how the imagery system works is the task of determining how many windows one has in one's house.[4] Most people will create an image of their house and actually count the number of windows. We remember quickly when visual images are evoked. Fantasy allows us to learn by using imagery codes in addition to the verbal-linguistic system.

Important support for the use of fantasy can also be found in the research regarding left-brain/right-brain orientation. Jerome Bruner, in his *On Knowing: Essays For the Left Hand*,[5] explains that the right hemisphere of the brain, or right-brain, controls the left side of the body and that the left hemisphere, or left-brain, controls the right side of the body. Education in general is usually geared toward the development of left-brain functions. The left-brain is the seat of analysis and logical, sequential learning, including verbal skills. The function of the right-brain is more intuitive, visual, creative, affectively-oriented, and holistic. Although we know that people must find a balance for integrating the functions of both the left-brain and right-brain for maximum development of potential, the development of right-brain functioning is a necessary and valid way of helping people to experience and discover their visual, symbolic, creative, and intuitive ways of learning. Visual images and the ability to perceive patterns, meanings, and relationships are all vital to the creative process.

We are only beginning to realize the importance of the research on right-brain and left-brain functions, but the findings do lend a strong measure of support for including fantasy in creative arts education. Educators have encouraged us to include guided fantasy as an essential part of the child's educational process, believing that it opens a door for children (and adults) to develop their intuitive, visual, and symbolic potential, all of which develop through our imagery system and our right-brain functions.

Bruner's pioneering work, Singer's research, Torrance's studies to identify characteristics of creative people, and the extensive contributions of prominent practitioners and educators seem to indicate that the attitude which characterized

the use of fantasy as "just your imagination" is being discarded. Thinking and learning through fantasy and developing the imagery code is being recognized as a natural inner resource with useful, inventive, and creative advantages. The process taps the wellspring of fluency, flexibility, and originality, which can have lasting effects on the development of the creative process in children and adults.

The use of guided fantasy with young children is rapidly gaining in popularity as teachers come to realize that fantasy is a useful natural resource for many children. Teachers use guided fantasy to reduce test anxiety in young children. They also use it to help children relax and be aware of feelings, emotions, and internal tensions and movements. Anderson[6] suggests that guided fantasies can provide a relaxed and nonthreatening environment conducive to increased awareness of feelings about the topic being explored. DeMille, in his classic work *Put Your Mother on the Ceiling*,[7] states that the use of fantasy helps children gain a sense of control over what happens to them. DeMille also suggests that we can teach children how to use fantasy to be more creative.

Guided fantasy can provide a relaxed and comfortable environment for older students as well as younger ones. In my own work with college students, both undergraduate and graduate, guided fantasies have been a welcome process toward reducing fears about creative production and the creative process in general. Students respond with more openness, a willingness to try, more motivation and most of all, a heightened sense of their own creative abilities. Every person's imagery system is distinctively different. Each of you will experience the guided fantasy with a diversity of colors, sounds, forms, and sensations, all of which are your own creation. There will not be fifteen or twenty identical images or "pictures" (all looking just alike) the way we sometimes see rows of identical drawings or paper flowers displayed on bulletin boards in children's classrooms. As you receive the images, you bring out your unique and intrinsic "material" that you need to transform these images into your own creation.

TEACHING STRATEGIES

Before you take the first step toward introducing young children to guided fantasy, there are a few guidelines you need to consider. Think carefully about them as you begin to develop skills, strategies, and methods for incorporating fantasy into your classroom.

1. Before using guided fantasy with children, "try out" the guided fantasy on yourself. Read the fantasy to yourself and be aware of how the images form, or have a friend or colleague read the fantasy while you experience images. This will help you practice your timing and appreciate what the children will be experiencing, as well as let you add to the fantasy or delete passages from it that don't "feel" right or provide little stimulus for your imagery system.

2. Tell the children what you are going to do. It is important for children to understand that their fantasy belongs to them, that they can *choose* to use their

imagination and take a journey in their mind, and that they are always in control. You might start by saying:

We are going to take an imaginary journey by making pictures in our minds. This journey will be a lot like pretending, and all the pictures will be like movies in your head. You can use your imagination to make anything you would like.

3. Give the children suggestions to help them relax. Relaxation techniques from *The Centering Book*[8] or selections from the "Sensory Awareness" section in *Left-Handed Teaching: Lessons in Affective Education*[9] are very good at helping children learn to relax. A few simple sentences may also be used, for example:

Find a place in the room where you can relax without touching anyone else. You can be lying down or, if you wish, you can just sit someplace where you can be quiet. Close your eyes and let your body and your mind rest. Take in a nice, slow breath and let it out. See if you can relax a little bit more until your mind and body are very still.

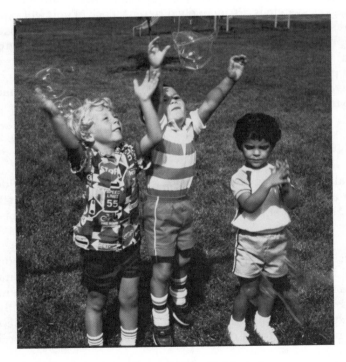

Use children's own concrete experience when writing guided fantasies.

4. Beginning fantasies should be simple. Guided fantasies that focus on the senses are particularly useful in the early stages of the process. At first, some children may have trouble keeping their eyes closed, but once they are familiar with the process, most children will look forward to relaxing and creating their own fantasies. It's also helpful to have soft music playing in the background. Music is soothing to children and can usually help them quiet down and relax. Ask children to imagine something that is familiar, such as a toy, a special food, or a pet. Encourage the children to think about how the object feels, whether it is soft or hard, whether it smells, whether it has color or taste.

5. Once your children are familiar with guided fantasy, you can write fantasies specifically desgined to enhace their concrete experiences. If you live near the beach, write a fantasy about walking along the shore, smelling the sea breeze, and feeling the waves. Ask the children to find something on the beach, pick it up, and feel it. Then allow the children to continue the fantasy on their own:

> Imagine yourself at the beach. The sun is warm and the waves are tickling your feet as you walk along the shore. Look up at the blue sky and see the seabirds flying around and listen to the sounds they make. Now picture something lying in the sand in front of you. Walk up to the object and pick it up. How does it feel? Is it heavy or light, does it move or is it still? Is there something you want to do with it? Take a minute to decide what you will do with your object before you come back to our classroom.

If you live in the mountains, take a hike up a mountain trail. If you live in the city, take an imaginary trip to the zoo or visit a tall building. You know the experience of your children. Since you are in the process of discovering *your* creative potential, you can design fantasy trips especially for your group.

6. Guided fantasy can be useful when introducing creative arts content. If you are beginning a unit on movement, ask children to imagine that they are tiny seeds, tucked deep in the warm ground. Let them use their "mind's eye" to come up through the ground and grass as they grow into beautiful flowers. When introducing rhythm instruments, use guided fantasy to encourage children to imagine different ways of playing the instruments and invite them to listen with their imaginations to the different sounds and tones the instruments make.

7. *Always* prepare children to return to the "here and now" of the classroom.

> Take some time now and let your imagination become quiet. Think about our classroom and remember how it looks. Think about who is in the room and listen for little sounds that you have heard before . . . the air conditioner or heater, voices, the rain outside. When you feel ready, wiggle your fingers a little, stretch your feet, and open your eyes. When you open your eyes, look around the room until you see me.

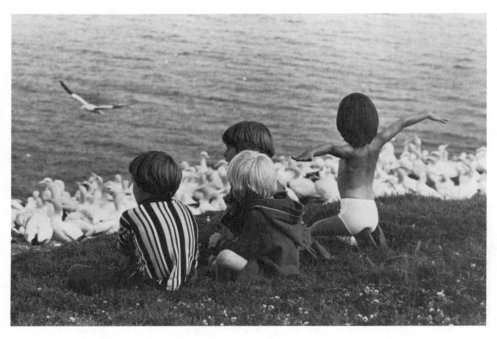

Give your children wings to fly and their imaginations will soar.

8. When guided fantasies are over, children need time to reflect or maybe talk about their images. The inner experiences of the children should *never* be judged, interpreted, or evaluated in any way. For young children, this is simply a time of sharing what they saw and how their images made them feel.

Emphasize to your children that the imagination can be brought to light on anything. They can use their "mind's eye" to journey to unknown places, bring objects or toys to life, see movement or images in color and music, or create new or different situations in their daily lives. They can look at clouds and imagine where they have been or what they've seen, listen to music and imagine what the composer looked like, observe animals or birds and imagine how they talk to each other or what their houses look like on the inside, or simply close their eyes and imagine who or what is making all the sounds they hear. Images of special, happy events can help a sad or troubled child feel better. Holding an imaginary kitten or imagining a butterfly on a flower can be soothing and calming. Encourage children to imagine a dream before naptime or bedtime, or imagine a funny or comical outcome to a stressful or frustrating experience. Using the imagination is certainly not limited to guided fantasy activity. Sometimes we just have to give children permission, or maybe a suggestion for incorporating imagery and fantasy into the here and now of their lives for them to begin using their imaginations in ways that are important and useful for them.

Once the children begin to understand guided fantasy, you can design fantasy journeys for all areas of the creative arts. Exploring different ways of experiencing the creative arts through guided fantasy can play an important role in tapping a child's ability to create. When children become deeply involved in the fantasy process, they experience the creative arts as something that is intrinsically satisfying and rewarding. Each child gets to be the artist, musician, sculptor, and dancer in every experience, and the source of every creation comes from within the child. This discovery is extremely important to the development of creative arts potential.

I have sprinkled several guided fantasies throughout this book and encourage you to use them as "seeds" for creating your own fantasies for the children in your lives.

Now let's get back to you, the teacher! Using guided fantasy in the creative arts classroom as a means of cognitive rehearsal is a very low-risk activity. Guided fantasies involve no physical movement or any risk of failure in the eyes of others. Only you will know how much you are attending to your imagination, and only you can assess your willingness to create images and get involved in the mental process of exploration. By using guided fantasies in this manner, we all take responsibility for the amount of emotional energy we elect to use to discover our own ability to use our imaginations creatively.

GUIDED FANTASY FOR THE COLLEGE STUDENT AND CLASSROOM TEACHER

This section includes two guided fantasies for you to experience: "You Are Creative" and "Searching for that Special Teacher." In the final portion of this chapter, there are suggested guided fantasies to use with young children. The first guided fantasy, "You Are Creative," will help you begin to discover the availability of your own imagery and your ability to tune out the external while focusing on your own internal creative thoughts. As the leader reads the guided fantasy, remember that you, and you alone, are responsible for exploring your own creativity and for the images you allow to flow into your "mind's eye."

The second guided fantasy, "Searching for That Special Teacher," is included in the activity "Characteristics of Effective Teachers."[10] This activity focuses on your personal and professional growth as a teacher. It will assist you in identifying the special characteristics of the most influential and effective teacher you have known. It will also help you collect data to assess your own personal teaching style and to project your potential for becoming an effective teacher.

You Are Creative

Group Size: Large group

Leader: College instructor, teacher.

Objective: Explore inner resources of imagination and creativity

Materials: Records or tapes of soothing music, preferably classical, playing softly in the background

Procedure:
1. The leader asks participants to find a place in the room where they can be comfortable. The participants should have enough space to sit or lie down without touching anyone else.
2. When all the participants have found a quiet place to rest, the leader reads the guided fantasy "You Are Creative."

Note: The leader should have the recording ready to be turned on at the designated place during the guided fantasy. Three (3) periods . . . indicate a pause.

You Are Creative

Find a good spot in the room where you can lie down without touching anyone else. Wiggle around a little until you find a way of lying down that is completely comfortable. Now close your eyes and let your muscles relax. Give in to the support of the floor . . . It's a solid base that will securely support you . . . Use your mind's eye to watch the thoughts that are running through your head right now. Use your imagination to transform these thoughts into shimmering, golden fish that flow across the front of your mind. Watch your thoughts as they drift in front of your closed eyes. Let them flow past . . . Notice them and allow them to drift on . . . drifting slowly out of your mind's eye . . . Begin exhaling slowly and smoothly through your mouth. Make a small sound so you can hear whether your breath is smooth or not. When you exhale, give one final puff to make sure all the air is gone . . . Relax and let the air enter your body slowly, in a smooth, relaxed rhythm . . . Think of warm. Think of a warm, yellow sun, sending golden rays of light through the dark universe . . . Imagine a thread, a shimmering, golden thread of warmth drifting aimlessly in space. Breathe in and absorb that golden thread with all its warmth. Breathe out and send it traveling back into space . . . Breathe in and send your warm, golden thread to your head . . . shimmering, filled with pure light to relax and warm your head . . . Exhale and send the thread speeding to the sun . . . Breathe in and take the warmth of your magic thread to your shoulders . . . Feel the glow in your shoulders as they relax and melt into the floor . . . Exhale and send your golden thread soaring through the sky traveling toward the sun . . . Watch your thread gliding through the heavens, beyond the starry host of the galaxy . . . Watch your radiant thread reflect the sunbeams as it absorbs the energy of the distant sun . . . Follow your thread as it streaks toward the Milky Way . . . Watch it as it settles beyond the constellations and shines its ever-warming beam through the darknesss . . . touching you and warming you as you glory in its light . . . As you lie

there in the darkness, glowing from your shimmering sun, imagine a closed flower in your mind . . . The flower is beautiful, yet unborn . . . Its petals are tightly closed . . . The flower waits to unfold . . . Listen to my voice as you allow your flower to merge with your body and become one with you . . . Now hide your flower self deep within a seed . . . a tiny seed that encases your lovely blossom . . . Allow your body to become that seed . . . Reach down through the center of your being and feel the ground . . . Connect yourself solidly with the earth . . . Imagine that you are part of the earth . . . cool . . . dark . . . moist . . . and mysterious . . . Your thread of golden light shines on the earth above where you lie . . .

(Start music here.)

Your golden stream of light warms you . . . It streams through the earth and you swell with warmth . . . Your legs become roots . . . roots that stir deep within the darkness . . . Your roots begin to move . . . slowly stretching outward . . . deep within the warm, moist earth . . . Your golden thread whispers a message that only you can hear . . . it whispers . . . grow . . . Feel yourself beginning to grow . . . already touched by the magic of the light from above. Your arms are seedlings that stretch up toward the light . . . mysteriously finding their way through the dark earth . . . They are tiny green seedlings . . . filled with your unborn flower . . . Out toward the sun your tiny buds come . . . reaching upward . . . Feel your arms as they push up through the ground . . . lovely . . . fragile . . . slender blades of green reaching for the light . . . your petals begin to spread and separate as the flower within you unfolds . . . You are filled with beauty . . . you are precious . . . you are the creation of all creations . . . joy of joys . . . delight of delights . . . loveliness beyond imagination . . . perfection of all creation . . . Your roots reach down through your center and you are solidly connected with the earth . . . You are the most beautiful . . . the most perfect creation . . . in all the world . . . Glory in your flower . . . Your flower is you . . . and you, special person . . . are your flower . . . And now let yourself come to rest . . . completely still and centered . . . feeling peaceful . . . alive . . . and filled with the joy and the goodness of your being . . . When you are ready . . . slowly begin to return to the here and now of this room . . . Stay quietly with your creation for a little while.

At the end of this guided fantasy you might enjoy describing your images, sights, and sensations. Judgment by others is not permitted, so you are free to discuss *your* fantasy and what you may have learned about your imagination.

*Characteristics of Effective
Teachers**

Group Size: Individual, small group

Leader: College instructor

Objective: To identify characteristics of effective teachers

Materials: Newsprint, markers

Procedure:
1. Find a place in the room where you can sit comfortably or where you can lie
 down without touching anyone else. Take enough time to find the place that
 is right for you. We are going to take a guided fantasy trip to look for our
 favorite teacher.

Searching for That Special Teacher

Now that you have found a comfortable spot, close your eyes and begin to
relax your body . . . Let your breathing be natural and smooth . . . Allow
your thoughts to pass before your mind's eye . . . Don't try to stop
them . . . Simply let them float by and enter the space in this room . . .
We're going on a journey to look for our favorite teacher . . . Scan the
years of your childhood . . . adolescence . . . adulthood . . . and remem-
ber all the teachers you have had . . . (Pause longer here, for two or three
minutes) . . . As you were bringing these teachers before your mind's eye,
there were probably one or two that kept coming back to visit . . . Take
another moment and identify the ones you loved the most . . . As you
remember them, try to choose one who was the most special . . . the one
you are sure loved and valued you . . . Bring that teacher to the center
of your mind's eye and think of the characteristics that made that teacher
your favorite . . . Was it attention . . . caring . . . warmth . . . knowl-
edge . . . dedication . . . Describe this teacher to yourself . . . Think of all
the words that enhance your memory of this special teacher . . . Continue
to think about your teacher for a minute or two . . . (Pause longer here,
for one or two minutes) . . . Now, try to clear this scene and prepare to
return to this room. I will count to five as you make the transition back to
the here and now of this place . . . One . . . Two . . . Wiggle your toes
and fingers a little until they begin to move . . . Three . . . Gently lift your
arms and move your legs around . . . Four . . . Cup your eyes to shade
them from the light . . . Five . . . Open your eyes, and when you are
ready, come back to the here and now of our room.

**Source*: "Characteristics of Effective Teachers," adapted with permission from
L. Thayer, 50 Strategies for Experiential Learning: Book One. San Diego, CA.:
University Associates Inc., 1976.

2. After the guided fantasy, write down all the words you can think of that describe the teacher in your fantasy.
3. When you have completed a list, pair up with a person sitting near you and share the information on your lists.
4. Next, combine your lists and come up with a new list that incorporates or summarizes the characteristics common to both lists.
5. One member of each pair should read the list of common characteristics. The leader or instructor writes these on newsprint.
6. Each pair should join with another pair. The groups of four will discuss the characteristics listed on the newsprint, talking about their own strengths and identifying within themselves some of these characteristics. The leader should emphasize that it is often difficult to identify and acknowledge our strengths. More often than not, it is much easier to focus on our weaknesses.
7. The leader prepares a handout of the characteristics to be given to the students at a later date.

GUIDED FANTASIES FOR CHILDREN

A Rainy Day

Find a place in the room where you can stretch out or sit very still . . .
Listen to your breathing and see if you can feel the air going in and out of
your body . . . Close your eyes and let your imagination make a picture of
nice, gentle rain falling down . . . Listen to the sounds the rain makes . . .
Can you hear it? . . . Let your imagination put out your hands and feel the
rain. How does it feel? . . . Is it cold? . . . warm? . . . wet? . . . Look
around to see if you can see any puddles, and watch the rain as it
splashes and makes the puddles larger . . . Imagine that you are going for

a walk in the rain . . . What do you see? . . . Do you see our school? . . .
Are there any trees or flowers? . . . What happens to the trees and flowers
when they feel the rain? . . . Do you see anyone else walking in the
rain? . . . Listen and see if you can hear any rain music . . . Is there any-
thing that you would like to do while you are walking in the rain? (Pause
longer here.) It's time to come in from your walk in the rain. Think about
our room and see if you can make a picture of it in your mind . . . When
you are ready, wiggle your fingers and give your body a gentle stretch . . .
Open your eyes and look around until you see me.

Fairies and Rainbows

Relax and close your eyes. See if you can be very still like a doll. Listen to
your breath as it goes in and out of your body, and then take a big breath
and blow it all out . . . Listen to my voice and let your imagination make
pictures of the things I am going to say. See yourself walking through a
beautiful meadow or grassy field . . . We are going on a journey to find
the end of the rainbow where the magic fairies live . . . Imagine that you
see the rainbow . . . Look at all the colors . . . Look at the rainbow as it
comes down and almost touches the ground . . . Find the end of the rain-
bow and imagine that you are walking, running, or maybe skipping
toward the rainbow's end. Do you think there will really be magic fairies
at the end of the rainbow? . . . As you get closer to the end of the rain-
bow, you see happy little fairies playing in the grass . . . Look at their
colorful hats . . . See their funny little clothes . . . Watch them float in the
air . . . See them dancing . . . Can you hear them singing or making fairy
sounds? Now imagine that you are playing with the fairies . . . They make
you happy as they dance and sing with you . . . How does it feel to be so
tiny and light? . . . Did you float or fly with the fairies? . . . Now get ready
to say goodbye to the fairies and come back to our room. When you are
ready, move your head around a little bit, think about our classroom,
open your eyes, and look around until you see me.

A Very Special Basket

Settle down in a very comfortable place and let your mind and body be
very still . . . Take in a nice big breath and then blow it all out . . . Imagine
that I am walking around the room and I have a very special basket filled
with wonderful things . . . My basket holds many special objects
(treasures) that only you can see. Imagine that I am going to give each one
of you a gift from my very special basket. Imagine that I am walking up to
you and holding the basket so that you can see all the things that are in-
side . . . I pass the basket to you and you reach in and take one of the very
special objects . . . Look at it . . . Feel it . . . Is it big? . . . Small? . . . Is it

round? . . . flat, or does it have many different shapes? . . . Is your special thing warm or cold? . . . Is it soft . . . hard? . . . Does your special gift have a smell . . . or a taste? I want you to keep your special gift, so think about a place you can put it where it will be safe . . . Take your gift to that safe place and tuck it away. Now that your gift from my very special basket is in a safe place, it is time to come back to our classroom. Listen to the sounds of our room . . . listen to my voice . . . Open your mouth and see if there is a yawn in there . . . Wiggle around a little and open your eyes. Look around the room until you see me.

I have found that when using this guided fantasy with young children, they usually are eager to tell about their gift from the very special basket and are especially interested in keeping the hiding place a secret! Recently, several days after we had been on this particular fantasy journey, a five-year-old took me aside to show me her imaginary gift transformed into a clay sculpture. After she spent a good deal of time describing it in exquisite detail, she whispered to me, "It was easy to hide my 'imagine' present, but I can't find a place to hide this."

Sometimes children will remember their fantasies and, long after you have forgotten about the experience, will create some type of concrete or material representation. When this happens naturally and spontaneously, you will know

that your children are enjoying the guided fantasies and are busy at work developing their imagery system for coding and retrieving knowledge. Remember, though, that fantasy exploration is intrinsically rewarding, and the *process* of exploring imagery is what is most important.

IDEAS TO EXTEND LEARNING

1. Select one of the guided fantasies for children and ask a friend or colleague to read it while you take the fantasy trip.
2. Respond to the following items and determine how easy or difficult it was for you to:
 a. be open to participating in the guided fantasy.
 b. allow images to form in your "mind's eye."
 c. accept guided fantasy seriously.
 d. "get lost" in the guided fantasy process.
3. Visit a kindergarten classroom and note the number and types of activities that encourage learning through the imagery code. Make a list of teacher behaviors that seem to interfere with fluency, flexibility, originality, and elaboration.
4. Review the book *Left-Handed Teaching: Lessons in Affective Education* and implement one of the lessons with a group of young children.
5. Make a list of all the things your college professors have done to help you become an effective teacher.

ENDNOTES

1. Krathwohl, D. R., B. S. Bloom, and B. B. Maria. *Taxonomy of Educational Objectives Handbook II: Affective Domain.* New York: David McKay Co., Inc. 1964.
2. Torrance, E. P. *Encouraging Creativity in the Classroom.* Dubuque, Iowa: William C. Brown Company Publishers, 1970.
 _____ *Guiding Creative Talent.* Englewood Cliffs, N.J.: Prentice-Hall, 1962. Reprint, Krieger, 1976.
3. Singer, J. *The Inner World of Daydreaming.* New York: Harper and Row, 1975.
4. Anderson, R. F. "Using Guided Fantasy with Children." *Elementary School Guidance and Counseling.* 1980, Vol. 15, No. 1.
5. Bruner, J. *On Knowing: Essays for the Left-Hand.* New York: Atheneum, 1962.
6. Ibid., 4. Anderson, R. F. "Using Guided Fantasy with Children." *Elementary School Guidance and Counseling.* 1980, Vol. 15, No. 1.
7. DeMille, R. *Put Your Mother on the Ceiling.* New York: Viking, 1955.
8. Hendricks, G. and R. Willis. *The Centering Book.* Englewood Cliffs, N.J.: Prentice-Hall, 1975.
9. Castillo, G. *Left-Handed Teaching: Lessons in Affective Education.* New York: Praeger, 1974.
10. Thayer, L. *50 Strategies for Experiential Learning: Book One.* San Diego, CA: University Associates Inc., 1976. (Adapted with permission)

SUGGESTED READING

Brown, G. (1971). *Human Teaching for Human Learning: An Introduction to Confluent Education*. New York: Viking.

Hendricks, G. and T. Roberts, *The Second Centering Book*. Englewood Cliffs, N.J.: Prentice-Hall.

Keat, D. B. (1977). *Self-Relaxation For Children*. (tape). Harrisburg, Pa.: Professional Associates.

Singer, J. (1974). *Imagery and Daydream Methods in Psychotherapy and Behavior Modification*. New York: Academic Press.

3
Music and Movement

A four-year-old watches and listens as her teacher magically transforms his fingers into a little cabin, a little man, and then a little rabbit. The child attends to the story line and the actions of this fingerplay and begins to respond with a few words and finger movements. The child finds pleasure in responding and enjoys the enthusiasm of her teacher and the rhythm and action of the fingerplay. This chapter begins with a discussion about the value of music and movement in the early childhood classroom. It continues with a description of the basic stages of children's early musical development. The chapter also includes music and movement activities written for you. These activities are designed to encourage you to respond and participate in music and movement experiences. They also provide a framework for you to move, sing, dance, and practice fingerplays and instrumentation. The final and major portion of this chapter is devoted to methods and materials. The suggestions on teaching strategies will be helpful as you prepare to structure an environment for music and movement in your early childhood setting. The appendix includes many songs and fingerplays. Musical notations for several action songs are also provided to assist you in playing melodies or musical accompaniment.

Objectives

This chapter will provide the information and opportunity for you to

- explain why music and movement are important components of a childhood curriculum

- describe basic stages of early musical development
- personally and individually respond to music and movement activities
- develop a framework for planning music and movement activities for young children
- design and implement music and movement activities with young children in an early childhood setting

MUSIC AND MOVEMENT: ENJOYMENT AND VALUE FOR THE YOUNG CHILD

Young children are action-oriented. Singing, moving, and dancing are not only fun; they provide young children opportunities to listen, respond, imitate, and use their voices, fingers, hands, arms, and bodies in ways that are creative and uniquely theirs. James Hymes, in his classic *Teaching the Child Under Six*, tells us that young children are not good sitters, they are not good at keeping quiet, and that they are hungry for stimulation.[1] Music and movement experiences offer endless possibilities for action and exploration. Young children are constantly on the go, and movement and music activities are most compatible with their active nature. Songs and fingerplays can be used to motivate children to use their voices and bodies to make patterns and forms out of natural, basic ways of being children. There is a richness in the variety of children's songs and fingerplays that challenges and stimulates children to play with melody and skills. Children delight in experimenting and responding to rhythm and music by dancing, moving, and singing. At this stage in their development, most young children seem to be natural musicians.

A child's awareness of music begins very early. Infants can be comforted by quiet singing, music boxes, and musical toys. As infants make cooing sounds and begin babbling, they experiment with different tones and rhythmic patterns. Typical toddlers can frequently be observed clapping, dancing, or parading around the room trying out different ways of moving to musical beats and rhythmic patterns. Their world is filled with dance, creative movement, and enthusiasm for the world of music. Young children at this age are sensitive to musical sound and respond freely and joyfully to different tempos and beats while discovering new and different ways of using their bodies and voices.

Throughout the early childhood years, children's major accomplishments in musical develpment in turn support many developmental milestones. One important by-product of music and movement exploration is language development. Because children like to move, and because movement is such a natural means of expression and communication, the music and movement experiences of young children are closely related to language. Communication for the very young child is largely nonverbal, and music and movement can enhance and expand the child's repertoire of communication skills and abilities. Choate suggests that "music activities provide one of the most powerful tools in developing language in an enjoyable and satisfying context."[2] Throughout his work on

Adults encourage creative expression by responding to children's creative efforts. Finger plays are a type of rhythmic pantomime and are excellent for introducing rhyme and rhythm.

teaching and brain hemispheric function, Robert Samples supports the belief that the acquisition of communication skills is easier for young children when they are involved in imaginative, creative movement and physical activity.[3]

For young children, language, music, and movement go hand in hand. Children share ideas and feelings in ways that require very few spoken words. Through movement, children can explore the elements of mood, rhythm, and form common to both music and language. Vernice Nye reminds us that songs, fingerplays, and other movement activities help to increase vocabulary, offer

models for patterning and sentence structure, and expand the development of auditory discrimination.[4]

Music and movement in the early childhood environment offer many opportunities for children to develop the characteristics of fluency and flexibility that Torrance[5] identified as being essential to the creative process (see Chapter 2). Aranoff[6] writes that

> the incumbent freedom to respond (within given limits) will develop the child's imagination, flexibility, and fluency in his musical thinking, and perhaps in his general attitude as well. Considerable insight into the nature of music can be achieved by experimenting with musical materials, and encouragement to explore is an essential part of learning by discovery. Through moving, singing, and playing, alone and with his classmates, the young child can demonstrate his accomplishments and thereby achieve the human dignity born of being productive.

Music and movement experiences provide young children with a developmentally appropriate medium for expressing ideas, feelings, and sensory impressions. The goal remains the *process*, which in itself reflects the child's thoughts, affective states, and sensory experiences. The responses of children, and your responses as well, come from within. As you and your children express yourselves both musically and through movement, you truly become involved with the affective aspects of knowing and learning.

Music and movement experiences increase the integration of the cognitive, the affective, and the psychomotor domains. Children sing while they play; you may hum a favorite song as you work. Children enjoy listening to music; you might study to Beethoven or contemporary recordings. Children create songs and rhymes, and they enjoy matching their movements to the music they hear. You may write lyrics or dance to songs that express your mood or state of mind at a particular moment. Howard Gardner, in his extensive research on feeling states and the artistic process, concludes that there is a relationship between affective, cognitive, and psychomotor development and children's experiences with the artistic process. Gardner states:

> The child attending to a piece of music or a story listens with his whole body. He may be at rapt attention and totally engrossed; or he may be swaying from side to side, marching, keeping time, or alternating between such moods. But in any case, his reactions to such art objects is a bodily one, presumably permeated by physical sensations. . . . A child's immersion on affective states while encountering the arts has a positive dimension. Because of its unity and potency, an affect may well have an integrating and structuring effect on the child's experience, influencing both his perception and his creation of objects.[7]

Young children possess a natural awareness and sensitivity to musical sounds. They explore music with more spontaneity than any other age group, and they venture forward into music and movement activities with their voices, their bodies, and their own feeling states. The whole child is involved. Each child's

affective, cognitive, and psychomotor responses to a musical encounter are the hallmark of creativity.

FUNDAMENTALS OF MUSIC AND MOVEMENT

Children are musically creative. However, in order for them to discover and find their own natural and spontaneous ways to use their voices and bodies creatively and joyfully, they must move, sing, and dance. To be better prepared to plan music and movement experiences for your young children, you should be aware of how young children explore these creative processes and of why music and movement are viable components of an early childhood curriculum. The following section provides an overview of movement, dance, singing, fingerplays, action songs, and instrumentation. Several activities and fingerplays are cited as examples. You'll find these in the appendix.

Movement and Dance

Dimondstein lists the major types of movement for young children in her comprehensive conceptual framework for dance.[8] She describes space, time, and force as the basic movement experiences for exploring creative dance. Day tells us that children move their bodies in time (fast, medium, sudden, sustained), in force (strong, light), and in flow (bound, free, or a combination).[9]

Space Observe children moving their bodies through *space*. They explore direction (straight, forward, backward, up, down), levels (high, low, or somewhere in between), relationships (above, below, over, under, through, around),

and plane of movement (horizontal, vertical, diagonal). Through space exploration children learn to organize the available space in relation to themselves and in relationship to objects and other individuals.

Time Children move their bodies in time. "Time is expressed in the body as rhythm."[10] Time is connected to different *speeds* (fast, slow, medium) and *rhythmic sensations* (strongly accented, smooth, irregular, or combinations of rhythmic sensations).

Force The concept of force is also important in movement and dance. Children experience light, heavy, sudden, or sustained qualities of movement. Children's movements flow freely when children integrate different motions. Alternatively, they can stop at the end of a movement before changing to something new.

Through experimentation and exploration of these different types of movement, young children can develop body control, confidence in the power and ability of their own bodies, and, best of all, intrinsic pleasure. Children are never wrong in their rhythmic responses. They choose their own individual rhythms, and the meanings and expressions of their movement emerge from the inner experiences of the individual child. Children create, shape, and express their feelings and ideas in a fluid symbolic form. Each gesture is important because it reflects children's experiences, ways of responding in their world, knowledge of what their bodies can do, and their affective states of mood, feelings, and emotion.

Singing, Fingerplays, and Action Songs

Movement is a basis for many types of musical expression, and young children who have had positive and pleasurable experiences with rhythm and movement will enjoy the same rhythmic patterns in singing, fingerplays, and action songs. Singing occurs spontaneously in young children. Children sing while they play. They make up nonsense chants and songs as they experiment with variations in rhythm, pitch and volume. According to Lundsteen and Tarrow, songs for young children should be pitched from middle C up to G, a fifth above.[11] As children develop their singing voices, their range extends to B below middle C and up to the D and E in the octave about middle C.[12] Songs for young children should be pitched in this range, be short, easy to sing, and have a steady beat and recognizable melody. Young children enjoy a variety of songs and especially seem to like songs that have personal meaning, such as songs about their names, body parts, clothes, feelings, and special occasions like birthdays. Songs about children's interests are appealing: home and family, things that happen at school, and animals and pets. Songs about animals, in which children can imitate or make animal sounds, capture children's interest and encourage them to become involved in singing activities.

When you first introduce songs to young children, they will probably not sing every word or follow every phrase. If the song has repetition or a chorus,

children will usually join in on the words or lines they hear most often. Don't be discouraged when you first introduce a song and your children sing just a word or two or don't match your pitch or sing with your tune. By the time you have sung it several times, your children will begin to pick up the lyrics and melody and ask you, "let's sing it again!" It is very important for the teacher to have a large repertoire of songs, chants, and fingerplays, available "in the moment." Teachers must constantly search for new songs and fingerplays, as they are an invaluable resource in the day-to-day happenings in the early childhood classroom.

Fingerplays and action songs are, in a sense, a type of rhythmic improvisation. They have strong appeal to young children because there is usually repetition of melody, words, and phrases. There seems to be some magic in transforming a tiny finger into a "Thumbkin" or rabbit, or "shaking all about" during "The Hokey Pokey." In fingerplays and action songs, the words provide suggestions or directions on what, how, when, and where to move. In general, children enjoy the continuity of hearing and playing with the fingerplays and action songs from the beginning to the end. If the fingerplays are short (or led by a teacher) and action songs are simple and repetitive, children can learn the actions or movements after doing them a few times. With longer action songs and fingerplays, it is still important that children first hear the *entire* song. When children are familiar with the content, lyrics, and melody, you can always divide the song or fingerplay into smaller, more manageable parts. Echo chants and fingerplays, such as "Let's Go on a Bear Hunt," are very easy for young children to respond to because they are

led by the teacher. The teacher chants a phrase and the children chant it back. Echo chants are popular among young children because all they have to remember is one short line or simple phrase.

Action songs and fingerplays can relate to curriculum development and can be used to enhance a young child's understanding of concepts. For example, the action chant I just mentioned, "Let's Go on a Bear Hunt," reinforces the concepts of under, over, around, and through. At the same time, action songs and fingerplays that directly relate to the children can provide personal, concrete experiences that are relevant and meaningful to the young child. "Where Is Thumbkin?" is an all-time favorite of young children. It is their fingers and arms that are the center of attention and the stars of the play.

Action songs and fingerplays can also help with transitions. A magical and masterful teacher of two-year-olds, whom I greatly enjoy observing, uses "Teddy Bear Teddy Bear, Turn Around" to redirect her children's energies when they need her to help them calm down during transitions. The movement is fun, and the two-year-olds pick up cues from the words and move through transitions with ease and pleasure. The process is so much gentler to young children than ringing a bell or switching the lights off and on. "Come Follow Me in a Line, in a Line" is a delightful action song (or chant) that can be used to assist children through transition periods. The teacher moves through a group of children while singing or chanting the verse in Pied Piper fashion and, one by one, touches the head of each child. As the children are touched, they join one hand and follow the teacher until they are all in a long, connected line. This is especially effective for moving children into a circle or a different area of the classroom. This calm process of forming a line and moving to a repetitive song allows you and your children to gather together or form a circle without the confusion that this request often causes! Words and musical notations for these action songs and fingerplays along with many others for you to use with young children are included in Appendix 1.

It is very important that we not limit the use of action songs and fingerplays to very young children. Children's ability to elaborate and expand their movement, actions, and singing abilities increases with age and experience. Three-year-olds may sing or chant short melodic songs informally as they move through an activity. These young children may not remember all the words or even understand the exact meaning of some words, but they often remember the feeling or affect they experienced during a song or fingerplay. Look at the response of a group of three-year-olds who had learned the fingerplay "Little Cabin in the Woods." This fingerplay is about a man who rescues a rabbit from a hunter. After the rabbit is safe, the man tucks the little rabbit in bed and covers it with a blanket. The last line of the fingerplay is "safely you'll abide." When the children were busy working in the block center, their student teacher observed several children tucking their little rabbits in block beds, using imaginary blankets and *real* kisses, and singing "safely on your side." The teacher made the perceptive observation that although the children had changed the words, the mood, feeling, and affect were the same: nurturing and taking tender care of an imaginary rabbit. The

children had simply substituted "safely on your side" for the more abstract and complicated vocabulary of "safely you'll *abide*."

For the older child, fingerplays and songs offer great potential for learning new words, rhyming and alliteration, developing language and verbal skills, and concept formation. Teachers can also use songs and fingerplays to expand children's awareness of tempo, accent, rhythmic patterns, and intensity, all of which are part of the language and reading process.

Rhythm Instruments

Making music with rhythm can be one of the most exciting parts of the creative arts experience. Children are responsive to musical instruments and they love to experiment with the different sounds and tone qualities of sticks, drums, cymbals, bells, and a variety of other instruments. Playing rhythm instruments, which are *real* musical instruments, provides rich and varied opportunities for creative exploration. Each instrument is different, they are simple to use, and they can be played in many special and interesting ways.

Some of you may remember the chaos associated with the traditional "rhythm band." Fortunately, there is a trend away from this approach to using instruments and toward a more relaxed and personally selective use of rhythm instruments. Under this approach, children can select an individual instrument and discover what tones can be produced, what the dynamic range is, and what musical textures can be developed. They can experiment with different ways of playing the instrument and notice how different a drum sounds when they play it with a mallet and tap it with their fingers. Children can compare the duration of the bell sound when a triangle is struck suspended from a string or when they hold it in their hand. They can discover the music hidden in the instrument and create rhythmic patterns of their very own! The more children experiment with rhythm instruments, the more sensitive they will become to the delightful patterns, combinations, and possibilities these instruments hold for making music.

Bringing a child and an instrument together with ample opportunity to explore can help eliminate the stereotypical "rhythm band" concept where all the instruments sound at once. Certainly, not many things can be more frustrating for a teacher and more confusing for a child than having to march to the beat of the drum as all the instruments crescendo to the maximum of their dynamic range.

Before you begin thinking about ways to plan and implement music and movement experiences for your young children, it's important for you to have an understanding of the basic stages of early musical development. The following information was selected from Althouse, 1981;[13] Bayless and Ramsey, 1982;[14] Haines and Gerber, 1984;[15] Jalongo and Collins, 1985;[16] Moomaw, 1984;[17] and Nye, 1975.[18]

BASIC STAGES OF EARLY MUSICAL DEVELOPMENT

The Two-Year-Old Rocks, sways, moves up and down, enjoys clapping games, fingerplays, and action songs.

Experiments with imitating rhymes and rhythms and responding to music through body movement.

Can learn short simple songs and enjoys experimenting with instruments and sounds.

Listens to music and occasionally matches body movement to simple musical beats.

Responds to songs with simple patterns.

Explores space by moving forward and backward, upward and downward.

Can move low to the floor or walk on tiptoe.

Experiments with voice and sings or hums at play.

The Three-Year-Old Sings along on certain phrases of familiar songs.

Can establish and maintain a regular beat.

Sings songs with repetitive words and sings in tune.

Talking and singing are a part of many activities.

More consistent in rhythmic responses and can accomplish sudden stops or "freezes."

Enjoys listening to recorded music and responding or imitating the motions of others.

Suggests words for songs or additional verses to songs.

Interested in rhythm instruments.

Enjoys when grown-ups play with them and provide simple rhythmic patterns to imitate.

Can learn simple fingerplays.

Claps in different tempos and at different levels when imitating an adult.

The Four-Year-Old Has improved voice control and rhythmic responses.

Makes suggestion for musical activities.

Adds words to songs and creates songs on instruments.

Creates new rhythms.

Enjoys singing and is more aware of sounds and rhythms in the environment.

Takes the lead in adding to the movement learned earlier by changing direction, time, or force.

Imitates movement of animals, machines, or other familiar objects of people.

Can learn longer and more complicated fingerplays and songs.

Has increased ability to master song lyrics.

Combines creative drama with movement and singing.

Matches and classifies sounds according to volume and pitch.

Reproduces rhythmic patterns vocally and with instruments.

Memorizes fingerplays, chants, and action songs.

Forms basic concepts such as loud-soft and fast-slow.

The Five- and Six-Year-Old Sings complete songs from memory.

Enjoys songs and dances with specific rules and patterns.

Moves rhythmically to a regular beat and can keep time with music.

Has greater pitch control and rhythmic accuaracy.

Abilities and individual talents come together and begin to take form.

Can learn simple dance steps and adapt them to rhythms.

Plays instruments with more precision and accuracy.

Has large repertoire of songs.

Changes in tempo and dynamics come easier, and music enhances dramatic play.

Works well with a partner and with small groups in musical activities.

Enjoys group singing in which everyone has a turn and is especially interested in musical games in which words are often repeated.

Longer attention span when listening to records and other recorded music.

Can compare several sounds and pitches.

This overview of early musical development provides you with an important framework for developing goals for music and movement experiences with your children. Now, what about you, the teacher? How is *your* creative development progressing? Let's shift the focus back to you and explore some ways for you to respond to music and movement experiences.

AFFECTIVE DOMAIN: RESPONDING

In the previous chapter we examined receiving, the first major category on the continuum of affective development.[19] The second category on this continuum is *responding* and refers to active participation on the part of the learner. At this level, I invite you to move beyond simply attending to a particular phenomenon, as you did when attending to the guided fantasies in Chapter 2, and to react by doing something and becoming actively involved. Throughout this chapter, you will have an opportunity to move beyond the level of awareness or perception and become an active participant in the creative process. Responding means that you are willing to participate; that you show interest in the content; and most importantly, that you take pleasure, enjoy, or gain some satisfaction by responding in creative ways.

How do you feel about being creative? Are you creative? Mimi Chenfeld defines a creative teacher as "a person who is open, flexible, willing to try new things and risk their failing, honest, responsive to people and situations, and welcoming of new experiences."[20] I believe that most of us who have chosen teaching as a profession are willing to venture into new and different situations. After all, in the early childhood classroom, a new happening occurs almost every minute! But if you are saying to yourself right now, "I really can't sing," don't worry. A beautiful singing voice is not a necessary requirement for bringing meaningful musical experiences to young children. You can recite or chant the fingerplays and action songs. The rhythm is more interesting to children than the melody. You can use records, simple instruments such as an autoharp or melody bells, or the talents of a musical volunteer. If your body just doesn't "feel" rhythm in movement or dance, begin slowly by experimenting with the different types of movement outlined earlier in this chapter and open yourself to the possibility of discovering something new about yourself and your musical creativity. Your children will respond to *you*, their teacher, and your enthusiasm, interest, and spontaneity. If you trust yourself enough to try, your children and their responses will help build your confidence.

The experiential activities in this chapter are designed to encourage you to *respond* as you explore movement, dance, instrumentation, songs, and fingerplays. You will experiment with pitch, melody, and rhythm while learning about percussion and tonal instruments. You (yes, you!) can use these simple rhythmic chants and songs to continue developing your self-confidence, your imagination, your ways of self-expression, and your own innovative and creative ideas for using these with young children.

Responding to these activities and actively participating may come easy for some of you. Others might already feel uncomfortable as you realize that you will soon be exploring and experimenting with ways of moving through space, singing or chanting, or playing instruments. Remember that there is safety in numbers. Imagine for a moment that you are opening a window to your own personal creativity and that you may see something new and exciting. Be assured, though,

that if a storm approaches or lightning flashes, you can close your window and watch and enjoy the movement and music of others.

MUSIC AND MOVEMENT FOR THE COLLEGE STUDENT AND CLASSROOM TEACHER

"The Mirror Dance" and "The Magic Forest" provide the security of working in a large group and with a partner. The group and partners serve as support and reinforcements for each other. Individual work can often bring out all those old fears about performance and talent. For this reason, both of these activities utilize the safety of numbers.

During music and movement activities, you will explore both nonlocomotor and locomotor actions. You can stretch, bend, twist, curl, leap, spin, spiral, advance, retreat, or move your body in many other ways. Individual body parts are also a focus of these movement and musical activities. Simple movements such as extending a finger, lifting an arm, or rolling your head from shoulder to shoulder can be used to move to rhythms and explore changes in tempo or force. As you participate in and try out these movement activities, give some attention to where your body moves, how one body part moves in relationship to another, and how you move in relationship to another person. Open yourself to all these expressive modes and allow them to come together in combinations that are flexible and natural for you. There are no correct or incorrect responses to this exploration except those that your body expresses. You are free to let go, to move, act, lead, or follow. Remember that the process is more important than the product, and in this case, the process is left up to you.

Movement and Dance

Group Size: Large group, dyads

Leader: College instructor, teacher

Objectives:
Respond to music through body movement
Express imagery, mood, or feeling creatively
Explore creative dance with a partner
Increase body awareness
Develop inner rhythms
Practice basic beat exercises

Materials: Recorded music, preferably a recording that has a variety of dynamics, tempos, and rhythms. Some classical suggestions, if available, are the Mozart *Concerto for Flute, Harp and Strings,* the Pachelbel *Canon in D,* any of the *Strauss Waltzes,* and *The Four Seasons* by Vivaldi. Percussion instrument, drum, or tambourine.

Mirror Dance

Procedure:
1. The leader sets up the audio equipment: record player or tape recorder.
2. Participants are asked to sit on the floor, in two rows so that one row is looking at the backs of the participants in the front row. Participants in the front row are instructed to begin moving very slowly by bending, stretching, twisting, or using body parts such as fingers or hands. Participants in the back row imitate or mime the motions made by the people in the front row.
3. After the back row has had a chance to imitate the motions of the people in the front row, both rows turn completely around so that the front row becomes the back row. Allow time for the back row to practice similar mirroring before going on to the next step.
4. Participants choose a partner and find a comfortable place to sit. Be sure that there is enough general space between each pair so that there is room for movement.
5. The leader than reads the following guided fantasy and begins the music as indicated in the guided fantasy directions.

The Dancers

Note: Three periods (. . .) indicate a pause.
Find a comfortable place to sit and then settle yourself on the floor facing your partner . . . Take a few minutes to find a position that is really comfortable . . . Notice the thoughts and images that pass by your mind's eye and prepare to let them go for just a few minutes . . . Close your eyes and imagine yourself at the edge of a large, sunny, grassy meadow with lots of spring flowers and Blue-eyed grass swaying in a sweet April breeze . . . Look around this place and be aware of the vastness of space and how you feel here . . . Look across the meadow and you will see someone else . . . You notice this person moving in a dance that is as fluid as the breeze . . . This person is a dancer and will come into this meadow without even noticing you and begin dancing freely . . . As the dancer moves deeper into the meadow and closer to you, just watch the grace and beauty of the movements and dancing for awhile . . . Soon this dancer will notice you . . . and come over to see you . . . Then the dancer will begin to move, and your body magically responds with grace and ease . . . You experience an effortless ability to respond in a mirrorlike manner . . . You and the dancer leap and spin . . . You turn and spiral . . . You and the dancer are free from space and time and form and practice . . . Mirror the movements of the dancer as you discover pathways . . . and airways . . . levels . . . and space . . . direction and weightlessness . . . Use your mind's eye to notice when you are following the dancer or when the dancer is following you . . . Notice your relationship with the dancer . . . Are you near or apart . . . meeting or parting . . . beside or behind . . . lead-

ing or following . . . '' (Note to leader: Pause here for a least one full minute. You might experience your own dancing fantasy or simply count to 60 very slowly to allow time for participants to complete the fantasy dance).

In just a moment, you will hear a melody for meadow dancing . . . When you hear the music, open your eyes and begin moving . . . very slowly at first and with a different dancer . . . your partner . . . One of you will be the mirror and one of you will be the dancer . . . You can change roles when it feels comfortable, but remember to do this nonverbally.

(Begin music here)

Let movement enter your body as you listen to the music . . . stand up and move around the room with your partner . . . as you create a mirror dance.

The Magic Forest

Procedure:
1. The leader selects music that includes both medium and slow tempos and then talks to the participants about a magic forest where everything and everyone can dance. Any of the recorded selections suggest for "The Mirror Dance" will work well. The following script is provided to assist in setting the mood for the creative dance.

We are in a wonderful forest where everything is magic! There are trees with branches that reach up toward the sky and drape down toward the earth. There's a stream that curls and bends as it flows along through the forest floor. There are birds that fly and turn and spiral in the air, and there are seeds, hidden deep in the forest floor, that grow into wildflowers and bloom and sway in the gentle breezes. Some of you will be majestic trees. You will be solidly connected to the earth and will sway your arms as branches and bend and twist your mighty trunks. Some of you will be the stream. The stream will flow, and splash and tumble over rocks on the journey along the forest floor. Some of you will be birds and you'll fly and soar and swoop through the trees. You may even find a nesting place in the branches of a giant redwood. Some of you will be tiny seeds that slowly grow out of the earth and blossom and shine as you point your faces toward the sun. Decide what you would like to be and find a place where you can have some space around you. Extend your arms and legs and make sure you have just enough space. You are the magic forest!

2. The leader makes sure that all participants have decided on a role and starts the music to begin "The Magic Forest" dance.

A Rhythm and Beat Activity

Rhythm and beat are an internal part of our physical makeup, and these concepts can be demonstrated by using our own bodies. In "Rhythm and Beat," you are encouraged to discover, mimic, and verbally respond to your own rhythmic heartbeats. You will use your body to express youself individually as you use your own name to develop an inner rhythmic sense. During this activity you will explore space, levels, and speed of movement. Basic beat activities, including note references, provide a fundamental framework for experimenting with rhythm and beat. Again, once you have mastered the basic technique, I encourage you to expand or narrow the scope of these or similar activities so that they are developmentally appropriate for the different children in your own particular setting.

Group Size: Large group

Leader: College instructor, teacher

Objectives:
Encourage awareness of rhythm
Explore inner rhythms
Express rhythm through movement
Practice basic beat exercises
Develop body control

Materials:
Percussion instrument

Procedure:

1. The leader asks students to find their heartbeat by placing their right hand in the center of their chest or on their wrist.
2. The leader asks students to jump up and down in place until their heartbeats are strong enough for them to feel the inner beat.
3. When all the students have found a steady inner heartbeat, ask them to make a small "beat, beat, beat" sound that matches what they feel inside.
4. For the basic beat exercise, match the following notes and actions:

 Whole note—sitting note
 Half note—hopping note
 Quarter note—walking note
 Eighth note—running note

 Using a 4/4 measure, the leader begins playing the percussion instrument with the whole-note count, tapping out the number of beats for each 4/4 measure. Ask students to listen to the beat and move around the room to this rhythm. Change the beat by adding in half notes, quarter notes, and eighth notes one by one. As the leader changes the basic rhythms, remind students to listen for changes while they try to respond to them through movement.
5. Name Game. The leader asks students to say their names individually and then uses the drum to reproduce the name rhythmically. The leader then plays the drum and matches the rhythm to the rhythm of each student's name. After all students have developed a rhythmic presentation of their names, ask them to say their names simultaneously. Add a little dynamics (loud, soft, etc.) and product beautiful sounds . . . music!
6. Rhythmic Names to Movement. Students move around the room saying their names in their own chosen rhythm. Encourage them to fill up all the space and to move in different directions (forward, backward, sideward), at different levels (low, medium, high), with different speeds (slow, medium, fast), and with different levels of exertion (strong, weak, heavy, light).

Two Instrumentation Activities

"Instrument Improvisation" provides an opportunity for you, in your own instinctive way, to explore rhythm instruments as you work out musical "scores" that reflect your interpretation of the instrument. During "Music In Your World," you will discover the distinctive, expressive potential of the individual instruments as you share your own musical world with others. You can do all of this without excessive practice, prior instruction, or any special musical expertise. Through guided exploration you, and eventually the children you work with, will acquire skill in controlling the sound of the instruments. As you experiment with repeti-

tions and combinations of sounds, you will be improvising your own patterns and phrases to form musical shapes.

Group Size: Large group, small group, individual

Leader: College instructor, teacher

Objectives:
Explore rhythm instruments
Develop rhythm awareness
Create musical forms

Materials:
Tape recorder
Instruments: tambourines, cymbals, finger cymbals, drums with mallets, claves, wood blocks with mallets, triangles with strikers and string holders, tone blocks with mallets, wood maracas, rhythm sticks, jingle bells or sticks, sand blocks
Optional instruments include the autoharp, Orff Instruments, resonator bells, string instruments

Instrument Improvisation

Procedure:
1. The leader places all the instruments on the floor in the center of the room. Participants are asked to experiment with the instruments and to be aware of the different tones, sounds, and rhythms each instrument can produce. Allow about ten minutes for this period of exploration.
2. Ask participants to select one instrument that they have especially enjoyed manipulating. When everyone has selected an instrument, ask participants

to choose a partner and find a space in the room where they can play their instruments together. The task is to experiment with the two instruments and see what musical possibilities they present.

3. After a short period of exploration, the leader asks each pair to join another pair to form groups of four. These small groups should find a place where they can be alone, preferably out of the hearing distance of others. Some may choose to leave the room or move to a far corner where they can play their instruments. The task is to create a musical improvisation, an interlude, rhythmic presentation, or a combination of patterns and phrases. Allow about fifteen or twenty minutes for this process.

4. Once the participants are reassembled in the large group, they are asked to lie on the floor, close their eyes, and prepare to listen as each small group plays their musical presentation.

5. The leader moves to each group, one at a time, and asks them to sit up and play their musical improvisation. The leader tape records each presentation to be played back to the entire group when everyone has finished.

Music in Your World

Music can be heard in almost every corner of our world. It may be in the song of the bird, the whistle of the wind, the pitter-patter of the rain, a cricket serenading at dusk, the sound of a doorbell, feet shuffling, a motor humming, a vocalist practicing, or a symphony playing in concert. As you allow yourself and the children in your classroom to explore rhythm instruments and participate with others to make original compositions, you can discover the patterns, rhythms, harmonies, and forms waiting to be heard. In this way, you will all naturally express your own ways of adding more music to the world.

Procedure:

1. Each participant selects an instrument. The leader asks the following questions and waits after each question for the participants to respond by playing their instrument.
 Which instruments can make the sound of a gently falling rain?
 Which instrument sounds like a Spanish dancer?
 Does anyone have an instrument that sounds like a church bell?
 What instruments make the sound of lightning flashing?
 Which instrument can sound like a kitten sleeping?
 Is there an instrument that sounds like galloping horses?
 What instruments sound like a firecracker?
 Do any of the instruments sound like thunder?

3. The leader asks each participant to continue experimenting with their musical sounds by making:
 the rain fall *stronger* and *gentler*
 the Spanish dancer spin *faster* and *slower*
 the church bells ring *louder* and *softer*

Playing rhythm instruments provides young children with rich and varied opportunities for creative expression.

 the lightning flash *brighter* and *dimmer*
 the kittens *purr* and *meow*
 the horses gallop *swiftly* and *leisurely*
 the firecrackers explode into *fireworks* and *fade*
 the thunder *roar* and *disappear*

4. The leader asks participants to exchange instruments and to experiment with their new instrument to discover what other "world" sounds they can find. Allow time for conversation and discussion as participants explore their new instruments and come up with additional sounds that can add music to the world.

 The music and movement experience in all of these activities can be changed and modified into developmentally appropriate activities for your young children.

You have had the personal experience of exploring the wonderful world of your own creative potential and should now have a better understanding of how children feel when they explore movement, music, and rhythms. Your role, as an early childhood professional, is to provide music and movement experiences that will bring satisfaction and enjoyment to your children. Remember that mastery is not the goal; the goal is for your young children to find pleasure and joy in the *process* of singing, moving, dancing, and playing instruments. Your part is to plan activities and experiences to introduce children to music and movement. You must be open and flexible in your planning and *know* the developmental levels of your children. You must search for new ideas and techniques. Even though young children like repetition, they will soon get tired of fingerplays if you have only three of four in your repertoire. You must encourage and support your children with as little interference as possible. You must motivate your children by providing a variety of music and movement experiences. And, you must enjoy and find pleasure in the creative self-expression that flows naturally and spontaneously from the child's own wellspring of creative potential.

TEACHING STRATEGIES FOR MUSIC AND MOVEMENT

Structuring An Environment for Music and Movement

Atmosphere One of your primary responsibilities as a teacher of young children is to establish a warm and safe environment of trust, freedom, and communication where positive and pleasurable music and movement experiences happen. Enjoyment of expression is the *prime* value of music and movement. We must be very careful that we don't demand perfection of form as children move through space or experiment with time and force. "Children move because movement gives them a tremendous lift, a senses of freedom, exhilaration akin to flying high above the waters, above the clouds, above the earth and into the sky"[21] Our job is to create an atmosphere that welcomes this freedom.

How will you structure this atmosphere? How will music and movement thrive in your classroom? Combs, Avila, and Purkey claim that positive involvement is more likely in an atmosphere in which students feel

- it is safe to try
- assured that they can deal with events
- encouraged to make the attempt
- more fulfilled for having done so[22]

When young children find themselves in a safe, supportive, and encouraging environment, they are free to explore, experiment, and respond with unlimited creative expression.

Space Children need space to bend, curl, leap, and spin. When involved in nonlocomotor activity where children move arms and legs or twist and extend individual body parts, they need an area of personal space. You can help children define their personal space by asking them to extend their arms while turning around and around to make sure they can't touch anyone else. You might tap their imaginative powers by asking them to pretend that they are moving inside a very large bubble.

Young children can also carry their personal space with them as they move during locomotor activities. Leaping, jumping, skipping, and sliding are examples of locomotor activities that involve moving from one place to another. Locomotor activities require a large, uncluttered space. You don't need a space as large as a gymnasium; a large open area in your classroom or even outdoors is adequate. It is important to remember that your children need to hear you and your suggestions during movement activities. In a large, oversized room your children will have difficulty seeing and hearing you. If you find, however, that a large area is the only space available to you, the problem of hearing and seeing can easily be solved by using a percussion instrument (drum or tambourine) as a signal to children when it is necessary for them to stop and listen. Movement invites squeals of delight, laughter, and many other appropriate "child sounds." A signal can provide structure and predictability to music and movement experience, both of which are important in establishing and maintaining a secure and trusting environment for young children.

Movement and Dance Activities
for Young Children

Exploring space, time, and force

It's important that your children know that they have their own space and that their space belongs to them and only them. You can help your children identify their personal space by guiding them through an imagery process of finding their own imaginary space bubble.

1. Walk among the children and point out all the space in the room. Show them the empty spaces between tables and chairs and wave your hand in the space between children. Ask the children to look up and see the space between them and the ceiling.
2. Have children find a space on the floor where they can stand, sit, or lie down without touching anyone else. Ask the children to move their hands and arms around, filling up as much space as they can.
3. Encourage children to move their legs and stretch them as far as they can, seeing how much space they can fill with just their legs.
4. Tell children to stand and move their arms through their own space, reaching as far as they can without moving their feet. Ask them to explore their own space with their feet and legs.
5. Ask your children to imagine that they are inside a big space bubble that is theirs and that no one else can come into their bubble or into their space unless they are invited. They can move inside their imaginary space bubble in many different ways. They can also carry their space bubble with them as they move around the room.

As you continue exploring space, time, and force with your children you can develop activities based on the following suggestions. These ideas are presented to assist you in your planning and to help you get started in developing your own music and movement activities. The experiences can be extended by adding recorded music or other rhythmic accompaniment. I hope that you will use your own ideas to change or revise these suggestions when planning music and movement experiences for the very special group of children in your classroom.

Tell your children:

Make yourself very, very tall.

Make yourself as small as you can.

See how much space you can fill by using different parts of your body.

Lie on the floor and make your body into a round shape.

See if you can move your round shape without touching anyone else.

Make your body into a straight, long shape and crawl like a snake and wiggle like a worm.

Be as low to the floor as you can and see how you can move around the room.

Make your body as tall as you can and move in and out of empty spaces.

Try different ways of moving through space.

Can you move straight?

Can you move zig-zag?

Can you move forward and backward?

Can you move sideways?

Can you move upward, downward, or in a circle?

Can you move very near to someone else without touching them?

Move your arms and bodies as high as they will go and then as low as they can go.

Find a medium level and turn around and around and then fall to the floor.

Lie on the floor on your backs and let your feet and legs fly in their space.

Lie on your sides and raise your arms and legs as high as you can.

Lie on your stomach and stretch your head back, kick your feet in the air, and wave your arms out to your sides.

Move around the room as slowly as you can.

Move around the room as fast as you can without touching or getting into anyone else's space.

Change your speed from fast to slow, from very slow to moderate, at my signal.

Move as fast as you can without leaving your space. Move as slowly as you can without leaving your space.

Can you move one arm very slowly and the other very fast?

Can you move one arm up and the other arm down at the same time?

Move as quietly as you can.

Can you move as quietly as a mouse?

Can you quietly creep and crawl like a spider?

Can you dance through the air like a butterfly?

How heavily can you move? Can you move like an elephant?

Can you make your muscles very strong and swing and sway like a bear?

Dance around the room like a heavy hippopotamus.

You can also play the game "Freeze." When you say "go," the children move around the room in different directions or levels. When you say "freeze" the children "freeze" in position. You can point out interesting body positions and call the children's attention to their individual body shapes.

Exploring expressive movement

When exploring expressive movement, you can include other curricular content. If your science or environmental center is arranged around an animal theme, you can encourage your children to dance or move like animals. As you are planning curricular content, units, or themes for young children, you can always include expressive movement activities to add an extra and special dimension to the experience. Each of the following suggestions can be used as a single activity, or you can group several ideas together to provide more complex experiences. Also, you might want to select musical recordings that encourage and enhance children's movement.

Ask your children to:

Move in a happy way.

Move in an angry way.

Move as if you are sad.

See how gentle (rough) you can move.

Dance like a kitten.

Dance like a rag doll.

Pretend you are a tree and the wind is blowing you around.

Pretend you are a bird and you are flying through the sky.

Make yourself very small, like a little seed, and grow up into a beautiful flower.

Gallop around the room like a horse.

Hop around the room like a rabbit.

Move as if you are carrying something very heavy.

Pretend that you are falling snow and drift around the room.

Imagine that you are pushing a very heavy wagon. How would you move?

How would you move if you were a washing machine?

How would you move if you were the clothes in a washing machine?

Swing and sway your body and arms like a monkey.

Pretend you are swimming. How would your body, arms, and legs move?

Pretend that you are a jack-in-the-box.

Sit with a friend and pretend that you are having a row-boat race.

Imagine that you are walking in the rain. Can you feel the rain? Can you splash the puddles?

Make yourself into a flat balloon and slowly blow yourself up.

Pretend that you are a puppet with strings and someone else is making you move.

How would you move if you were exploring a haunted house?

How would you move if you were looking for something you have lost?

Pretend that you are popcorn popping. How would you move?

Move as if you are walking in very deep snow, through a deep river, in hot sand, on cold ice.

The use of materials can also encourage and stimulate children to express themselves through movement. Some materials that are especially enjoyable to young children include:

Scarves Give your children lightweight, colorful scarves and encourage them to let the scarf flow up and down and all around as they move through space.

Streamers Children can use long streamers to make interesting, flowing designs as they move and sway in a group movement activity.

Hoops You can place several hoops on the floor and let the children explore different ways of moving inside the hoop, in and out of the hoop, and outside the hoop. Encourage your children to experiment with putting some parts of the body inside the hoop and other body parts outside. For example, ask "Can you put both feet in the hoop and let your hands walk around the outside of the hoop?"

Balloons Balloons are wonderful "props" to touch and watch. Children enjoy blowing them with their breath, throwing and catching them, and bouncing them in the air.

Parachute Parachutes with sewn-in fabric handles seem to work best for young children. Very young children, especially, find it difficult to hold on to the fabric if there are no handles. Encourage your children to move the parachute up and down. Help them move it in a circular pattern or put a lightweight ball in the middle and let them bounce the ball around. You and your children (with the help

of a few extra adults) can make a momentary "tent" out of your parachute. Position your children at close intervals around the parachute. Raise it high in the air, run under it, and quickly sit on the edges. The parachute will balloon and you and your children will delight in the magical quality it creates!

Fingerplays and Action Songs for Young Children

Before using fingerplays and action songs with young children, you must learn and practice the words and movements until they are committed to memory. Fingerplays, especially, should involve a warm, initimate exchange between you and your children. This atmosphere can be lost if you have to read or refer to written notes during the play. You must be enthusiastic about sharing fingerplays and action songs with your children and be involved both with the play and with your children. Learn and practice a few fingerplays until you are totally familiar with the words and actions. Once you are comfortable with the words and actions, you can present them with the warmth, naturalness, and spontaneity needed to give them excitement and life. I hope you will change or revise the basic forms to create your own versions or to accomodate the different age of levels of your children. Approaching action songs and fingerplays from this perspective will allow you to use your own creative abilities and should limit the potential stereotyping of having all your children doing the exact same thing at the same time. Your children should make their "Eency Weency Spider" move the way they want it to move. And, if you'll think about it, all children shake their "Hokey Pokey" in individual and different ways!

Appendix 1 contains words and actions of familiar fingerplays for you to learn and share. Appendix 2 contains music.

Instrumentation for Young Children

Instruments can provide young children with one of the most exciting ways to explore the world of music. Unfortunately, some teachers avoid using instruments because they are often associated with the unstructured banging of the marching "rhythm band." While it is important for children to be free to manipulate and experiment with instruments, it is equally as important that we, their teachers, provide guidance and structure when introducing instruments.

One of the first things that we must do is adopt the attitude that percussion and tuned instruments are real instruments. Each instrument in your commercial rhythm band set can produce a distinctive and unique sound quality. Tuned instruments, such as resonator bells, have their own particular rich and resonating tone qualities. Young children stand ready to model our behavior and take our word on things, and our treatment of instruments and our attitude toward them can have a lasting effect on the way children handle and play all instruments.

Introduce one instrument at a time. If possible, have several identical instruments so that all of your children can explore and discover what sounds the instrument can make and how to produce these sounds. Young children are not good at waiting—they want to play the instrument now! Encourage your children to play the instrument and try different ways to produce sounds. Give them the

time they need to get to know the instrument. If you have only one set of instruments, you may try placing an instrument in a music center and introduce it as a small group activity.

By introducing instruments one at a time, you allow your children to develop a musical sensitivity to each instrument gradually. When children have experimented with several instruments, you can encourage them to make rhythmic patterns or melodies. Give your children this type of respectful introduction to musical instruments. You will be opening an avenue for them to respond to rhythm, tone, melody, and harmony—and avenue to music.

Using Instruments

Triangles are suspended from a cord so they hang free. Strike them gently with a metal striker. The triangle produces a lovely, bright sound.

Claves are thick, polished sticks made of hardwood. Place one clave in the palm of your hand and strike it with the other clave.

Rhythm Sticks are played in pairs. They can be smooth or serrated. Play them by holding one rhythm stick and striking it with the other or rub one along the ridges of the other. Rhythm sticks are wonderful for keeping time or, when appropriate, helping children maintain a steady beat.

Woodblocks are small hollow blocks of wood that produce a resonant sound. Strike the woodblock lightly with a wooden or hard rubber mallet.

Maracas are made from gourds (or hard plastic) and are filled with seeds or pebbles. Shake them sharply, at intervals, to produce rhythm. Maintain steady shaking for continuous sound.

Drums produce many different sounds depending on how they are played. Drums can be played with your fingers, hand, or knuckles, or with a drumstick or mallet. Drums sound best when struck with a quick bouncy touch so that the drum head can reverberate.

Sandblocks are small wooden blocks covered with coarse sandpaper or emery cloth. Hold them by the handle or knob and rub them together.

Jingle Bells mounted on sticks can be shaken vigorously or tapped rhythmically against your palm. Other types of jingle bells are mounted on plastic or fabric and can be shaken by hand or when attached to an ankle or wrist.

Tambourines are a favorite of young children. They are circular frames of wood or plastic with a plastic or skin drumhead and small sets of jingles fastened around the frame. You can strike the head with your hand or finger, shake the tambourine to hear the jingles, or combine both actions.

Finger Cymbals produce delightfully delicate sounds. Put one on a finger of each hand and bring them together to lightly chime the finger cymbals. You can also put one finger cymbal on your thumb and another on your middle finger of the same hand and strike them together.

Cymbals are usually made of brass and have handles or straps. Cymbals produce their best tone when they are struck while being moved in a vertical motion. Hold one cymbal slightly higher than the other, bring it down, and let it strike the lower one. You may want to practice playing cymbals and master the technique of producing a pleasant-sounding ring before you introduce cymbals to children. If your children can hear the lovely tone cymbals can make, they may be more inclined to respect them as a *real* musical instrument.

Resonator Bells are played with a mallet and can provide children with experiences in pitch, melody, and harmony. Because resonator bells are tuned, children can experiment with an accurately pitched instrument while working out patterns and melodies.

Orff Instruments were originally designed by the German composer, Carl Orff. Although these instruments are expensive, they are a wonderful addition to an early childhood environment. They are very high quality and produce beautiful, pure tones. The lowest pitched instrument, the *metallophone*, produces rich alto and bass tones. The bars are made of thick metal. The bars of the *xylophone* are made of hardwood. They are removable and can be taken apart and changed for different tonal patterns. The *glockenspiel* is the highest pitched instrument. The bars are also removable metal, and they produce a bright, soprano tone. Very young childen may have difficulty playing the glockenspiel because of the small size, but four-year-olds, five-year-olds, and older children will enjoy striking the bars and hearing the crisp, clear tones.

Autoharps can be valuable if you consider yourself to be a nonmusical teacher. You don't need special musical training to play an autoharp. It is a stringed instrument that can be played either by holding it flat on your lap or in an upright position. You strum the autoharp while pressing the buttons. Each button has a letter, or musical notation, that corresponds to the chords you are playing. Most music includes chord notation in the form of letters above the music bar. Follow the letter notation as you press the corresponding button while strumming the autoharp. Your children can learn to play the autoharp, too, so don't be afraid to let them explore all the chords, sounds, and sensory impressions the autoharp provides.

IDEAS TO EXTEND LEARNING

1. Observe a teacher during a fingerplay activity. Describe this teacher's facial expressions, tone of voice, and eye contact with the children.

2. Observe a group of children as they respond to a fingerplay. Make notes on their behavior, their efforts to imitate the play, and their use of language.
3. Set up an area in a classroom that will allow for movement exploration. Make a list of the things you will have to do to create a positive atmosphere and a manageable environment for your children.
4. Plan and implement a movement activity with young children that involves time, space, and force.
5. Read one of the Suggested Readings and identify ten new fingerplays you would like to learn.
6. Learn four new fingerplays and do a fingerplay activity with a small group of children.
7. Set up a rhythm instrument activity for a group of young children. Introduce the instruments one at a time using the ideas from this chapter.
8. Design an outdoor activity utilizing a parachute.
9. Write the following words at the end of each lesson plan for the above activities: "It is the process that is important, not the product."

ENDNOTES

1. Hymes, J. L. *Teaching the Child Under Six.* Columbus, Ohio: Merrill Publishing Company, 1981, pp. 38–45. If you have not read this book, I strongly urge you to seek it out and absorb Hymes's wisdom.
2. Choate, R. A. *Beginning Music.* New York: American Book Company, 1970, p. vii.
3. Samples, R. "Are You Teaching Only One Side of the Brain?" *Learning Magazine,* Feburary 1975, pp. 25–28.
4. Nye, V. *Music for Young Children.* Dubuque, Iowa: Wm. C. Brown Company Publishers, 1975, p. 173.
5. Torrance, E. P. *Encouraging Creativity in the Classroom.* Dubuque, Iowa: Wm. C. Brown Company Publishers, 1970.
6. Aronoff, F. *Music and Young Children.* New York: Holt, Rinehart and Winston, 1969, p. 21.
7. Gardner, H. *The Arts and Human Development.* New York: John Wiley and Sons, 1973, p. 152–153.
8. Dimondstein, G. *Children Dance in the Classroom.* New York: Macmillan Publishing Co., Inc., 1971, pp. 16–17.
9. Day, B. *Early Childhood Education: Creative Learning Activities.* New York: Macmillan Publishing Co., Inc., 1983.
10. Dimonstein, G. *Children Dance in the Classroom.* New York: Macmillan Publishing Co., Inc., 1971, p. 123.
11. Lundsteen, S. and N. Tallow. *Guiding Young Children's Learning.* New York: McGraw-Hill, 1981.
12. Haines, J. E., and L. L. Gerber. *Leading Young Children to Music.* Columbus, Ohio: Merrill Publishing Company, 1984.

13. Althouse, R. *The Young Child: Learning with Understanding*. New York: Teacher's College Press, Columbia University, 1981.
14. Bayless, K. M., and M. E. Ramsey. *Music: A Way of Life for the Young Child*. St. Louis: C. V. Mosby, 1982.
15. Haines and Gerber, op. cit.
16. Jalongo, M. R., and M. Collins. "Singing With Young Children." *Young Children*, January 1985, pp. 17–21.
17. Moomaw, S. *Discovering Music in Early Childhood*. Newton, Mass: Allyn and Bacon, Inc., 1984.
18. Nye, V. *Music for Young Children*. Dubuque, Iowa: Wm. C. Brown Company Publishers, 1975, p. 173.
19. Krathwohl, D. R., B. S. Bloom, and B. B. Masia. *Taxonomy of Educational Objectives Handbook II: Affective Domain*. New York: David McKay Co., Inc., 1964.
20. Chenfeld, M. *Teaching Language Arts Creatively*. New York: Harcourt Brace Jovanovich, Inc., 1978, p. 39.
21. Logan, W. M., and V. G. Logan. *A Dynamic Approach to the Language Arts*. Toronto: McGraw-Hill, 1967, pp. 92–93.
22. Combs, A. W.; D. L. Avila; and W. W. Purkey. *Helping Relationships: Basic Concepts for the Helping Profession*. (2nd ed.) Boston: Allyn and Bacon, 1978, p. 143.

SUGGESTED READING

Andress, B. L. (1973) *Music in Early Childhood*. Washington, D.C.: Music Educators National Conference.

Bley, E. S. (1978). *The Best Singing Games for Children of All Ages*. New York: Sterling Publishing Company.

Boorman, J. (1969) *Creative Dance in the First Three Grades*. Don Mills, Ontario: Longman's Canada Ltd.

Bryan, A. (1974) *Walk Together Children, Black American Spirituals*. New York: Atheneum.

Burton, L., and W. Hughes. (1979) *Music Play: Learning Activities for Young Children*. Reading, Mass.: Addison-Wesley.

Cherry, C. (1971) *Creative Movement for the Developing Child: A Nursery Handbook for Nonmusicians*. Belmont, Calif.: Fearon Publishers.

Glazer, T. (1973). *Eye Winker, Tom Tinker, Chin Chopper: Fifty Musical Fingerplays*. Garden City, N.Y.: Doubleday.

Jenkins, Ella. (1966) *The Ella Jenkins Song Book for Children*. New York: Oak Publications.

Jones, B., and B. L. Hawes. (1972). *Step It Down: Games, Plays, Songs, and Stories from the Afro-American Heritage*. New York: Harper and Row.

Joyce, M. (1973) *First Steps in Teaching Creative Dance: A Handbook for Teachers of Children, Kindergarten through Sixth Grade*. Palo Alto, Calif.: Mayfield Publishing Company.

Landeck, B. (1950) *Songs to Grow On*. New York: Edward B. Marks Music Corp.

Mandell, M., and R. E. Wood. (1977). *Make Your Own Musical Instruments*. New York: Sterling Publishing Company. Inc.

McCall, A. (1971). *This Is Music for Today—Kindergarten and Nursery School*. Boston: Allyn & Bacon.

McDonald, D. (1979). *Music In Our Lives: The Early Years*. Washington, D.C.: National Association for the Education of Young Children.

Nelson, E. L. (1977). *Singing and Dancing Games for the Very Young*. New York: Sterling Publishing Co., Inc.

Nocera, S. D. (1974). *Reaching the Special Learner Through Music*. Morristown, N.J.: Silver Burdett, 1979.

Palmer, H. *Getting to Know Myself*. Freeport, N.Y.: Activity Records.

Seeger, R. C. (1948). *American Folk Songs for Children*. New York: Doubleday.

Sinclair, C. (1973). *Movement of the Young Child—Ages Two to Six*. Columbus, Ohio: Merrill Publishing Co.

Sullivan, M. (1982). *Feeling Strong, Feeling Free: Movement Exploration for Young Children*. Washington, D.C.: National Association for the Education of Young Children.

Recordings

Folkways Records, 43 West 61st St., New York, N.Y. 10023.

Jenkins, Ella. *Growing Up With Ella Jenkins: Rhythms, Songs and Rhymes*. Folkways Records 7662.

———— . *Play Your Instrument and Make a Pretty Sound*. Folkways Records 7665.

———— . *We Are America's Children, Songs, Rhythms and Moods Reflecting Our People's History*. Folkway Records 7666.

Johnson, Y., and B. Mosley. *Moving Makes Me Magic*. Folkways Records 7518.

Seeger, P. *Animal Folk Songs Sung by Pete Seeger with Banjo*. Folkways Records 7611.

———— . *Folk Songs for Young People*. Folkways Records 7601.

Educational Activities, Inc., 1937 Grand Avenue, Baldwin, N.Y. 11510.

Palmer, Hap. *Creative Movement and Rhythmic Expression*. Activity Records 533.

———— . *Easy Does It. Activity Songs for Basic Motor Skills Development*. Activity Records 581.

———— . *Feelin' Free*. Activity Records 517.

RCA Victor Records, 155 E. 24th Street, New York, N.Y. Barlin, A. "*Dance-A-Story*," L. E. 101–108. Records and story books with music and narration for expressive movement.

Golden Records, Educational Division, Michael Brent Publications, Inc., Port Chester, N.Y. 10573. Catalog contains many classical titles that are excellent for use in an early childhood classroom.

4

Basic Art

This chapter introduces a variety of art media that children can use for experimenting with drawing, painting, printing, cutting, tearing, and pasting. You will read about many different ways that children can use basic materials to explore the artistic process as they engage in personal creative expression. Specific activities included in this chapter are designed to focus on image awareness with you and your children as the focal point of the art experience. Also included in this chapter is an experiential component designed to encourage you to look at communication processes and communicative behavior. This activity will provide an opportunity for you to gain a greater understanding of your own communication style, your nonverbal communication behaviors, and the impact of these behaviors on others. This type of interpersonal work will give you practice in making statements about how you interpret other people's behavior and on how we all make assumptions based on the nonverbal behavior of others.

Objectives

This chapter will provide the information and opportunity for you to

- describe basic art materials and methods for using them with young children
- explain artistic development in young children
- appreciate the role of nonverbal communication in teaching and learning
- describe different types of nonverbal communication and its impact on others

HOW IMPORTANT IS YOUR ROLE, TEACHER?

One of my students brought me the following story written by Helen E. Buckley. After reading it in class, we had a lengthy discussion about children's creative potential and how we as teachers, sometimes unknowingly and unintentionally, discourage creative exploration.

"The Little Boy"
by Helen E. Buckley

Once a little boy went to school.
He was quite a little boy,
And it was quite a big school.
But when the little boy
Found that he could go to his room
By walking right in from the door outside,
He was happy.
And the school did not seem
Quite so big anymore.
One morning,
When the little boy had been in school awhile,
The teacher said:
"Today we are going to make a picture."
"Good!" thought the little boy,
He liked to make pictures.
He could make all kinds:
Lions and tigers,
Chickens and cows,
Trains and boats,
And he took out his box of crayons
And began to draw!

But the teacher said: "Wait!
It is not time to begin!"
And she waited until everyone looked ready.

"Now," said the teacher.
"We are going to make flowers,
And he began to make beautiful ones
With his pink and orange and blue crayons.
But the teacher said, "Wait!
And I will show you how."
And she drew a flower on the blackboard.
It was red, with a green stem.
"There," said the teacher,

"Now you may begin."
The little boy looked at the teacher's flower.
Then he looked at his own flower.
He liked his flower better than the teacher's.
But he did not say this,
He just turned his paper over
And made a flower like the teacher's.
It was red, with a green stem.

On another day,
When the little boy had opened
The door from the outside all by himself,
The teacher said:
"Today we are going to make something with clay."
"Good!" thought the little boy. He liked clay.
He could make all kinds of things with clay:
Snakes and snowmen,
Elephants and mice,
Cars and trucks,
And he began to pull and pinch his ball of clay.
But the teacher said,
"Wait! And I will show you how."

And she showed everyone how to make
One deep dish.
"There," said the teacher, "Now you may begin."

The little boy looked at the teacher's dish.
Then he looked at his own.
He liked his dishes better than the teacher's.
But he did not say this.
He just rolled his clay into a big ball again,
And made a dish like the teacher's
It was a deep dish.

And pretty soon
The little boy learned to wait,
And to watch,
And to make things just like the teacher.
And pretty soon
He didn't make things of his own anymore.
Then it happened
That the little boy and his family
Moved to another house,
In another city,

And the little boy
Had to go to another school.
This school was even bigger
Than his other one,
And there was no door from the outside
Into his room.
He had to go up some big steps,
And walk down a long hall
To get to his room.

And the very first day
He was there,
The teacher said:
"Today we are going to make a picture."
"Good!" thought the little boy,
And he waited for the teacher
To tell him what to do.

But the teacher didn't say anything.
She just walked around the room.
When she came to the little boy
She said, "Don't you want to make a picture?"
"Yes," said the little boy.
"What are we going to make?"
"I don't know until you make it," said the
teacher.
"How shall I make it?" asked the little boy.
"Why, any way you like," said the teacher.
"And any color?" asked the little boy.
"Any color," said the teacher.
"If everyone made the same picture,
And used the same colors,
How would I know who made what,
And which was which?"
"I don't know," said the little boy,
And he began to make pink and orange and blue
flowers.
He liked his new school . . .
Even if it didn't have a door
Right in from the outside!

Do you ever remember being in a situation like that of the little boy, cautious
to experiment with your creative abilities or to follow your own creative instincts?
Just like the little boy in the story, we are all born with our own creative abilities
and among these are those which can be classed as artistic. If you were to broaden
your focus and take into consideration some of the less formal creative experiences

you indulge in at one time or another (e.g., the doodles in the margins of your notebooks or the intricate designs you draw when talking on the telephone), you will see how you spontaneously experience expressive and creative activity. Occasions of this kind are familiar to all of us, and the pattern of their development can usually be traced to childhood.

But what happens to young children's creativity? How many times have you heard a child say "I can't draw a flower" or "My picture's not as good as his?" If I were to ask you to sit down, right now, and draw a self-portrait, how many of you would want to quietly disappear? The creative process must not be stifled by preconceived notions of rightness and wrongness. When you, or children, become dependent on someone else's idea of what the final product should resemble, the freedom of creative self-expression becomes lost, and the product is no longer a reflection of your own creative efforts.

Consider the following challenge as you think about exploring your own creativity and designing and implementing creative arts experiences for children:

An attitude of trust and an atmosphere of security are essential to the creative arts process.

Put away the patterns, hide your ditto books, and put the coloring books in the back of the closet for awhile. Enjoy the freedom that basic materials provide. Have faith in your own efforts and the creative attempts of your children. Acknowledge children's work, encourage the creative process, and let your children know that you value their choice of color, their shape of line, their different approaches to design and their very special creative efforts.

 Place the emphasis on the process and the inherent joy children feel as they create. Remember that creative expression comes from *within* the child. Their products are important because the creative process is serious work for children. Very often final products reflect children's growth and understanding of the world around them. They are expressions of the children themselves and therefore special and meaningful. It is only when we pressure children to produce a perfect representation that is recognizable to an adult, that we may be stifling the child's creative potential. Be gentle with your children and work toward instilling in them the idea that their creative efforts are diverse, important and worthwhile.

CHILDREN AND THE ARTISTIC PROCESS

Lowenfeld and Brittain in their classic work *Creative and Mental Growth*[2] identified stages that children progress through as they experiment with and explore the artistic process. Lowenfeld and Brittain's stages are known as scribbling, preschematic, and schematic representation. Early attempts at artistic expression are usually random scribbles and begin during the child's first or second year.[3] Children at this age find pleasure in the kinesthetic process of random movements and the visual process of noticing the color left by a moving crayon. They can enjoy the texture and smell of fingerpaint, and random scribbling gradually becomes more organized as children repeat lines, or begin to make circular, horizontal, or vertical patterns. During the latter part of the scribbling stage (around the age of three and-a-half or four), children may begin naming their scribbles and telling stories about what they have drawn. This is an important step in the artistic process because children are no longer involved with just the physical movement of making lines and patterns. They are also involved in imaginative and symbolic thinking, and their attempts should be encouraged by teachers and other adults. These early representational drawings may appear meaningless to an adult but they hold great value for the child producing them. A teacher's positive comments of interest and encouragement can make a lasting impression on children. When we talk to children about their nonrepresentational art we are acknowledging the value of their creative abilities. By attending to and respecting their creative efforts we encourage them to continue using their imaginations to develop other ways of artistic expression.

Young children begin to make their first representational attempts between the ages of four and seven.[4] During the preschematic stage children are involved in the relationship between what they see or know and making recognizable art forms. Children may draw a circle with lines for arms and legs to represent a person. Flexibility is a key word during this stage because children constantly change their representational symbols. The circle that represented a head today may be changed to an oval tomorrow. The use of color and representation is also

Painting allows the young child to represent feelings, experiences, and sensory impressions through the artistic process.

very flexible during this stage. It is not unusual for children to color their figures with green hair or red faces. Children will choose these colors because they like them and are more interested in using colors that appeal to them than in exact color representation. During this stage, as children become more aware of their environment, they begin to use a baseline. Grass, flowers, houses, and trees will be drawn on a baseline at the bottom of the page, and the sky will be represented by a colored strip across the top of the paper.

It is of paramount importance that children in this stage of development be given the freedom to represent what they know of the world in ways that are meaningful and significant to them. Remember, there is no right or wrong in

children's early representational attempts. We must be very careful not to impose adult standards on children's art work or to evaluate their ways of artistic expression. A child's drawing is a representation of a very special and tender inner-self and must be treated with respect and dignity.

TEACHER COMMUNICATION

Few occupations demand the level and intensity of communication as teaching. Teachers interact with large groups of students for sustained periods of time, and communciation is an inevitable part of the interaction. As we interact with each other, and with children, there are two imporant processes we use to get to know one another: (1) we tell about ourselves; and (2) we observe what the other person does. On the basis of words and behaviors, we make inferences or assumptions about each other. Communications include both *verbal* language when we use words to communicate and *nonverbal* language conveyed through body movement, gestures, eye contact, and facial expressions. One problem with nonverbal communication is that it can be so easily misinterpreted. A frown, for example, can mean being in an uncomfortable sitting position, not that someone is angry or upset with us. In the ordinary, everyday process of interacting with others, we make assumptions that what others do are expressions of the part of themselves that we simply and honestly cannot know. On the basis of these assumptions, we make inferences about the meaning of each other's "body language."

Effective communication is an essential and integral part of being an effective teacher. If we pay attention just to the words people speak, we are not fully communicating or interacting. Think of the sentence uttered by most people at some time in their lives, "I'm not angry," while at the same time the words are

cold, harsh, and uttered with enough control to fuel a bonfire. Think about your work with young children. Can you remember a situation where standing close to a child, gently touching a shoulder, or smiling with sincere empathy was much more important than the words you were whispering? The child probably did not remember your spoken words, but your understanding and your concern were clearly communicated. As teachers, we have to be masters of communication, both verbally and nonverbally, if we are to comprehend the meaning of what our children are conveying and gain an understanding of their messages. Anything less than full communication with children, and each other, hinders the whole teaching/learning process.

The next activity involves a small group experience which focuses on communication through a nonverbal, artistic form and will take you through an exercise for experiencing your own communication styles and those of others. Both components of the activity are designed to increase your awareness of your own perceptions and of how all of us make inferences and interpretations about others. Throughout this book you have been introduced to many "affective" experiences. One purpose for including these is to encourage you to deepen your personal and professional relationships through an increasing acceptance and support for the similarities and differences between our own unique responses to an experience and the responses of others. I hope this exercise in nonverbal communication will assist you in this important aspect of personal and professional development.

Drawing Dialogue[5]

Group Size: Small group

Leader: College instructor, teacher

Objectives:
Encourage communcation using nonverbal, artistic form
Develop awareness of our own behavior and the behavior of others
Enhance observation skills
Describe different types of nonverbal communication and its impact on others

Materials:
White drawing paper (one 12 x 18 sheet for each two participants)
One box of oil pastels for each participant
Unlined newsprint for charts
Markers

Procedure:
1. Look at all the colors in the boxes of oil pastels and quietly choose a favorite color, a color you would like to experiment with, or a color that expresses some important aspect of yourself.
2. Next, pair up with someone who has a different color than you do. Take one of the large pieces of paper and find a place on the floor to work. The paper

should be placed between you and you should sit at opposite sides of the paper.

3. Hold your color in the hand that you usually don't write with. When you feel ready, begin to draw silently together on your paper. Don't divide the paper and make separate drawings, and don't plan, discuss, or decide what you will draw together. Just begin to draw slowly and focus your awareness on the process of drawing and how you feel as you interact with your partner. Let your awareness and your thoughts and feelings flow into the process of drawing. You might alternate drawing, or draw at the same time, or you might even gently move your partner's hand for a short time and draw with your partner's color if your partner is agreeable to this. Begin to do this now, and take ten or fifteen minutes to interact with your partner as your drawing develops between you.

4. Allow 10-15 minutes for drawing.

5. When both partners have completed their part of the drawing take turns telling each other what you experienced as you were working on the drawing together. Express what you were aware of as you interacted and how you felt during the silent dialogue.

6. When everyone has had time to talk for a few minutes, use your textbook as a guideline for completing the following exercise:

Perception Checking

We can check the accuracy of our perceptions by first paying attention to observable behavior, second, being aware of inferences we make about different behaviors, and third, asking others if our perceptions are correct or incorrect. For example:

BEHAVIOR	**INFERENCE**
(Observable data)	(Interpretations)
Frown	angry, upset
Sudden movement	scared, surprised
Laughter, giggles	happy, comfortable

When we are communicating with someone else, verbally or nonverbally, we tend to look beyond what is directly observable and make our own interpretations of what the other person is saying. We also experience affective states as we develop an emotional awareness of what we are feeling throughout the interaction. We can explore this process further through a systematic approach to checking our own perceptions. The following examples outline this process.

I SEE (observable data)
 Example: "I SEE you looking at my drawing."

I IMAGINE (interpretations)
 Example: "I see you looking at my drawing and I IMAGINE you are criticizing it."
I FEEL (emotional awareness)
 Example: "I see you looking at my drawing, I imagine you are criticizing it, and I FEEL anxious."
I WANT (request for change)
 Example: "I see you looking at my drawing, I imagine you are criticizing it, I feel anxious, and I WANT you to tell me what you are really thinking."
Other examples: "I SEE you turn away when I talk, I IMAGINE you are bored with me, I FEEL hurt, and I WANT you to look at me when I speak to you."
"I SEE you alone and crying, I IMAGINE you are sad, I FEEL compassion, and I WANT to know how I can help you."
I SEE you smiling as you draw, I IMAGINE you are enjoying yourself, I FEEL good that we are working together, and I WANT to talk about our drawing.

1. Remain with the same partner you had for the Drawing Dialogue. Take turns responding to each other using the Perception Checking guidelines. You may choose to respond to nonverbal communication which occurred during the DRAWING DIALOGUE or you may practice perception checking in the "here and now." Try to go through the process for at least 10 minutes before clarifying, validating, or discounting each other's perceptions. Be sure and use "I" statements.
2. Allow yourself some process time to talk about your drawings and other learning that occurred during the activity. The following questions should help you to process the activity:

The things I enjoyed about the drawing dialogue were . . .
Some of the thoughts and feelings I was having during the drawing activity were . . .
If I were to do the activity again I might try . . .
Some new thoughts I have on nonverbal communication are . . .
Some of the frustrations I felt during the activity were . . .
My perception of the overall atmosphere during both activities were . . .
 (pleasant, bored, interesting, etc.)

TEACHING STRATEGIES FOR BASIC ART

Crayons

 Texture Rubbing Lay newsprint on top of a flat item that has a definite texture (sandpaper, leaves, coins) and rub the flat side of the crayon over the object. Children also enjoy making texture rubbings of different surfaces in the room or

on the playground. Encourage children to rub over cracks in the walls or sidewalk, the floor, wooden blocks, carpet or tile, puzzle shapes, or anything else they can find.

Etching Select light colored crayons and color the surface of a tag board or other heavy paper with the crayons. When the crayon has a shiny surface, color over the light colors with black, dark blue, or other dark color. Polish the dark surface with a tissue until it shines. Use a craft stick or other blunt utensil (fork, handle of a spoon) to scratch through the dark crayon to the bright colors underneath.

Crayon Resist Use crayons to draw a design or a picture. Be sure to press down heavily and cover the colored area well. Leave some areas and background uncolored. When the drawing is complete, brush a thin coat of tempera over the entire surface of the paper. The areas covered heavily with crayon will resist the tempera.

Craypas Craypas are a combination of crayons and pastels. They are usually flat on one side and come in a variety of brilliant colors. Children enjoy working the Craypas as an alternative to crayons especially when they discover that Craypas work better when they take the paper wrapping off! Craypas can also be used in an interesting way when working with older children. When a picture is complete, use paint thinner to liquify the Craypas. When paint thinner is added to a Craypas picture, the colors are transformed into an oil-like substance which gives the effect of an oil painting. Use small brushes to apply paint thinner to pictures.

Colored Chalk

Chalk and Sandpaper Paint the surface of the sandpaper with a clean brush and water. Use colored chalk to draw pictures or designs on the moist sandpaper. The moist paper brings out greater richness of color. Once the drawing is complete and dry, it must be sprayed with a fixative if it is to be preserved.

Chalk and Buttermilk Paint the surface of the paper with a coat of buttermilk or dip the chalk into buttermilk before drawing. When dry, the colored chalk will adhere to the paper and have a glossy look. An alternative is to draw with the colored chalk first and then wash the entire surface with the buttermilk.

Paints

Tempera Tempera can be purchased in liquid or dry powder form. When planning painting activities for children be sure that colors are bright and rich and the paint is thick. When children are painting with tempera they should not have to worry that their paint will drip or run off the paper. Small amounts of paint should be mixed daily to insure freshness and eliminate wasting due to drying. On days when it is impossible to mix new paint, a drop of oil of wintergreen can be added to each container to prevent molding.

Tempera spreads easily and children can use brushes, sponges, Q-tips, or rollers to create drawings. Paintings can be done at the easel, on the floor, or on table tops. Painting with tempera can be a messy experience, and young children, especially, should be provided with smocks. When children are painting at the easel it's a good idea to cover the floor to protect it from dripping or spilled paint. Containers of clear water should be kept near the painting area for washing brushes.

Surprise Art Fold a large sheet of paper in half and place it on a flat surface. Dip a piece of yarn or string into a container of tempera until it is coated completely. Hold one end of the string and arrange the paint-soaked end in a coiled or looped shape in the inside of the folder paper. Hold on to the clean end of the string and let it extend beyond the edge of the paper. Fold the paper over and hold it gently with the other hand. Pull out the string and open the folded paper to see the surprise design. When using the surprise art with very young children, you may need to assist the child in holding the paper while the child pulls the string out.

Straw Painting Use finger paint paper or other paper that has a slick, shiny finish. Let children use spoons or eye-droppers to put small amounts of different colored paint on the paper. Give each child a large plastic straw and let them blow the paint in different directions. Encourage children to blow one paint color into another, creating mixed and new color combinations.

Using basic art material is wonderfully inviting to young children.

Dry Tempera Lay paper on a flat surface and wet it with a sponge and water. Sprinkle different colors of dry tempera from a flour sifter or scatter the dry tempera by turning the handle and "sifting" the dry painting onto the paper. Children can also use a dry brush to mix and blend the colors to produce interesting effects.

Spatter Painting Spatter painting will be easier for children if you provide them with a spatter painting stand. The stand is simple to make and gives them a sturdy base from which to work. Make a square wooden frame approximately 12″ x 12″. Purchase a piece of window screen (meshed wire) and cut it slightly larger than the wooden frame. Turn under the edges of the wire and cover with several layers of tape. This protects the children from being stuck or scratched by the rough edges of the wire. Staple or nail the screen to the frame. This becomes the top of the spatter painting stand. Make four wooden legs and use a commercial wood glue to glue them to the underside of the frame. If woodworking and frame-making are not one of your strong points, ask someone who is skilled in this art to make a stand for you. You will be rewarded when you see how much children delight in this somewhat mysterious process of making a picture. Provide children with different shapes of pre-cut paper, various things from nature such as leaves, fern leaves, small branches or pre-cut stencils. Cover the spatter painting area with several layers of newspaper. Place a piece of drawing paper on the newspaper and lay the object on the drawing paper. Use thumb-tacks or small pieces of tape to hold the object in place. Place the spatter painting stand over the drawing paper. Dip an old toothbrush into the paint and shake off excess. Rub the brush back and forth across the screen. Carefully remove the object and enjoy the image that has been produced. Experiment by using dark construction paper and light paint colors or use several different colors for one painting. When the activity is complete, thoroughly wash the spatter painting stand by scrubbing it with a clean

toothbrush. Tempera will dry if not properly removed and will clog up the tiny holes in the screen.

Mural Painting Mural painting is an excellent outdoors activity. Tape sheets of mural paper to the outside wall of the building or to any wall that you have in your play yard. Fasten the paper so that the bottom edge touches or nearly touches the ground or sidewalk. Dripping paint will end up on the ground or sidewalk and not on the building wall! Give children a container of liquid tempera and a large brush and let them paint. There may or may not be a central theme. Some children will paint in their own space while others will engage in more of a group activity. How they approach the mural is not as important as the process of working and creating together. The mural can be left as a collective painting or cut into smaller pieces so that children can keep their own particular sections.

Finger Painting Finger painting lends itself to motion and sensory exploration. Children use fingers, hands, arms, fingernails, and even elbows to create a

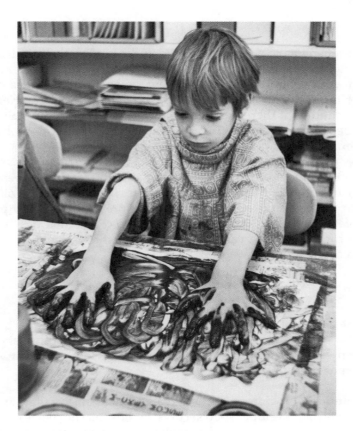

Fingerpainting is wonderful for motion and sensory exploration.

picture or design. The picture can be erased and a new picture created. Finger painting should be a pleasurable experience and children should be encouraged to experiment with several colors and different movements to create a variety of effects. Since finger painting is usually not a clean and neat experience, it is helpful to the children if there are several large sponges, buckets of water, and plenty of paper towels near the finger painting table. Smocks will help keep clothing clean.

Wet finger paint paper on both sides and place it on a smooth, flat surface. Put two tablespoons of finger paint on the wet paper, or if you are using several colors, put a heaping teaspoon of each color on the paper. Too much paint will crack or chip off when the painting is dry. Encourage children to spread the paint and suggest different body parts that they might use to create their designs. When paintings are completely dry, carefully lift them by the corners and lay flat on newspaper to dry.

Printing

Sponge Printing Cut sponges into several small shapes and sizes. Each child should have several containers of different colored paint and an equal number of sponge shapes. Watercolor paper is best for sponge printing because of it absorbency. Children create designs by dipping the sponge into the paint and then pressing the sponge on the paper.

Object Printing Provide children with a variety of objects that can be used for making prints such as empty spools, corks, jar lids, plastic cookie cutters, and wooden blocks. Children dip the different objects into thick tempera and overlap

prints and colors to create designs. Children can also experiment with different objects by twisting them or rotating them when printing. Very often children will experiment with new ways of placing or moving the printing object. This is all part of the process of creating so be sure that you provide them with this freedom.

Fish Prints Fish prints seem to amaze and fascinate children. Before the printing process begins they want to touch the fish or feel its eyes, or the pointed tips of its fins. There is usually a lot of conversation about where the fish came from, who caught it, and whether or not they are going to eat it! Select a medium-sized fish which is relatively flat. Flounder is ideal but trout, snapper, or even bass will make good prints. Cover a large, flat surface with white butcher paper or other clean paper. Newspaper does not work because the type adheres to the fish and will show through the print. Place the fish on its side in the center of the paper. Use a large brush to paint the entire surface of one side of the fish. Make sure the tail, fins, and eyes of the fish are well covered. Place a ''fish size'' (large enough to cover the fish and leave a border) piece of paper over the fish and use fingers and hands to press the paper onto the contour of the fish. Be sure to press around the body, tail, fins, and eyes. Carefully peel the paper away from the fish. The image of the fish will be duplicated on the other side.

Vegetable Prints Cut vegetables so that there is a smooth, flat surface. Vegetables with center seeds, such as apples, squash, and cucumbers, are excellent for making prints which reveal the shape and center designs of the vegetable. When using other vegetables such as potatoes or carrots, children can use a pencil, large nail, scissors, or ball point pen to scratch a design into the surface of the vegetable. Children can use these safe tools without the dangers involved in the use of knives or other sharp carving instruments. Use a brush to cover the surface of the design with paint and press the vegetable onto paper. Let children experiment by using different colors of paint on different colors of paper.

Paste and Glue

Pasting and gluing can be a difficult and frustrating process for very young children. They may not understand the properties of pasting and as a result, may treat paste and glue in much the same way as they treat finger paint. Children get great pleasure from the sensory and tactile experience of smearing paste, feeling its sticky properties, sticking their fingers together, smelling it, or watching it form pools on the paper. They put paste directly on the picture to be pasted and only realize they have made a mistake when the back of the picture appears on their paper. They use too much paste for large, lightweight objects, and not enough paste for smaller, heavier objects. Be patient with these young learners and provide them with many simple pasting experiences until they have acquired the

skill to successfully use glue and paste. Provide them with many activities, such as pasting large pieces of construction paper together, pasting large strips of paper to paper plates or cardboard, or pasting cut-out shapes together.

Collage Collage is a process of creating designs and pictures by pasting different types of materials onto a surface. As an art form it is a favorite of young children and older children alike. This may be due, in part, to the idea that there is no "right" or "wrong" way to make a collage, and the resulting product is often nonrepresentational and abstract in form. Collage materials should be stored in separate containers with each container holding a similar collection of material. Children can keep their own collage material in a "picture-making box" and add to it as they find new and appealing objects. A beginning collection of items include scraps of cloth and material, carpet scraps, buttons, bottle caps, shells, seeds, toothpicks, small pieces of wood, sand and pebbles, rick-rack, glitter, match boxes, different colored straws, dried leaves, flowers, and twigs. Children enjoy collecting their own objects or bringing in material from home or outdoors. A short walk around the playyard or an excursion to someone's backyard will usually result in a large and assorted collection of interesting materials.

Children arrange their objects into a design or picture. They can select from one container holding a similar collection of objects if they have a theme or subject ideas in mind or they can use a combination of objects and materials from different containers. As children look for objects and make choices in their selection they are already involved in the creative process; *deciding* what to use is the beginning

of a collage. When children have experimented with different objects and designs, they paste or glue them on heavy paper or cardboard. Make sure the background paper is sturdy and strong enough to support heavy objects. Thin paper is difficult to handle when covered with pebbles and sand. Children should also be given the option of painting or coloring the background or adding details to their collage.

Mosaic Mosaic is a surface decoration, picture, or design made by inlaying small pieces of colored paper, stone, seeds, beads, or other material. A picture or design made in mosaic can be a long and tedious process. It also requires children to focus on a design and concentrate on maintaining this focus over a long period of time. When introducing young children to mosaic, make sure the designs are simple, and the material is easy to handle.

Children use felt-tip pens to draw a simple design on construction paper or cardboard. Then they spread glue on the design and press material into place. Older children might want to experiment with different arrangements, designs, and materials before actually gluing the objects to the paper. Other children may enjoy the process of applying glue to one piece of material at a time and then placing it on the paper. This part of the process depends on the skill and manipulative ability of the children.

ART ACTIVITIES FOR THE COLLEGE STUDENT OR CLASSROOM TEACHER

Many well-meaning teachers have tried to teach children and older students how to draw something that has a definite relationship to a real object. Remember "The Little Boy?" Drawing real objects can be a frustrating process for young children, older children, and adults who do not consider themselves to be "real" artists. Children are usually more interested in the colors and shapes of their drawings, the smell of their crayons, and the pure kinesthetic activity itself more than the outcome or final product. Older children often enjoy the freedom of a drawing

assignment that does not have to be perfectly representational. For adults, it is often a relief to be encouraged to emphasize the process of the artistic experience and not to be worried about producing a perfectly representational product.

The scope and procedures of these activities can be changed, broadened, or narrowed or extended to meet the needs of any age student. These activities were created to encourage you to develop your natural capacity for creativeness in an environment that places emphasis on the *process* of exploration. Viktor Lowenfeld says teachers must be truly involved in creating with materials.

> A teacher who has never gone through the process of creating in a specific art material may never understand the particular type of thinking that is necessary to work with clay, paint, or whatever. This means that the teacher must have been truly involved in creating with materials, not in dealing with them in an abstract way by reading or mechanically carrying out some project. The material and the expression should be as one.[6]

The central theme must be constantly reinforced. You and your children should be involved in a free and uninhibited process between yourselves and the art material you are using!

"Self-Portraits" is an artistic activity that encourages *abstract* representation. The abstract nature of drawing self-portraits from this perspective will help you to become absorbed in the experimental process and the personal expression that this structured experience offers. Each portrait will be different and will symbolize each "artist" in an individually descriptive way.

"Gesture Painting" is an excellent activity for exploring line, balance, and movement in painting or drawing. Each of you will perceive the gesture or action from a different physical perspective, and no two interpretations will be or look the same when represented on paper. As you experience the process of transforming a three-dimensional visual image of an action or gesture into a two-dimensional art form, you will be representing the "feeling-ness" of things. I encourage you to focus on the process as a way of abstracting and exaggerating the sensory elements of actual gesture to show movement. Although gesture painting involves flat form the artistic process is one of creating shapes that give the illusion of movement. You simply capture the line of movement and the balance of the action. Paintings often resemble Chinese calligraphy and are never actual representations of the model. Stick figures are discouraged because they inhibit you from attending to the flow of the movement or action.

Self-Portraits

Group Size: Individual

Leader: College instructor, student, or teacher

Objectives:
Interpret quality of "self" artistically without self-consciousness

Encourage abstract representation
Promote self-expression

Materials:
One 12 inch by 18 inch sheet of white drawing paper for each person, black felt-
 tipped markers, and Craypas

Procedure:
1. Give each participant one sheet of white drawing paper and a black, felt-
 tipped marker.
2. Begin drawing at a point near the edge of the paper. Using a combination of
 straight line, curved line, angled line, and free line, draw a closed shape on
 the paper. The closed shape might look like this:

3. When each participant has completed their closed shape, they have created
 the beginning of a "self-portrait." Participants should study the free-form
 shape and use the Craypas to transform that shape into a self-portrait. They
 are to match the color of their clothes, physical features, jewelry, hair color,
 and shape.
4. These "self-portraits" will all be different and will not represent the actual
 body form or appearance. These portraits usually elicit a great deal of
 laughter, which reduces the pressure that often accompanies the drawing
 process.

Gesture Painting

Group Size: Individual

Leader: College instructor, student or teacher

Objectives:
Promote awareness of line, balance, and movement in painting
Explore three-dimensional representation
Express sensory elements of movement

Materials:
White drawing paper (ten sheets for each participant)
Black tempera thinned with water
Medium-tipped wash brushes (one for each participant)

Procedure:

INTRODUCTION. Gesture painting captures the movement or action of a person rather than the body form. Instead of trying to "draw" the person, the artist pays attention to the line of the movement, the pressure points, and the overall balance of the gesture or movement.

1. The leader performs an action (catching a ball, spinning around) and uses the stop-action technique to show the body momentarily frozen in midaction. Participants observe the line of the body, which part of the body is under the most pressure, and where the balance point is.

2. The leader asks participants to help demonstrate the stop-action technique. The leader makes several suggestions for movement (running to fly a kite, pretending to climb a ladder, walking into a strong blowing wind). As the gestures are being made, the leader uses the stop-action signal "stop" to have participants "freeze" in the position. The leader then points out the pressure points and balance points.

3. At this point, volunteers take turns being models while others make gesture drawings. The leader says, "When you are the model, freeze in the middle of your movement, action, or gesture, and count to seven. When you are the painter, quickly capture the gesture on your paper paying attention only to the flow of the movement." Participants should be able to get four or five gesture drawings on one sheet of paper. Models will change very quickly so participants should take a few minutes to think ahead of time of some gestures they will model for the class.

4. The leader asks for a volunteer. If no one volunteers, the leader should pose for the first few gestures.

5. As participants volunteer to model gestures, the activity should move from one model to another as soon as a pose has been held for seven seconds. As participants fill up one sheet of paper, they put it aside and start a new sheet.

IMAGE AWARENESS ART ACTIVITIES FOR CHILDREN

"Pattern Peep" introduces the concept of pattern. Children are encouraged to become aware of the creative uses of pattern by representing familiar patterns in an abstract form. Children use visual discrimination skills as they are involved in the experimental use of patterns and designs.

"A Fantasy Trip with Frederick" provides a relaxed and nonthreatening environment, which encourages the development of image awareness. Through the use of guided fantasy, the children become imaginary mice who follow Frederick on a trip to gather magical things. This activity enables children to internalize and personalize Frederick's fantasy into a personally meaningful and expressive creative arts experience. Children develop listening skills while strengthening visual memory for translating their own images into an art form.

"The Shape of You" has the children themselves as the central point of the activity. They use their bodies as the focal point of the art experience as they

represent their bodies in artistic form. Children also begin to develop an awareness of others as they extend this activity into a visual discrimination game.

Pattern Peep

Objectives:
Promote color recognition
Develop fine motor skills
Stimulate creative use of patterns
Enhance pattern awareness
Develop visual discrimination
Promote matching skills

Materials:
White construction paper (one piece for each child)
Large strips of white paper (one strip for each child)
Crayons
Hat or basket large enough to hold all the paper strips

Be patient when children are learning to use scissors. Cutting can be a complicated process.

Procedure:

1. Ask the children to look at their clothing and to think of some words to describe their clothes. Facilitate the discussion by asking some of the following questions:

 Is it all one color?
 What shapes can you see?
 Can you find some stripes?
 Does anyone have polka dots?
 See if you can find stripes going in different directions

2. Give children large pieces of white construction paper and crayons and ask them to represent their own clothing in some way, with particular attention being paid to pattern and color.
3. When the children have finished their drawings, display them at student eye level and proceed to the next step.
4. Give the chilren strips of white paper and ask them to write their names on them. If they are very young children, you will write their names for them. Put all the name strips into a hat or basket.
5. Pass around the hat or basket containing the name strips and let each child draw a name. The children then look at the drawings and try to match the name with the different representational designs.

A Fantasy Trip with Frederick

Objectives:
Develop listening skills
Enhance image awareness
Strengthen visual memory
Encourage use of fantasy

Materials:
Frederick, by Leo Lionni. Pantheon Books, Inc., 1967
One large piece of white paper for each child
A variety of colored tissue, cut into random shapes
Water-glue mixture

Procedure:

1. Read the story of *Frederick*. Discuss what kind of mouse Frederick was: was he cooperative, did he help, in what way? Ask other open-ended questions related to the story. Encourage responses by asking the children if they have ever daydreamed, which dreams they would have liked to keep, whether they would like to share their dreams, and whether they would like to go on a fantasy trip.

2. Ask the children to get ready for our special fantasy trip. Encourage the children to find a place on the floor where thay can lie down and be comfortable. The teacher begins the fantasy by saying:

> "Let's lie on the floor, close our eyes, and pretend we're little mice. Snuggle up with another friendly mouse. Keep your shiny eyes closed and feel your soft, soft fur keeping you warm. Tuck your tiny pink feet closely under you. Gather in the golden sun to save for a rainy day. Scoop up the foam from the tops of the ocean waves and place it gently in a huge, glistening abalone shell. Gather in the smell of popcorn. Feel the silky touch of a puppy's ears. Watch balloons float through the sky and listen to the songs that the birds sing."

3. At the end of the fantasy, prompt various children to respond about their images and tell about the things they would like to gather and save. Be sure to use each child's name when asking questions like "What did you daydream about and what will you save?"
4. When each child who wishes has responded, whisper softly that the mice may "sneak over" to the table and make a collage of the images they want to keep from their fantasy trip. Children move to a previously set up art table and create a collage with tissue shapes dipped in the water-glue mixture.

The Shape of You

Objectives:
Reproduce body images artistically
Develop body awareness
Enhance spatial relations
Develop visual discrimination

Materials:
Mural paper
Crayons
Scissors

Procedure:
1. Facilitate a discussion about the special attributes of each child. Special attributes such as funny, helpful, busy, silly, playful, and lively should be highlighted.
2. Following this discussion, ask children to choose a partner. Each pair is given two large pieces of mural paper slightly longer than the length of their bodies. One child lies down on the paper and the partner traces around the body shape.
3. The roles are then reversed.

4. Once the drawings are complete, children can tear or use scissors to cut out the drawings. The teacher should assist very young children who may have trouble using the scissors.
5. Each child then colors himself or herself as dressed at the time of the tracing. Allow ample time for children to make their drawings as detailed as they wish. This part of the activity must not be rushed.
6. When all the children have completed coloring their body shapes, the shapes should be displayed around the room.
7. The children are then guided around the room to see if they can recognize and name their classmates' ''body shapes.''

IDEAS TO EXTEND LEARNING

1. Try to remember some of the feelings you associate with your own early art experiences. Think of a specific time, during your early school years, when you were involved in ''art lessons'' and then discuss them with a colleague.
2. Brainstorm a list of all the methods and techniques that teachers can use to discourage creativity in the creative arts.
3. Visit an early childhood classroom and make a list of all the materials available for the children to express themselves using the basic art materials.
4. Collect samples of art work from one child for several months. Note any changes or similarilties in style, subject matter, form or methods the child uses as a means of expression.
5. Arrange an art area that young children can use independently. Observe how the children approach the area and make notes about how different children experiment with the materials.
6. Discuss what is wrong with the following situation.

 Jane is a five-year-old attending kindergarten. One afternoon her teacher stops to look at her drawing and picks it up to show the other children. The teacher says ''Look, boys and girls. Jane has made a lovely drawing today. She has colored all the leaves on her tree a beautiful green and the apples are so red they look real!'' Then the teacher tells Jane ''Your apples are much nicer and more real looking than the blue ones you drew yesterday.''

7. Examine your own feelings about nonverbal communication. Think of some times when you have been confused or puzzled about the nonverbal behavior of others. Discuss some ways that you might have checked out the accuracy of these perceptions. Begin mentally practicing the technique of perception checking and try it out the next time you are in a similar situation.

ENDNOTES

1. Buckley, Helen. Professor Emeritus, State University of New York at Oswego ''The Little Boy.'' *School Arts Magazine*. October 1961.

2. Lowenfeld, V., and Brittain, W. L. *Creative and Mental Growth* 5th ed. New York: Macmillan, 1970.

3. Lowenfeld, V., and Brittain, W. L. *Creative and Mental Growth.* 5th ed. New York: Macmillan, 1970.

4. Lowenfeld, V., and Brittain, W. L. *Creative and Mental Growth* 5th ed. New York: Macmillan, 1970.

5. Adapted from John O. Stevens, *Awareness: Exploring, Experimenting, Experiencing.* Moab, Utah: Real People Press, 1971.

6. Lowenfeld, V., and Brittain, W. L. *Creative and Mental Growth* New York: Macmillan, 1970, p. 62.

5
Creative Drama

Creative drama offers many opportunities for growth. As children react to creative drama, they are thinking, feeling, imagining, moving, and communicating. Creative drama is not new to young children; playacting seems to come naturally to them as they use their voices and bodies and familiar objects to act out fantasies in real or make-believe situations. As a teacher, you will have unlimited opportunities to assist children in creative drama experiences. The "seeds" for developing and implementing creative drama activites here are a beginning point. Your ability to see potential in a story, an image, a situation, or an object will help you develop skills to stimulate creative drama adventures with your children.

This chapter continues the theme of affective development with a focus on *valuing*, the next major category on the continuum. Valuing implies that we see the worth of our participation in the creative arts. This chapter presents an experiential activity designed to help you take a look at your behavior and how your behavior reflects your own affective development.

Objectives

This chapter will provide the information and opportunity for you to

- describe the basics of creative drama for young children
- identify techniques that can be used to engage young children in creative drama

- experience the process of the creative arts through pantomime and improvisation
- be perceptive regarding your own participation in creative arts activities
- be open and responsive to the ideas, feelings, and reactions of others
- design and implement creative drama experiences with young children

UNDERSTANDING CREATIVE DRAMA

In *Creative Drama in the Classroom*, Nellie McCaslin makes a distinction between dramatic play and creative drama. She defines dramatic play as "the free play of the very young child in which he explores his universe, imitating the actions and character traits of those around him. . . . It has no beginning and no end, and no development in the dramatic sense."[1] Creative drama is more structured. "It may make use of a story with a beginning, a middle and an end. . . . It is, however, always improvised drama."[2] Both processes are based on the children's interests, imaginations, and natural responses.

Creative drama is not children's theatre; it is improvised drama. Children interpret suggestions, stories, or events using their own actions and dialogue. Simple props can sometimes be useful but they should always enhance imagina-

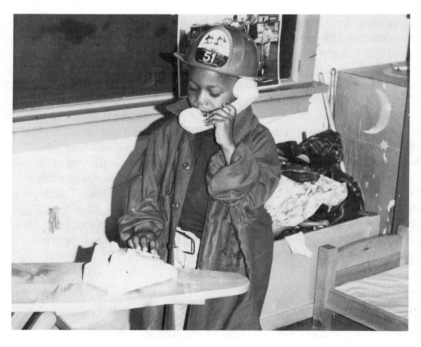

Dramatic play and creative drama are improvised by the child.

tive expression and not limit the creative impulses of the child. Creative drama for young children has four major objectives: artistic exposure, social awareness, expressive development, and enjoyment.[3] The goal is not to perform for an audience but to enhance the artistic, intellectual, and affective growth and development of children.

Creative drama is a means of self-expression that encourages movement, gesture, language, and nonverbal communication. When introducing very young children to creative drama, you might begin by encouraging them to explore familiar images and moods. For example, begin by asking the children to walk around the room as you play a steady, even drum beat. "Now it's beginning to rain. Lift up your arms and feel the rain on your hands. Look up and feel the rain on your face. Is it cold? Is it warm? Show how you would walk through a big rain puddle!" Children will have individual responses to walking in the rain, deciding what actions are meaningful to them. Ask children to move their bodies like falling leaves, drifting snow, or trees being blown in the wind. These types of simple, imaginative experiences will bring spontaneous sounds of delight. For very young children especially, spoken words can often get in the way of the experience. Your continued leadership in providing interesting and new creative drama experiences may lead your very young children toward vocalization, dialogue, and dramatizations.

Nursery rhymes, poems, and songs are excellent material for encouraging dramatic expression. Remember the poem "Teddy Bear" from Appendix 1: Fingerplays? Children as young as two years old may enjoy dramatizing this familiar poem. Nursery rhymes like "Hey! Diddle, Diddle" can be acted out by a small group of children. They can decide whether they want to be the cat, the fiddle, the cow, the moon, the dog, the dish, or the spoon! Or the children can act it out together as they jump over the moon, laugh, and run away. This is an instance in which a simple prop may be useful. A small block, placed on the floor, can be transformed into an imaginary moon for your children to jump over. Simple nursery rhymes such as "Little Robin Redbreast," "Humpty Dumpty," or "Jack and Jill Went Up the Hill" give young children many opportunities to explore familiar roles and identify with different characters. Children want to "be" the robin and "niddle, naddle" their heads, and they love to fall into collapsed laughter as they act out Humpty Dumpty.

Well-known stories can provide wonderful creative drama experiences. The teacher can read the story and pace the timing to match the children's movements and actions. Or, as children become thoroughly familiar with the story line, sequence, and plot, they may improvise their own dialogue and actions without the teacher's guidance. Remember that the actions, movements, and dialogue are created by the children. There are no "correct" lines to be memorized and spoken or directions to be rigorously followed in the *process* of self-expression, and children should be under no pressure to create a "product" for an audience. *Caps for Sale, Swimmy, Ask Mr. Bear, The Three Little Pigs, The Three Billy Goat's Gruff,* and *The Three Bears* are just a few good stories that lend themselves well to dramatization.

We all know how young children love to hear their favorite stories over and over again. They also want to dramatize a story many times and change roles to experiment with different characters. Spontaneous dialogue that adds new dimensions to the story line may emerge, some parts of the story may be omitted, and some new and interesting plots may develop. This is all part of the creative drama process, and we must accept children's creativity and encourage them to explore stories in ways that have relevance to them.

You can use creative drama to expand your own understanding of this personally creative process. You do not need formal training to use creative drama as a learning tool; you simply need to trust yourself and become involved in the process. There are no special words to say, no scripts to memorize, and most importantly, no pressure to create a final "product." Later in this chapter, you will find creative drama activities for you to explore and creative drama activities and ideas to use with children. You and your colleagues will improvise your own solutions to dramatic suggestions. You can make up your own dialogue of words and movements to bring characters, stories, situations, or fantasies to life. The only "equipment" required is your personal experience, the experiences of your children, the planned ideas of a leader, and resource materials such as poems, stories, images, and ideas.

AFFECTIVE DOMAIN: VALUING

Teaching and learning experiences that focus on the affective domain emphasize the development of self-awareness, insight, and self-knowledge. Because of the very nature of affective development, the process of moving toward these levels of self-understanding involves interpersonal experiences and involvement with other people. As a group exploring the creative arts process together, you have already developed some skills in communicating with each other. To become personally involved in the creative arts process, you must feel that you can trust your colleagues and express your opinions openly and without reservations. The process of *valuing* is concerned with the worth we attach to the creative arts. Many of you already have an increased appreciation for the role the creative arts play in the process of growing and learning. Similarly, your behavior may be beginning to demonstrate commitment to creative arts content. Valuing ranges in degree from simply accepting the value of the creative arts (creative arts are important) to assuming responsibility for the effective implementation of creative arts in educational programs. Krathwohl, Bloom, and Masia perceive *valuing* as "based on the internalization of a set of specified values, but clues to those values are concerned with behavior that is consistent and stable enough to make the value clearly identifiable."[4] Remember, however, that development in the affective domain is a gradual process. You may have experienced some very positive feelings or some uneasy feelings about your participation in the creative arts experiences. If your overall response has been positive and has produced growth, I hope you will continue with even more enthusiasm. For those of you still unsure of your role, I encourage you to use creative drama as a new starting place for responding and

valuing. Development in the affective domain is a continuous process of internalization; it is not a static quality. This chapter offers new experiences for you to explore in your personal journey.

As a first step in understanding valuing as a process in affective development, the activity "An Awareness of Self" will help you assess your participation in the creative arts. This activity focuses on participation, communication, sensitivity, and openness. You will talk with a partner about your level of participation, your willingness and ability to communicate, your feelings about sensitivity and openness, and your personal learning goals and their relationship to the creative arts.

An Awareness of Self

Group Size: Small group

Leader: College instructor, teacher

Objective: Assess level of interaction, participation, and learning

Materials: None

Procedure:

1. Form small groups or pairs and take turns asking and answering the questions listed below. You need answer only those questions you feel comfortable answering. However, you should consider taking advantage of this opportunity to assess your own participation in the creative arts activities; your opinions on communication, sensitivity and openness; and the level of learning that may or may not have occurred.
2. There are a few ground rules to follow as you begin your discussion:
 a. All the information discussed is confidential.
 b. Each person responds to each question before continuing. If you choose not to respond to a particular question, you can pass.
 c. Questions can be answered in whatever depth you wish.

Participation:
 a. Did I participate in all the activities?
 b. Which activities did I find the easiest to participate in?
 c. Which were the most difficult for me?
 d. How did others participate?
 e. Did I notice anyone being excluded?
 f. In what ways did I feel included and encouraged?
 g. Why am I satisfied or not satisfied with my level of participation?

Communication:
 a. Did I feel free to talk or was I inhibited? Why?
 b. What evidence do I have to indicate that others listened to me?
 c. What evidence do I have to indicate that I listened to others?
 d. Did my instructor attend to what I was saying? Cite an example.
 e. Did I attend and respond to my instructor? In what ways?

Sensitivity and Openness:
 a. How were others sensitive or insensitive to my needs?
 b. In what ways was I sensitive to others and their experiences?
 c. What feelings and thoughts have I shared with others?
 d. How difficult or easy was it to be open to the ideas and feelings of others?
 e. How did I handle positive and negative feelings?

Learning:
 a. What did I learn from other people?
 b. What have I learned about the creative arts or affective development?
 c. What do I know now about the process of creative development that I did not know before?
 d. How did I contribute to the learning of others?
 e. Have any of my own personal learning goals been achieved?
 f. What will I do with my learning?
 g. How could I demonstrate my current attitude toward creative arts education?

GUIDED FANTASY FOR THE COLLEGE STUDENT AND CLASSROOM TEACHER

Teachers are continually bombarded with stimuli, all of which have an impact on our ability to be creative. Often the influences of these "then and there" personal experiences hinder our ability to be totally present in the "here and now" of the creative arts experience. Spontaneously responding to the creative arts means being free, or at least temporarily released, from the pressures and anxieties that we all encounter in day-to-day living in the outside world.

One of the first things you explored in this book was guided fantasy. Remember the feelings you had upon discovering that you are the most beautiful, most perfect creation in the world? The guided fantasy in this section, "Your Gunnysack," is designed to help increase your awareness of what is going on inside of you in the "here and now" of the creative arts classroom. This includes an awareness of inner tensions, physical sensations and experiences, and events and people that you have dealt with throughout the day. This guided fantasy should help you eliminate some of the stumbling blocks that may stand between you and free, creative expression.

Your Gunnysack

Group Size: Large group

Leader: College instructor or student volunteer

Objectives: Observe, inventory, and eliminate events that hinder creative expression

Materials: None

Procedure:

1. The leader reads the following guided fantasy:

Your Gunnysack

Sit down and let your body become comfortable . . . Move around until you are sitting squarely . . . Let your body find a balance point . . . Allow yourself to become calm . . . Take a couple of deep breaths, letting all the tension flow out of your body and into the floor . . . As your body becomes quiet, let your mind become quiet also . . . Imagine that your mind is a slow, flowing stream . . . slowing down to a smooth, gentle pace . . . Take a few minutes to watch your stream as it flows to places unknown.

Much of the time we are not aware of how our everyday encounters with others and experiences in our environment affect our behavior . . . Take a few minutes to recreate an image of where you were when you first woke up this morning . . . Who was there? . . . What was happening? . . . What feelings did you have? . . . What were your thoughts about today? As these images begin to shift in your mind's eye, allow yourself to move from an image state to a thinking state and mentally follow the events of your day that led you to this place and time . . . Where did you go? . . . Who did you see? . . . What did you do? . . . Take a few minutes to reconstruct your day until you arrive in this "here and now" moment . . . Now direct your attention to the events of the day that troubled or bothered you . . . These events might have involved another person . . .

many people . . . or some bit of trauma that was out of your control . . . You may have had a disagreement with someone . . . Maybe you missed the bus . . . or had car trouble . . . a bad class . . . or any number of other experiences that left you feeling unsure, unsafe . . . upset . . . tired . . . or out of control. Now return to an image state and imagine a very large sack lying on the floor near you . . . This gunnysack has a very important purpose. It is especially designed to hold all of the experiences . . . events . . . or people that have disrupted your day today . . . This gunnysack is a safe place to keep those things, and once they are safely tucked away, only you can decide if and when you want to get them out again . . . Remember all the troubling elements of your day . . . and one by one . . . pick them up and tuck them away in your gunnysack . . . They will be very safe . . . You can get them out again anytime you wish . . . but for right now . . . put them away and free yourself from their influence . . . Be gentle . . . Handle them with care . . . Watch yourself as you fill up your gunnysack . . . Listen to what is going on inside your mind . . . This will help you get in touch with their influence . . . When your sack is full, use your mind's eye to pick it up . . . It may be heavy or light, but even if it is heavy you can carry it . . . I have asked a very wise and trustworthy companion to watch over your gunnysack while we spend some time exploring our creativity . . . use your mind's eye to carry your sack out the door and leave it outside this room in the watchful care of my companion . . . When you feel sure that your gunnysack and all the things it contains are safe . . . use your image eye to walk back into this room . . . free of the troubles and unpleasant events of the day. As long as you know where your sack is, you will have more control over what to do with it . . . Now it's time to enter the creative process . . . You are free to explore . . . to move . . . to dance . . . to play. Begin to move your fingers and toes a little . . . Open your eyes slowly and let the sight of this room come in . . . When your eyes are fully open, stand up, shake off any remaining tension and prepare for the next experience.

CREATIVE DRAMA FOR THE COLLEGE STUDENT AND CLASSROOM TEACHER

Creative drama can be a useful process toward self-expression. Through it you can expand your imagination and develop skills in body movement, gesture, and verbal and nonverbal communication. You do not need formal training in drama or theatre to be successful in planning and implementing creative drama experiences for adults or young children. The creative drama activities in this chapter focus on creating optimum conditions for exploration, risk-taking, and free expression. One goal of these activities is to help you establish a foundation for building basic trust among members of your group so you will feel that it is safe to try, assured

of nonjudgmental acceptance and respect. Creative drama will enhance not only your own learning but the learning of others as well.

The following activities will help increase your awareness of the creative drama process and your understanding that all teachers can use it in the classroom regardless of previous training or lack of it. The activities will encourage you to exercise your imagination, explore your own creativity, and overcome fears of "performing."

Pantomime is one of the most pleasurable nonverbal forms of creative drama. Pantomime can involve movement, the use of isolated body parts, full body action, expression, or gestures. It does not require the use of oral language, which can sometimes inhibit our creative endeavors. As your participate in "The Human Machine" and "Characteristics of Inanimate Objects," you don't have to worry about trembling voices or "forgetting the lines!" However, as you practice the art of pantomime, you will probably find yourself wanting to use language as an aid to understanding. When this happens, you will experience what children experience when they spontaneously add verbal language to their pantomime experiences. "Animals," "Getting to Know You," "The Wise Woman," and "The Floating, Swirling, Circling, Storytelling Star" are experiences that will get you involved in improvisation. Read through these activities, think about how you might enter into the process, and then be ready to enjoy the world of creative drama.

The Human Machine

Group Size: Large group, dyads, individual

Leader: College instructor, teacher

Objectives:
Experience a nonverbal art form
Encourage group participation
Interpret gestures and expression
Decrease self-consciousness

Materials: None

Procedure:
1. You are going to make a human machine! Participants should move to the outer perimeter of the room and stand next to the wall.
2. A volunteer moves to the center of the room and begins a motion. The motion can involve a total body action such as turning or rising and sinking or an individual body action such as bending an arm or twisting a foot.
3. Once the volunteer has the action going at a steady pace, others think of a way to join the machine and, one at a time, connect themselves to create a full group human machine.

4. After the machine is complete, participants add sounds, one at a time, until the human machine is a working, rumbling, clanging, hissing, moving, living work of art!
5. Once the human machine is in full operation, complete with movement and sound, the leader shouts "FREEZE" and all participants freeze in position.
6. At this point in the activity, participants move out of position one at a time to take a good look at the creation. Everyone should have a chance to see what the creation looks like.
7. For the climactic event of this imaginative process, all participants should speed up their actions and gradually increase the volume of their sounds until actions and sounds reach a peak that cannot be sustained.
8. Any participant can shout "COLLAPSE" and the whole group falls into a jumbled mass of spent energy!

Characteristics of Inanimate Objects

Group Size: Large group, dyads, individual

Leader: College Instructor, teacher

Objective: Explore the art of pantomime

Materials: None

Procedure:
1. Spend a few minutes talking about what inanimate objects are, and think of some examples like tools (hammers, screw drivers, scissors), household appliances (can openers, toasters, irons, microwave ovens), or food (popcorn, jello, ice cream). Keep a mental list of the things *you* think of.
2. The leader or a volunteer then demonstrates how we can make inanimate objects animate if we use our imaginations. Demonstrations may include a washing machine agitating, corn popping, or a microwave oven beeping.
3. Everyone finds a partner to work with and then thinks of an inanimate object they can become. The partners should find a place in the room to talk or leave the room to practice.
4. When each pair is ready, they return to the room and "act out" their inanimate object for the rest of the class. This can easily be transformed into a game of guessing what the inanimate object is.

Note that while pantomiming the object, it is very important to use some element of the object to show what it is. Instead of working the object, the person's action represent the *actual movement* of the object.

The following activities can be implemented in large or small group settings *and* they can be narrowed or extended to be used successfully with children. Your instructor may serve as the leader or may ask for volunteers or assign leadership

roles. If you have not seized the opportunity to lead previous activities, you might want to consider it now. The more practice *you* have in a leadership capacity, the more confident you will become in planning and implementing creative drama experiences for children.

Animals

Group Size: Small group, large group

Leader: Teacher

Objectives:
Elicit laughter
Establish a relaxed atmosphere

Materials: None

Procedure:
1. The leader asks someone in the group to give the name of an animal and the sound it makes. Once an animal is named, everyone makes the sound of that animal together.

Animal puppets can be a useful prop when introducing children to creative drama.

2. Think of another animal and the sound it makes. Then think of a third animal and the sound it makes.
3. When there are three animals with different sounds, participants should close their eyes and start making the sound of *one* of these three animals.
4. Keep your eyes closed and walk around the room making your animal sound. Listen for other people who are making the same sound and form a group with the people who are making the same sound as you.

Getting to Know You

Group Size: Small group, large group

Leader: Teacher

Objectives:
Increase creative communication
Interpret characteristics of animals and objects
Creatively portray someone other than self

Materials: None

Procedure:
1. Think about a variety of animals and decide on one that you would like to be. Consider all kinds of animals from pets to animals we find in the wild, at the zoo, or in the ocean, including cats, tigers, dogs, squirrels, birds, frogs, lizards, snakes, whales.
2. When all participants have decided what animal they would like to be, describe yourself to the others.
3. After everyone has had a chance to describe his "animal self," form pairs (or triads if there is an uneven number).
4. The leader or a participant tells the following story.

This is a magic place where all the animals can talk but none of them know each other. You don't even know what kind of animal is standing next to you. But you like this new animal and think that you would like to get to know it better. Take a few minutes and talk to this animal and find out just exactly who and what it is. Ask what it likes to eat and what it would *never* eat! Ask if it is afraid of anything or anyone and what kinds of sounds it can make. Find out how it moves about and what it looks like when it is sleeping. When you have found out all about your new friend, tell all about yourself.

5. When all the animals have talked about themselves for a few minutes, come back together in a large group, where each animal tells "The best thing about me is . . . " (Note to the leader: Since dialogue is often difficult for beginners, the leader should carefully monitor the conversations and bring the group together before any of the participants slip out of character.)

The Wise Woman

Group Size: Small group, large group

Objective: Use the imagination to stimulate spontaneous dialogue

Materials: None

Procedure:
1. Pretend to be one of the following objects:

 car kite
 piano flower
 star shoe
 sailboat airplane
 diamond penny

 If none of the above objects or things seem to "fit" you, then think of others and select one for yourself. Your object might be something you have already dealt with today such as a textbook, exam paper, or even what you had for lunch!
2. When everyone has chosen an object to become, the leader tells the following story.

 We are going on a journey to see a very wise woman. She lives at the end of a long path and at the top of a great hill. This wise woman has magic powers and she will grant wishes to almost anyone who makes the journey along her long path and up her great hill. Think about who you are and see if you can think of some wish that you would like the wise woman to make come true. Before we arrive at her hilltop home, let's talk to each other about what we will wish for. When you have decided on a wish, tell someone standing near you what your wish is and why you think the wise woman should make it come true. When you have talked about one wish, see if you can think of two more you would like to tell the wise woman.

3. The leader assumes the role of the wise woman as you take turns telling what your wishes are and why you think your wishes should be granted. Of course, since the wise woman is very, very wise, she grants all the wishes!

The Floating, Swirling, Circling, Storytelling Star

Group Size: Small group, large group

Leader: Teacher

Objective: Increase storytelling skills

Materials: None

Procedure:
1. Form a star by lying on the floor or arranging chairs in a large circle. Use your collective imaginations to create your star.
2. When everyone is in position and resting comfortably, a leader begins the story by saying "We are *floating, swirling, circling, storytelling star!* We will all help to make up a story, and each one of us will add to the story when we have something to say."
3. The leader continues the story by saying:

> Close your eyes and imagine that it is the end of a beautiful summer day. The sun is slowly going down and the sky is filled with orange and red and lavender sunset colors. Soon the sun will be completely set and the sky will begin to turn light grey. You will begin to see the dim glow of a few stars as they peek out of the evening sky. Watch these stars as they gradually get brighter and brighter until the whole sky is filled with millions of blinking, shining stars. As you watch the twinkling of the stars in the night sky, imagine that we are all parts of a very special star. Magically, and without even moving our bodies, we slowly begin to float . . . and spin . . . and swirl . . . as we lift off the floor and gently move upward, toward the other stars. We are the brightest star in the universe, and our shining light radiates on the earth so we can see all the things that are happening on earth tonight. I see people walking down the street and a kitten perched in a window. What do you see from your point on the star?

4. The story continues until everyone has described what they see.
5. The leader then brings the participants floating back to the earth.
6. When everyone has had enough time to make the transition back to the here and now of the classroom, the leader suggests that each participant "act out" the things that she saw. All the participants should move about the room and dramatize everything they remember of what they saw during the storytelling.
7. At the conclusion of this experience, participants should be given the opportunity to talk about their feelings and reactions to transforming an image into a dramatic expression.

TEACHING STRATEGIES FOR CREATIVE DRAMA

In his keynote address to the National Invitational Conference sponsored by The Getty Center for Education in the Arts (January, 1987), Dr. Elliot W. Eisner of Stanford University presented a compelling rationale for art education. "Art is one of the important means through which the potentialities of the human mind are brought into being. . . . Far from a mindless activity, our engagement with art calls

upon our most subtle and complex forms of perception." Creative arts experiences enable children to draw upon their own personal experiences and emotions "as a source of content that allows [the] imagination to take wings."[5]

Creative drama, as an art form, taps the roots of children's experiences and emotions so they can "take wing" through spontaneous sound and movement and creative expression. Children come to us bring all the "equipment" they need. There is no body of information or technique that children must master, nor need they rely on knowledge that is outside their realm of understanding. Movement, pantomime, role-playing, and improvisation enable children to act upon creative impulses in a personal, exciting way. Your role as a teacher is to liberate yourself from the "cookbook" approaches to creative drama and to focus your energy on *your* children's experience, knowledge, feelings, and perceptions. Remember that creative drama springs from the inner resources of your children; they provide the raw material. Rugg and Shumaker proposed in the early twenties that drama is the most completely personal, as well as the most highly socialized, art.[6] This idea is still accepted today. Because creative drama for young children is highly personal *and* uniquely individualistic, you must be open to children's creative efforts and establish a supportive atmosphere that is child centered rather than product centered. Explore ideas with your children, observe their dramatic and sociodramatic play, note what poems and stories they are the most familiar with, and keep track of material that evokes the most interest and excitement. When designing creative drama activities for your children, you should know what they know so you can plan experiences in which all your children can use their bodies, voices, imaginations, and feelings to express themselves. Books like this can only provide a framework to help you develop materials and methods for creative drama. You must utilize your own experiences and those of your children when planning for children of different ages and levels of development. The following ideas can help you and your children ease into this rich and rewarding process.

Movement and Pantomime

Pantomime the growth of a seed into a tall, strong tree. Begin by snuggling deep in the soft earth. Feel the sun making you warm. Feel the gentle rain that helps you to grow. Slowly peek out of the ground and grow and stretch into a tall, strong tree. Stir up a little breeze and let your tree twist and turn. How do your branches move? How do you move during a rain storm? On a quiet sunny afternoon? Show how your leaves fall to the ground. Show what happens when a strong wind blows.

Take a walk through a grassy field, through a rain puddle. Walk in the snow and across a hot, sandy beach. Show how you feel when you see a flower garden, and then walk through it. Walk under a waterfall. Show how it feels to be wet. How do you look when you are very hot?

Move body parts in many different ways. Pretend that one body part is a giant paintbrush and paint a picture in the air.

Walk on your tip-toes and try to touch a star. Walk backwards into a pool (ocean, river). Walk barefoot across hot pavement. Walk on your knees through slippery mud.

Using a drum, produce a variety of rhythms and tempos and move to the different sounds.

Make some parts of your body move like objects: a washing machine, windshield wipers, wheels going round and round, a bouncing ball, a jack-in-the-box, a hammer, popcorn popping, a rag doll.

Have your children pretend they are balloons and slowly blow them up. Tie an imaginary sring on each balloon and let them float around the room. Untie the string to let the air out slowly or pop balloons with a pin for a quick collapse.

Stretch your arms and take off like a jet plane, circle in the sky, make a slow landing, and come to a stop.

Put your hand out in front of you and follow wherever it goes. Let your ear lead you around, your elbow, your shoulder.

Pretend that you are marionettes (string puppets). You are limp in a little pile on the floor until I pull your string. How can you move as I pull your string?

Put some imaginary seeds into an imaginary wagon. Pull your wagon into a garden and pretend to plant your seeds. When you have finished planting, turn on the water and give them a good drink.

Play a piano, a violin, a drum, a guitar. Show how you have to hold them differently and what you have to do to make music. Play some fast songs, some slow songs, some loud songs, some soft songs.

Bounce like a ball across the playground. Roll like a ball down the street.

Catch this imaginary ball when I throw it to you. Look at it and then throw it to someone else. Roll the ball to another person. Pick up the ball and show how big (small, heavy, light) it is. Bounce your ball to a friend. Take the ball and put it someplace where it cannot roll around.

Move like a giant. Fly like a butterfly. Crawl like a snake. Tiptoe like a spider. Children love to pretend to be animals, even animals that they have never seen. Some favorites of young children are cats, horses, rabbits, monkeys, frogs, birds, snakes, and dogs. You can expand this type of dramatization by asking the children to select one animal and move in as many ways as they can think of. Let children choose a variety of animals that jump, crawl, gallop, or pounce and let them demonstrate these similar movements. Be prepared for emerging sounds and vocalizations!

Pretend that it is early in the morning and you are getting dressed. What are you wearing and how do you put it on? Don't forget to comb your hair. Show how you eat your breakfast. It's raining outside so be sure to put on your raincoat and rain boots.

It's your birthday. Blow out the candles on your cake. Open your presents and show what you got. Show how you taste your cake and how you eat it. Show what else you have to eat and what you are drinking.

Let your thumb talk for you. What is it saying? Who would it like to talk to? Find a friend and let your thumbs talk to each other.

Be water flowing down a river, over slippery rocks, over a waterfall, freezing in winter. Show how you feel when you see children putting on ice skates and beginning to skate on you. How do you look when you start melting?

Go fishing. Throw your line in the water and wait for a fish to bite. Show how you feel when the fish bites your hook. Show how strong your fish is. Reel in your fish and cook it up for dinner.

Take off your shoes and walk along the beach (through a field, along a sandy lakeshore) and feel the sand between your toes. Show how it feels. Walk barefoot across the snow. Feel the snow between your toes. Show how the snow feels.

We are going on a journey. Everyone pack a suitcase and lunch box and meet me over here at the station (train, bus, airport). Everyone get a ticket and climb onto the train (bus, airplane). (A small chair for each child is a useful prop). Show how you feel about going on a journey. You hear an announcement that the train cannot leave. Show how that makes you feel. Look behind you and see the engineer (driver, pilot) coming. She says, ''We're all ready to go now!'' Show how you feel now.

Walk down a long path and see a little kitten sitting on the side. Show how you would pick the kitten up and how you would hold it. (Continue the journey and find a shining rock, an apple tree, a new, shiny penny, or other objects that your children are familiar with.)

Show how your body looks when you are relaxed, happy, angry, hurt, excited, sad.

Have your children work with a partner to play ''mirror image.'' Two children face each other and take turns mirroring each other. Encourage children to make very slow movements. This is an especially rewarding experience when accompanied by music.

Making Rain

Read a story about the weather or rain such as *Rain Drop Splash* and then ask the children to form a circle. Stand in front of one child and demonstrate rubbing your hands together in a back-and-forth motion. When the child begins to make the

motion, ask that he or she continue that same rubbing, back-and-forth motion until you demonstrate a new action. Move to the next child in the circle until all the children are rubbing their hands together. When you have completed the circle and are standing in front of the first child, change your hand motion to a finger-snapping action. Show this child how to make the finger-snapping action. Move to the next child in the circle. That child also stops the rubbing motion and begins the finger-snapping action. The rubbing motion is gradually phased out until all the children are snapping their fingers. Continue this pattern by changing finger snapping to leg slapping and then feet stamping on the floor. The actions produce sounds that sound like an approaching storm, climaxing with thunder and loudness. In order to "quiet this storm," you should reverse your actions while continuing to move around the circle in the same manner. The sounds diminish as the rain finally goes away. The effect is delightful! For easy reference, the sequence is listed below:

> Rubbing hands . . . pitter, patter of raindrops
>
> Snapping fingers . . . rain drops get bigger
>
> Slapping legs . . . it's raining harder
>
> Stamping floor . . . thunder!

Improvisation

In improvisation, children make up their own dialogue, movements, and expressions. There are no lines to memorize or "correct" responses; children react and interact from their personal perspectives. Each child's method of self-expression has value. Include all the children who want to participate, and be gentle with the children who are inhibited or reluctant to take part. These children need your support and encouragement as much as the active children. Probably, deep down, they really want to express themselves and be a part of the experience. Offer these children the opportunity to participate in a small, nonthreatening way and give them the time they need to move into the process.

Imaginary Situations

1. Select or tell a story that lends itself to lots of sound effects. First, tell the story to the children and ask them to imagine the sounds. Next, read the story again and let the children add the sound effects. For example, read "It was a very windy day and the wind was blowing through the trees . . ." and encourage your children to make the sound of the wind. Stories about animals such as *Ask Mr. Bear* are particularly appealing to children.

2. Ask your children to talk in gibberish, making sounds that have no meaning. Suggest situations where they can talk to each other in gibberish such as asking for more juice, asking if they can go out to play, asking a friend if they can borrow a toy, scolding an imaginary puppy who is running around the class-

room, getting angry at an adult. Encourage discussions and suggest that children add movement, expression, and action to their dialogue.

3. Set up situations where children can take on different roles and interpret the suggestions through improvisation.
 a. What if you were a ghost living in a haunted house?
 b. What if creatures from outer space came down to earth and landed in our school yard?
 c. What if a leprechaun lived on your back porch?
 d. What if it suddenly rained ice cream?

4. Ask children to use their imaginations to act out suggestions.
 a. If *you* were an airplane, what would you do today? If *you* were a kitten, a bicycle, a pair of scissors, a paintbrush, a pencil, the wind?
 b. Take a ride on a magic carpet and make several stops along the way. Stop at a zoo and let the children be the animals, stop at a grocery store and let the children go shopping, stop at a restaurant and let the children order a fancy meal, stop at a toy store and let the children *become* the toys, stop at a circus and let the children improvise the different characters and animals found there.
 c. Encourage children to exchange dialogue and actions as they express
 how to catch or ride a whale
 how to fly a space ship

how to talk to a dinosaur

how to climb to the moon

how to make witches' brew
how to feed the sun

5. Collect old hats and let the children decide where they have been, who they belonged to, and what adventures they have had. Encourage children to wear different hats and become the person that the hat represents.

Field Trips

Take a field trip around the school yard or to an interesting place in your neighborhood. Ask the children to look at all the things they see and listen to all the sounds they hear. After the field trip, let the children improvise some of the things they saw and heard.

Stories and Poems

When children are familiar with a favorite story or poem, encourage them to expand the experience through improvisation. Stories that are good for dramatization should have a simple plot; a variety of cumulative actions; dialogue, especially between children and other children and between children and animals; and repetitive words, phrases, or sentences. The following stories make good beginning dramatizations:

The Three Billy Goats Gruff
Goldilocks and the Three Bears
Adventures of Three Little Rabbits
Teeny Tiny Woman
The Little Red Hen
The Elves and the Shoemaker
Stone Soup
Ask Mr. Bear

Caps for Sale
Little Red Riding Hood
The Little Engine That Could

When selecting stories for improvisation, remember that there are often more roles than the obvious ones. The story of *The Three Little Pigs*, for example, requires sticks, straw, bricks, and houses as well as the pigs and the wolf. Where did the sticks come from? Who made the bricks? Where did the wolf live and what was his house made of? Put your imagination to work and allow your children to explore all the nooks and crannies of the story. A simple suggestion from you could open up spontaneous dialogue and exploration of all the potential a story holds.

IDEAS TO EXTEND LEARNING

1. Read *Creative Drama in the Classroom* by Nellie McCaslin. Select several activities from the section on pantomime and several from the section on improvisation. Decide what age or developmental level these seem appropriate for and explain how you came to these conclusions.
2. Review the methods and materials suggested in this chapter and design a creative drama experience for young children. Implement your plan with a small group of children and evaluate the outcome. Note the children who participated and those who didn't. Why do you think this occurred? Make a list of ways you might include more children. What parts of the creative drama where the most fun for you and the children? How can you improve the activity?
3. Describe how teachers can establish a classroom atmosphere in which children feel safe to enter the creative drama process.
4. Select a story that has repetitive phrases or words and read it to a group of children. On the second reading, invite the children to join you in speaking the familiar phrases.
5. Spend a day visiting a local day-care center or early childhood classroom. Record the times and occasions during the day that are devoted to creative drama. Observe the teacher and make notes on the techniques the teacher uses to involve children in creative drama.
6. Make a list of all the things you put into your "Gunnysack." Show this list to a good friend and talk about why these things were troubling you or getting in the way of your creative expression.
7. Begin a file of nursery rhymes and poems that are good for pantomime and improvisation.
8. Expand on the creative drama suggestions in this chapter by making your own list of "What if . . ." "How to . . ." and "If you were (?) what would you do today" suggestions.

ENDNOTES

1. McCaslin, N. *Creative Drama in the Classroom*. New York: Longman Publishers, 1980, p. 6.
2. McCaslin, N. *Creative Drama in the Classroom*. New York: Longman Publishers, 1980, p. 8.
3. McCaslin, N. *Young Children and Drama*, 2nd ed. New York: Longman Publishers, 1981, p. 16.
4. Krathwohl, D. R., B. S. Bloom, and B. B. Masia, *Taxonomy of Educational Objectives Handbook II: Affective Domain*. New York: David McKay Co., Inc. 1964.
5. Eisner, E. W. Keynote address to the National Invitational Conference, Sponsored by the Getty Center for Education in the Arts, Los Angeles, California, January 15, 1987.
6. Rugg, H. and A. Shumaker, *The Child-Centered School*. New York: World Book, 1928.

6
Three-Dimensional Art

Antoine de Saint Exupery's little prince said: "It is only with the heart that one can see rightly; what is essential is invisible to the eye."[1] The young child's creative exploration and experimentation in the creative arts is also often invisible to the eye. Children express themselves in their own unique ways, and the material reflection of this creative process may be visible only through the heart of the creator. This is especially true when children begin to explore three-dimensional art.

In their book, *Creative and Mental Growth*, Lowenfeld and Brittain stated "A work of art is not the representation of a thing but rather a representation of the experiences we have with that thing."[2] Three-dimensional art provides the artist with a multitude of representational experiences. Unlike painting, which is only seen, three-dimensional art can be touched, felt, *and* seen from a variety of perspectives. This chapter presents a variety of processes to help you explore three-dimensional art, one of which requires a high level of trust between you and a colleague. Also in this chapter is a description of how young children approach three-dimensional art and suggestions for developing environments that support children's creative efforts. You and your children will have an opportunity to focus on the sensory elements of touching, feeling, and forming creations from clay, fabric, sand, and other materials. As you explore these different materials, focus on your ability to "see" the artistic process emerge through your hands, your eyes, and your own sensory impressions.

The processes you have been experiencing have been structured to

promote a teaching/learning atmosphere in which you can interact with your colleagues and peers in a supportive environment. Giving support and receiving support from each other is an important aspect of our role as professionals. This chapter includes an activity designed to give you insight into your current "support system" and ways to enhance the level of personal and professional support you are now receiving . . . and giving.

Objectives

This chapter will provide the information and opportunity for you to

- describe how young children create in three-dimensional art
- identify conditions that encourage children to enter the creative process
- work with another person in a high-trust, three-dimensional art experience
- create symbolic representations in clay
- evaluate your personal and professional support system
- design and implement three-dimensional art activities with young children

YOUNG CHILDREN EXPLORE
THREE DIMENSIONAL ART

Children begin at a very early age to experiment with three-dimensional form. They stack blocks and transform them into cars and trains; they dig holes in sand and discover the magic of inverting a container of moist sand to create a sand castle. This is serious work for children. It is through these play experiences that young children begin to explore form, depth, spatial relations, and texture—all elements of three-dimensional art. Unlike two-dimensional art, which requires children to transform their awareness and experiences of three-dimensional objects in space onto a flat surface, three-dimensional art allows children to represent their knowledge of the world in a more real and concrete manner.

Molding and Sculpting with Clay

Clay, as you and your children will discover, seems to provide the ultimate relationship between sight and touch. It can be flattened, poked, and rolled into abstract representations or molded into shapes and forms that are recognizable and useful. For very young children, the process of molding and manipulating clay is largely experimental. Two- and three-year-old children get a great deal of satisfaction from patting clay, poking it with other objects, or smearing it across a table top. These children often lack the dexterity required to form clay into objects. They will pinch, pound, roll, or add and subtract bits and pieces of clay to discover what *it* can do and what *they* can do to change its shape or form. This "messing about" provides immediate sensory (tactile and visual) pleasure to the child. It is through this exploratory process that the very young child discovers the properties and potential that clay holds.

When children touch a piece of clay, they don't see it in terms of color or line; they see it through their own sensory experiences or "through their hands." They feel its slippery, lumpy moistness as they squish it through their fingers or pound it onto a flat surface. Even though a "product" may evolve, it is the experience of working with clay that releases the sculptor's expressive nature; the product is simply a reflection of this experience.

Clay provides immediate sensory pleasure and gives children experiences in a three-dimensional creative arts material.

Your children will usually let you know when objects, people, toys, animals, or other representational symbols begin to take form. Creating simple shapes and naming them is a favorite activity of the four- or five-year-old child. A mass of clay suddenly becomes a motorcycle and the shape goes rumbling across the table! The "motorcycle" is a representation of the child's experiences with or knowledge of the object and the clay *becomes* the object, regardless of whether or not it is actually representational in the eyes of an adult. In the child's mind (and heart), it *is* a motorcycle and this is all that matters.

Around the age of five or six, children become more particular in their modeling and creating. They enjoy making definite objects and use them in their play for longer periods of time. They make more complex representations, often decorating them with toothpicks, pipe cleaners, or craft sticks. The process of molding and creating may begin with an image the child has in mind, or an object may emerge as the child explores the clay and gives its shapes and forms new meanings. These images or ideas often go through many transformations before the child is finally satisfied with a creation.

Two types of clay commonly used in early childhood settings are earth or potter's clay and oil-based clay. Earth clay is water-based and will harden; it can be painted and fired in a kiln. Oil-based clay remains pliable and can be used over and over again. An alternative clay that is very suitable for young children is salt-based, homemade clay that you can mix up in your classroom. I recommend the following recipe for clay. The clay lasts for months, even when used daily.

Cooked Clay
1 cup flour
1/2 cup salt
2 tablespoons cooking oil
1 teaspoon cream of tartar
1 cup water
optional: food coloring or flavor extract
such as peppermint or almond.[3]

Combine all ingredients in a cooking pot and cook over medium heat, stirring constantly, until the mixture thickens and loosens from the sides of the pot. Turn out onto a flat surface and let cool. When it is cool enough to touch, knead the clay until it is smooth. Store in plastic bags or airtight containers. This recipe may be doubled or tripled.

After your children have had many opportunities to manipulate different types of clay, they may enjoy a more challenging process with a specific purpose in mind. As your children move from the experimental level to more sophisticated levels of representation, some knowledge and skill on your part is useful. "Clay: Basic Equipment, Terminology, and Methods" in this chapter introduces you to different ways of handling and working with earth clay. With this basic information, you will know what to do when a child comes up to you with two pieces of

clay and asks, "How can I make these stick together?" Your children will let you know when they need more information. Until your children ask you or you observe that they are ready for more information, you should carefully avoid demonstrations or the "Wait and I will show you how" approach. We must constantly remind ourselves that the child's experiences in molding and sculpting are primarily a "touching" and exploratory process. Any products that emerge should be the result of the process and should not be predetermined by the "art lesson" contrived by the teacher. As a reminder to yourself, you might consider copying Dr. Buckley's "The Little Boy" onto a note card and placing it in a prominent place in your classroom.[4] It can be a wonderful deterrent to the temptation to provide "instruction" in the art of molding and sculpting!

Whatever the age of your children, the process of exploring clay should never be hurried. Requiring a child to produce a final product, be it a dinosaur, a dragon, or a "dish," can inhibit the creative efforts of your children. Provide helpful guidance and give your children the freedom to represent their own experiences with this exciting, artistic medium.

This chapter includes some clay activities for *you* to explore. These activities neither give you a model nor expect you to model a reproduction of something already existing. Rather, the process involves shaping something from your imagination. Some of you will work from material to image and discover the meaning of your forms only after you have completed them. On the other hand, some of you may begin with an idea and attempt to express it in forms. In either case, the sculpture should never be judged in terms of product. It is the process of sensory exploration that is important for you and for your children. The product is just an image of these sensory experiences.

Boxes, Wood, and Sand

Clay is certainly not the only material that can be manipulated to form three-dimensional art. Young children can learn to use glue, tape, and boxes to construct three-dimensional designs. Several small cardboard boxes can be transformed into three-dimensional forms that have personal meaning to children such as cars,

trains, planes, or even people and animals. When provided with large boxes, such as those using for shipping appliances, young children can design and create a variety of imaginative structures that can be painted and decorated. Once your children have mastered the techniques of using paste, glue, and tape, they will need only your encouragement and gentle guidance to enter the process.

Small pieces of wood, which can be purchased commercially or collected from a local lumber yard, appeal to children because they offer a variety of possibilities for combining shapes three-dimensionally. When I introduced the woodworking center to my own kindergartners, they constructed, glued, and painted the small pieces of wood into elaborate and quite sophisticated three-dimensional objects. These small pieces of wood offered unending possibilities in three-dimensional design and construction for my five-year-olds and provided them with a new way to explore form, depth, spatial relations, height, width, and texture.

Sand castings are another form of three-dimensional art that children of all ages enjoy. In sand casting the artist uses a disposable casting mold made from a small box and clean sand. Small quantities of plaster of paris are mixed and then gently poured into the mold. The purpose is to reproduce a design in a permenant material. Children love to play in sand and usually welcome the chance to make lines or drawings in moist sand or to arrange objects such as pebbles, shells, or sticks in special designs. Children delight in the process because the relief sculpture is the *reverse* of the mold. When sand casting with very young children, you will have to mix and pour the plaster of paris into the children's containers. But older children can complete the process with little assistance from you—they can arrange their designs and objects in the sand and mix and pour the plaster themselves.

In most three-dimensional art activities, the focus is on the sensory elements of touching, seeing, and feeling because the artists "feel" the movement of the material as they use their hands to mold it into objects that have meaning. When children experiment with three-dimensional art they use their fingers to discover textural qualities. They use their imaginations and knowledge of the world to create patterns and designs. With each experience they develop an increasing ability to "see" objects emerge and unfold in the artistic process. The creative arts activities in this chapter are designed to help you and your children "see and *feel*" the process of creating. I hope that as you explore and experiment with three-dimensional art in a process that is not product-oriented, you will begin to develop a deeper sensitivity to the sensory explorations of children and the value these experiences hold for them.

CONDITIONS THAT ENCOURAGE CREATIVE EXPRESSION

Your attitude, room arrangement, availability of materials, and classroom atmosphere can all have an effect on how readily your children respond to three-dimen-

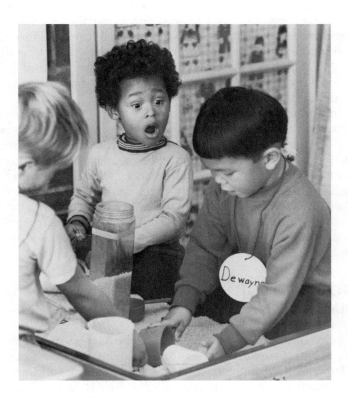

You should let your children collect their own sand for sand casting.

sional art experiences. Of utmost importance is your attitude toward your children's efforts and the development of a good rapport between you and your children. In three-dimensional art, as well as other creative arts forms, your children must know that their individual experessions are unique, even in the simplest forms, and that you do not expect perfect representations. One way to insure such an attitude is to make open-ended suggestions and allow your children to think, work, and experiment with different ways of manipulating materials as a means of self-expression. When children create, they are often entering an unknown realm of self-expression. They will be more willing to try and to accept their own attempts if they feel secure in their relationship with you.

It is important that you set the stage for children to be successful as they experiment with concrete materials to express their thoughts, feelings, and ideas. Remember that children's expressions are based solely on their experiences and their personal knowledge of the world. It is vitally important that we remember that they have not yet had the time to accumulate the knowledge and information that we adults have. They will represent their world according to adult standards when they become *adults*.

One way to allow children to be successful is to give careful attention to room arrangement and placement of materials. When children are using earth clay, the clay tables and materials should be located near a sink or you should provide containers of water. Smocks, hand towels, and materials for embellishment or decoration need to be placed within easy reach of the children. When your children are involved in making a large box sculpture, you should have already arranged the room so that they have the needed space to experiment and enlarge their designs. Allow your children the freedom to create and make sure that they have all the materials and tools they need.

Another important component of success is to give your children time to be creative. They need to manipulate, explore, and experiment with materials to discover their properties. All of these processes take time. To hurry children through an activity in search of a product denies them the practice and exploration needed to fully understand the potential of an art material. Children will learn these properties slowly and at their own pace, just as they learn to walk or use language. Skills, such as making a pinch-pot, have no value until children need them. More often than not, teaching skills will confuse and frustrate children rather than encourage individuality and originality. In creative expression, the outcomes are always unpredictable!

TEACHING STRATEGIES FOR THREE-DIMENSIONAL ART

The following ideas are appropriate for children who have had many opportunities to manipulate and explore three-dimensional art. Until the time and moment are just right and you are sure that your children can benefit from additional information, these methods must remain your *closely guarded secret*. Don't use these

activities as a means of introducing your children to clay. If you listen to your children, observe them, and remain sensitive to their needs, you will know when they are ready to begin developing some of these skills.

Earth Clay: Basic Equipment, Terminology, and Methods

The basic information in this section will help you develop your own skills so you can meet the needs of your chldren when the moment arises. Proceed carefully when demonstrating skills to insure against the "do it like me" approach. The teacher-centered method sends a clear meassage to children that their ideas and creative attempts are not acceptable or valued.

Earth clay can be purchased from potters and school supply companies. It must be kept in airtight buckets with lids. Clay should be moistened regularly or covered with a damp cloth to keep it soft and pliable. If clay becomes dry, use a blunt tool (pencil eraser or small wooden block) to make indentations and then fill them with water. Seal tight and allow to sit overnight or longer if needed. If the clay becomes totally dry and hard, put it into a thick, plastic bag and pound the clay into a powder. Then mix it with water. Clay can be purchased in a variety of colors, but a good supply of red earthenware or white clay is all that is needed for children to enjoy the sensory experience.

Necessary Equipment Clay, sponges, smocks, linoleum floor squares (standard 12-inch squares), bowls for water, and containers for storing clay.

Supplementary Equipment Children enjoy using a variety of tools when working with clay. These materials should be available to children who become interested in creating and designing specific objects or projects rather than just exploring and manipulating the clay itself. Never force children to use tools; the key word here is *available*. Too many instructions or tools for refining the product can restrict the creative nature of the clay experience.

A beginning collection of available tools might include: rollers (round, wooden cylinders from the block center), rolling pins, craft sticks for cutting, cooking cutters, spoons, toothpicks, and scissors (utilize scissors that are old or too blunt to cut paper anymore.) Tempera paint can be used to decorate hardened projects that children want to keep.

Wedging Wedging is the process of stretching and kneading clay to remove air bubbles. If you are fortunate enough to have access to a kiln, clay should be thoroughly wedged if the final product is to be fired. Air bubbles left in clay that has not been properly wedged will cause the product to explode when exposed to the intense heat in a kiln.

Scoring Children can join pieces of clay together by making grooves in the clay before pressing them together. Use scissors to roughen the surfaces and then

press the pieces firmly together. Children can use wet fingers to smooth over the joint and make it practically invisible.

Slip Mix clay with water until it resembles the consistency of cream. Use the slip as glue to adhere pieces or surfaces of clay together.

Pinch-Pot Method This is the process of turning a lump of clay around and around in your hands, using thumbs and fingers to make a bowl-like object. Place thumbs in the center of a ball of clay and turn the clay around and around while pushing downward with the thumbs to form a well. Use fingers to pull up the clay to form the wall of the bowl. To make a flat bottom, simply press the clay firmly onto the linoleum square.

Coil Pot Method Use the pinch-pot method to make a base for the pot. Roll out a strip of clay (commonly known to children as a "snake"), press it on top of the pinch-pot base, and coil it around. Add more coils, pressing each one onto the last coil until the wall of the pot reaches the desired height. If the clay does not join together easily, the base and each added strip can be scored or joined together with slip. Once the layering is complete, children can use wet fingers to create a smooth surface.

Slab Method Place two wooden sticks (ordinary rulers will work nicely) parallel to each other on a linoleum square. Place a ball of clay between the sticks and use a round wooden cylinder or rolling pin to roll out the clay to a flat slab. The thickness of the slab will be determined by the thickness of the wooden sticks. Use a pencil to draw a design or pattern on the slab and then use scissors or a craft stick to cut out the design. When the design has been cut, gently remove the background clay and allow the design to dry. If the design is to be fired, a thickness of 1/8 of an inch is ideal. When fired, clay that is too thin will crack and clay that is too thick will explode.

Activities for Children

An Imaginary Lump of Clay

Group Size: Small group, large group

Leader: Teacher

Objectives:
To pretend to be a lump of clay
To experience the properties of "being" clay

Materials: Previous experience in working with and handling clay

Procedure:
1. Talk to your children about what it might feel like to be clay. Discussion can center on how clay feels, what you can do with clay, what makes clay get hard and dry, and what happens when you add water to clay. Children should be allowed to add their own ideas and comments about the properties and uses of clay.
2. Tell your children that they are going to pretend to be lumps of clay and imagine themselves being rolled into a big ball. The teacher then moves among the children while talking to them and molding them into different shapes. The following dialogue is a guide to this process.

You are all wet, cold, lumpy balls of clay. In just a minute I am going to come over to where you are and mold you into a shape. (Teacher then moves to a child and begins to move the arms, legs, head, or whole body.)

When I have made you into a clay shape, be sure to try and stay still so that you can dry. (Teacher continues to move among the group until all the children have been molded into a shape).

Now, I want you to look around the room at all the shapes we have. In just a minute it will be time to be lumps of clay again. I will pat you back into a ball of clay and then pour imaginary water on you to make you nice and soft again. (Teacher moves from child to child, pats them and pours imaginary water over them.)

3. Follow up "An Imaginary Lump of Clay" with conversations about what it felt like to be molded. Were there any shapes that could have had names? Was it hard to be still long enough to dry? If they could have been placed somewhere in the room for others to see, where would they like to have been placed?

Clay Impressions

Group Size: Small group, large group

Leader: Teacher

Objectives: Visually discriminate clay impressions

Materials:
Potter's clay or plastic clay
Objects for making impressions: keys of different sizes and shapes, toothbrush, comb, clothespins, pine cones, blocks of different shapes, forks, spoons, pointed objects

Procedure:
1. Show your children how to make impressions in the clay. Begin with a single impression and move gradually to making different impressions of each object.
2. Then, hide the objects, show the children the clay impressions one at a time, and let the children guess which object made each impression. When the guessing game is complete, give the objects and a large lump of clay to each of your children and let them make their own impressions or combinations of impressions. Children may choose to use more than one object to make a single impression. Accept whatever process the children use since there are no correct (or incorrect) ways of making clay impressions!

Burlap Unweaving

Weaving is basically a method of interlacing strands of yarn, strips of cloth, thread, paper, or other material to combine them into a whole texture, fabric, or design. Although five- and six-year-olds can understand and manipulate the over-and-under back-and-forth technique involved in weaving, most three- and four-year-

old children lack the dexterity, eye-hand coordination, and patience to complete a weaving project.

Unweaving is the opposite of weaving. Beginning with a whole, separate materials are *removed* to create a design. "Burlap Unweaving" is an excellent first activity to introduce young children to this creative arts process. It is a simple activity that requires a minimum of fine-motor control, and it is rewarding since children are taking something apart rather than having to put something together in a predetermined pattern. Since there is no loom to fill, weavers can stop when the design seems complete or when they get tired.

Older children and adults can reweave the fabric with different colored threads or strands of yarn to create new color combinations, textures, and patterns.

Group Size: Small group, large group

Leader: Teacher

Objectives:
Experiment with color, texture, and design
Create artistic patterns
Provide an alternative method to weaving designs

Materials:
Burlap fabric in several colors (one 8-inch by 12-inch piece for each participant)
Toothpicks
White, clear-drying glue

Procedure:
1. Demonstrate how threads can be loosened by using toothpicks to hook, lift, and separate individual threads from the woven fabric. Threads can also be removed by pulling them from the frayed edge of the cloth.
2. Random or patterned designs can be created by unweaving, fraying, raveleing, or reweaving the fabric with different colors.
3. White, clear-drying glue can be used to secure the designs once the process is completed. If the edges of the burlap have been frayed, rub a thin layer of glue along the edge where the fraying begins. If the edges are not frayed, apply glue to the burlap where fraying could occur as a result of handling.

Box Sculpture

Three-dimensional art provides children with many ways to discover form and shape, texture and pattern. "Box Sculpture" is a wonderful process for allowing children to combine different sizes and shapes to create interesting and imaginative three-dimensional art forms. Provide your children with many shapes, sizes, and types of boxes ranging from small match boxes to the large boxes used for shipping refrigerators and other large appliances. Other cardboard forms such as paper towel tubes can be used to make wheels or to join two boxes together. Wooden sticks or dowels are also excellent for adding those final touches.

Creating in a three-dimensional art form encourages children to explore form, depth, spatial relations, and texture.

Box Sculpture can be a group activity where children share ideas and interpretations about construction or an individual activity where children develop a sculpture on their own.

Group Size: Small group, large group, individual

Leader: Teacher

Objectives:
Create designs and shapes using three-dimensional art material
Provide experience for creative expression
Combine different shapes to enhance the design

Materials:
A variety of boxes in different sizes and shapes (cereal boxes, oatmeal boxes, salt boxes, tissue boxes, mailing tubes, paper towel tubes, cartons or large boxes, and other containers that can be obtained from the grocery store)
An assortment of other materials that can be used to accent shape and design (egg cartons, Styrofoam packaging pieces, string, toothpicks, pipe cleaners, spools, orange juice cans, and small pieces of scrap lumber)
Masking tape

Glue
Tempera paint and brushes

Procedure:

1. Box Sculpture gives the artist an opportunity to manipulate, design, and construct interesting and imaginative shapes and structures. For this reason, directions should consist of an "invitation" to sculpt rather than of step-by-step instructions of *how* to create the sculpture. When the sculpture is complete, it can be embellished with accent materials and painted if the artist wishes to do so. Tempera will not adhere to waxed surfaces such as milk cartons, so add a little detergent to the paint before painting these surfaces.

Sand Casting

Group Size: Small group, large group

Leader: Teacher

Objectives:
Explore creative expression through three-dimensional art
Experiment with imaginative and representational forms
Combine natural and man-made material to create texture and surface patterns

Materials:
Sand
Water
Shoe box for each participant
Plaster of paris
Objects to make impressions: spoons, pencils, shells, stones, wooden block
 shapes
Large paper clips or wire hangers
Plastic buckets for mixing plaster
Cups for dipping mixed plaster
Paper towels and newspaper for cleanup

Procedure:

1. Fill shoe box slightly over half full with sand. Moisten the sand with small amounts of water until the sand will hold a shape when pressed with an object.
2. Use fingers to smooth the sand into a flat surface.
3. Designs can be scooped out of the sand to form a concave depression or objects can be pressed into the sand to create designs. Shells, pebbles, and other objects can be added to enhance the design.
4. Mix the plaster of paris with water until it is thoroughly wet. Stir the plaster mixture until it begins to thicken to the consistency of white liquid glue. Pour the plaster mixture gently into the shoe box sand mold or use a cup to dip the plaster mixture into the mold. Pour slowly so that the plaster mixture does not splash or break the design in the sand.

5. Immediately begin cleaning up objects and buckets after pouring plaster over the sand. Empty the buckets onto newspaper or outside. The plaster of paris mixture will harden very quickly. Never clean plaster buckets at the sink. The plaster will harden and clog drains.

6. When the plaster mixture has been hardening for about fifteen minutes, insert a large paper clip or wire hanger into one end of the sculpture. This embedded fastener will serve as a hanger for displaying the sand-cast sculpture.

7. When the plaster of paris has hardened, carefully lift the sand-cast sculpture from the mold. Excess sand can be washed off with an outside water hose.

Give your children the material and then give them the nicest gift of all, the freedom to make choices about how to use it. Given the opportunity, they will make the choices that are important to them, they will become problem solvers, they will find ways of entering the process, and they will create!

THREE-DIMENSIONAL ART FOR THE COLLEGE STUDENT AND CLASSROOM TEACHER

Pariscraft Face Masks

Pariscraft is a heavy-weight fabric embedded with plaster of paris that can be easily manipulated when wet and that dries hard into a permanent shape. Pariscraft forms well over cardboard, newspaper shapes, balloons, bottles, and other objects with interesting shapes and designs. It can be painted with tempera, poster paint, acrylics, or oils. This activity is for adults only and should not be used with children. After you have experienced the sensory and tactile sensations it evokes, you will understand why you should use more appropriate methods when introducing Pariscraft to young children. Most young children do not like to have their faces covered, even with the seemingly harmless, small, traditional holiday masks. Making Pariscraft face masks is an activity for *you*!

Pariscraft Face Masks: The Trust Circle

In preparation for making your masks, I encourage you to participate in an experience to help you feel relaxed and comfortable about trusting the people in your group.

Group Size: Small group

Leader: College instructor or teacher

Objectives:
Participate in a physically trusting experience
Feel relaxed and comfortable

Practice trusting in preparation for making Pariscraft face masks

Materials: None

Procedure:

1. Form groups with seven or eight people in each group. Each group should form a circle with the smaller (shorter, lighter) participants evenly spaced around it. A volunteer or the leader now moves to the center of one of the circles for a demonstration.

2. The person in the center of the circle crosses both arms in front of his or her chest. The participants forming the circle move up to the center person and place their hands lightly on the person's body. The person in the center closes his or her eyes and, while keeping the body straight, relaxes the ankles and begins swaying to one side. The participants forming the circle use their hands and arms to hold the center person up. As the person in the center begins to relax more, the participants forming the circle begin to pass the center person around the circle or across the circle. Continue passing the center person for a while . . . and then slowly return the center person to an upright position in the middle of the circle.

The idea of the trust circle is to give the person in the center an experience of trust. That person must trust the rest of the group not to drop him or her and the group must be trustworthy enough to provide the center person with a comfortable situation. It is often helpful if you do the whole exercise in complete silence, so the center person won't be distracted.

Before implementing the trust circle, read and follow these guidelines:

1. Everyone in the circle group should place one foot forward and one foot well behind the other. If you do this, you can hold up quite a lot of weight even if you are not strong. If you stand close to the center person, you will have less weight to hold up, so if you are small or if the center person is large, stand closer and keep the circle smaller.

2. *Watch the feet* of the center person. As you pass this person around, his or her feet may shift to one side of the circle. If this happens, shift the circle so that the feet are again in the center. If you don't stay aware of the center person's feet you may suddenly find yourself trying to support more weight than you want to. If you do find yourself with more weight than you can hold, let the person down to the floor as slowly and gently as you can.

3. The center person should relax as much as possible while still keeping the body straight. *Don't bend the knees or hips. Leave both feet flat on the floor and let only the ankles go completely limp.* If the person in the center seems quite tense, take it slow and easy, and your actions may encourage that person's trust.

4. Participants should volunteer to be the center person, and the exercise should be repeated until everyone who wants to experience the trust circle has had a chance to do so. During the process, the leader should give just enough instructions to remind the group of the guidelines or to maintain timing of several different groups.

5. This is an excellent activity to discuss, and after everyone has had a chance to participate as either the center person or a member of the circle, the following questions can be used:

 What was your experience like when you were the center person?
 What are some of the things you experienced as a member of the circle group?
 Could you relax in the center?
 Did you trust the group?
 When you were a member of the circle group, did you feel trustworthy?
 How did the others pass people around, with gentle caring or as if they were loading wood on a truck?

Making Pariscraft Face Masks

This process involves both physical touching and physical presence. You will be working with a partner and talking while your facial features are being captured in a durable and lasting art form. Since your entire face will be covered, including your eyes, for about five minutes, anyone who has real fears or phobias should ask to be a mask maker and not volunteer as a model. I encourage you to participate in this wonderful sensory experience. If at any time you feel uncomfortable during the process, you can stop by simply lifting the mask from your face.

Group Size: Dyads

Leader: College instructor or teacher

Objectives:
Explore sensory awareness
Capture facial features in a mask
Experiment with molding Pariscraft
Work cooperatively with a partner

Materials:
Pariscraft cut into 6-inch lengths (one 20-pound box for a group of twenty participants)
Large plastic straws
Plastic containers for water (one container for each pair)
Plastic wrap (commercial brands used for food storage are ideal)
Small rug or a towel for each participant

A mask maker and a model should demonstrate the entire process before the activity begins.

1. The model sits in a chair and leans back to rest the head on a rug or towel on a table. Or, the model lies on the floor, face up, with the head resting on a rug or towel.

2. Using several long pieces of plastic wrap, the sculptor covers the models face, hair, and upper clothing. The model uses a plastic straw to punch a hole in the plastic wrap and then uses the straw or straws to breathe through. The sculptor *talks* to the model throughout the process.

3. The sculptor softens the Pariscraft by dipping it in water, one piece at a time, and removes excess water by squeezing it through two fingers. Still using one strip at a time, the sculptor starts to cover the model's face, beginning at the chin and working around the mouth and nose. The eyes are the last facial feature to be covered so the sculptor must move to the forehead after covering the nose.

4. The sculptor then adds strips vertically from the jawbone to the temples on both sides of the face.

5. The sculptor adds another layer using the same steps to give the mask extra strength. As each strip is placed on the model's face, the sculptor tells the model what is happening and checks often to see if the model is comfortable and can breathe well. It is important to attend to the model throughout.

6. When two layers of Pariscraft have been applied, the sculptor must tell the model that the eyes will be covered next.

7. After covering the eyes, the sculptor can use *very light* finger pressure to mold, shape, and accent the features of the model.

8. When the Pariscraft begins to harden, the sculptor stops touching the mask, sits down next to the model, and makes physical contact in another way— touching the model's arm or head, holding hands, and so on.

9. The sculptor talks quietly with the model until the Pariscraft has hardened enough to be lifted from the face without collapsing, usually fifteen minutes from the start of the process.

Once the demonstration has been completed, participants form pairs and proceed to make their masks. Participants can put names on their masks with a pencil and then let them dry and harden. When the masks are completely dry, the sculptors and models paint them, decorate them, or leave them as a simple reminder of the experience. The mask becomes an outgrowth of the activity; it is the *process* of exploring the tactile and sensory impressions Pariscraft provides that should be the focus of your awareness and your attention.

Remember when you clean up not to pour the leftover plaster water down the drain. It will harden!

Working with Clay

*Self-Sculpture**

"Self-Sculpture" integrates the use of guided fantasy and exploration in clay. This experience will help you to become more aware of all the special characteristics

*Adapted from: Stevens, J. *Awareness: Exploring, Experimenting, Experiencing.* Moab, Utah: Real People Press, 1971.

that make you uniquely *you*. Throughout the process you will be creating an image of yourself out of clay—what you are like, how you feel, and how you imagine yourself to look and be. As with all guided fantasy experiences, Self-Sculpture is a very low-risk activity. Some lumps of clay may evolve into fairly realistic representations while others will be quite abstract.

Group Size: Small groups, large groups

Leader: College instructor, teacher

Objectives:
Create abstract or representational image of "self" in clay
Attend to imagery created by the guided fantasy

Materials:
Two large handfuls of potter's clay for each individual.
Linoleum floor square (standard 12-inch square) for each individual.
Flat, smooth working space.

Procedure:
1. Each participant should have a large lump of clay. Make sure you have a comfortable working space and take a few minutes to explore the tactile properties of the clay. A leader then reads the following introduction and guided fantasy.

> I want each of you to take two good full handfuls of clay. Also get a piece of linoleum to put the clay on and find a comfortable place to sit. Now take a few minutes to get acquainted with the clay . . . Feel its texture and weight . . . Feel the way it changes shape as you explore it with your fingers . . . Try different ways of shaping it . . . squeezing, patting, rolling, pulling, pushing, stroking, punching . . . Discover what this clay is like and what it is capable of.
>
> Now that you have explored your clay, shape it into a fairly round ball and set it gently on your board in front of you. Close your eyes, sit in a comfortable position, and focus your awareness on your hands and fingers that have just been exploring this clay . . . Notice how your fingers and hands feel . . . Now turn inward even more and let your attention flow into the different areas of your body . . . Become aware of what you feel in each different part of your body.
>
> Now visualize an image of your round ball of clay, and imagine that it will slowly change and shape itself into an image of yourself. This image might be a fairly realistic representation, or it might be quite abstract. Don't try to change this imaginary ball of clay; let it change itself slowly into some representation of yourself . . . It might go through quite a few changes, or perhaps form two or more images of yourself . . . Whatever it does, just feel it closely as it develops, without interference from you.
>
> (Pause here for two to five minutes.)

Now keep your eyes closed and reach out to the real ball of clay in front of you, and hold it gently in your hands for a little while . . . Focus your attention on your fingers and hands, and let them begin to move and get acquainted with the clay again . . . Now I want you to begin to create another image of yourself out of this piece of clay. As you do this, focus on all the details of the process of shaping the clay . . . how the clay feels, how your fingers move, the images that come to you as the clay changes shape . . . As much as you can, let the clay and your fingers lead you in this shaping. See what develops out of this process of shaping another image of yourself out of clay . . . You will have about ten minutes to do this.

(Pause for ten minutes.)

Now slowly open your eyes and look at what you have made out of the clay . . . Continue to work on it a little if you wish, but don't make any major changes in it . . . Look at it carefully and be aware of what it is like . . . all its properties and characteristics . . . How do you feel toward this image of yourself? . . . Now identify with this sculpture. What are you like? How do you feel as this sculpture? What is your existence like? . . . Explore all the details of being the person this sculpture represents.

Now I want each person, in turn, to take a few minutes to describe your self-sculpture. Tell us what you are like, how you feel, and what the experience held for you. Do all this in first-person, present tense.

Allow time for participants to describe their self-sculptures.

You all come from different backgrounds and bring a variety of experiences and levels of self-awareness to the creative arts process. Your self-sculpture need only be meaningful to you. The actual sensory contact with the clay and your awareness of yourself form the "heart" of the activity. As in making Pariscraft face masks, it's the process, not the product, that is important.

Group Sculpture

This activity provides an opportunity to build on the ideas of others to create a form or design out of a large piece of clay. Sculptors work as a group to transform the clay into a group sculpture. Acknowledgment and acceptance of the ideas of others emerge from the group sculpting experience. The form that evolves contains the different ideas of everyone in the group and becomes a reflection of the group process.

Group Size: Small groups, large groups

Leader: College instructor, teacher

Objectives:
Encourage group interaction to develop a common design

Promote experimentation with three-dimensional art material
Stimulate interest and appreciation of each other and our imaginative ideas

Materials:
Large lumps of potter's clay for each group
Large piece of linoleum or large, flat working surface for each group
Bowl of water for each group
Sponges
Molding tools

Procedure:
1. Form small groups of four or five.
2. Each group should have one large lump of clay.
3. Each small group creates a group sculpture. The following guidelines, suggested by the leader, may be useful in getting the group started, but instructions should be kept to a minimum so that participants will not feel inhibited. Keeping instructions simple will encourage participants to allow the form to emerge rather than to decide beforehand what they will sculpt.

 If you have an idea, simply begin to sculpt without verbalizing your idea to the others.
 Allow the clay to take its own form as your group works together simultaneously.
 The clay does not have to "become" anything; remember the product is simply a reflection of the group process.

4. When the group sculpture is complete, the leader directs a discussion about the group experience. The following questions can be narrowed or extended, depending on the age and experiences of the participants, to get everyone talking about the process.

 What did you do during the sculpting experience?
 How would you describe the group sculpting process?
 What similarities or differences did you notice in the way different people approached the sculpting activity?
 Tell us about your sculpture.

It's now time for a transition. You have worked alone, you have had experiences with a partner to explore trust and cooperation, and you have molded clay into a group creation. You have brought to these experiences many of your own *inner* resources. The trust circle, group sculpture, and pariscraft face masks activities helped you to understand and appreciate the significance of building and depending on *external* resources as well. I'd like to continue this theme of trust, security, and social interaction by addressing a personal and professional issue that takes a closer look at the ways we give and receive care and attention. The topic is support

systems, what they are, how to define them, and how to know if you are getting the support you need, both personally and professionally.

DEVELOPING A PERSONAL AND PROFESSIONAL SUPPORT SYSTEM

Teaching has been referred to as a lonely profession. Preservice teachers in seminars and professional teachers in graduate school, workshops, and short courses often reveal their feelings of isolation due to a lack of opportunity to discuss educational ideas and professional issues with friends and colleagues. It is ironic that, in a profession where people interact with children every minute of the school day from morning until afternoon, teachers find themselves isolated from each other. With all the demands placed on you, it is rare when you have the time or luxury to talk about experiences or issues that influence your effectiveness as a professional. Indeed, it is even rarer when teachers who are learning the skills for guiding and supporting children have the opportunity to develop the skills for guiding and supporting each other. By developing and implementing a systematic means of gaining and giving support, you can take real steps to stop the primary causes of isolation and gain the support you so rightly deserve.

The activity, "Developing a Personal and Professional Support System," can be used for several purposes, depending on your own individual situation: (1) reestablishing contact with friends and colleagues who share similar personal and professional concerns; (2) establishing new relationships to provide support when you experience stress, tension, or conflict; and (3) developing new skills and identifying resources that will contribute to your personal and professional growth. The process of giving and getting support on both a personal and professional level can lead to a larger network of support as you continue your commitment to being an effective and *supportive* teacher.

Group Size: Small group

Leader: College instructor, teacher

Objectives:
Facilitate getting to know each other better
Evaluate current support system
Understand what a support system encompasses
Increase awareness of how to get support

Materials: Paper and pens

Procedure:
1. As a first step in looking at your own *internal* support systems, list at least three things that you do well or three qualities that you value in yourself. This is an individual exercise. When you have spent a few minutes doing this, choose a partner and use "I" statements to talk about your internal strengths. For example: "I value my honesty," "I work very well with children." Use this opportunity to maximize your internal strengths and practice giving yourself credit for these strengths.
2. Stress is a major reason why we all need support. To help you get in touch with the stresses in your life, think of three things that cause you stress and write them on your paper. These might be physical, environmental, interpersonal or simply the generalized stress that human beings encounter in day-to-day living.
3. After everyone in your group has identified their stresses, find partners and spend a few minutes talking with each other about all these stressful things.
4. The next step is to take a look at your current support system and identify the people who are providing support for you. You can do this by completing the following form and writing down the names of all the people who provide support in the special areas.

5. When everyone has had time to complete the form (usually fifteen to twenty minutes), join your partner again and spend a few minutes talking about the status of your current support system. Consider the following questions: Is my current support system balanced? In what areas do I need more support? What would I like my support system to give me? What do I have to offer someone else? How can I increase my current support system? Am I "overloading" any one person?

6. When you think you have completed an accurate assessment of your support system, return to the large group. The whole group should talk about any insights, discoveries, feelings, or thoughts that may have occurred during the process.

Support System People[*]

Below is a description of some of the functions human relationships can provide. Please read the descriptions, then enter the names of the people in your life who fulfill that function in your relationships with them. Think of friends, family members, neighbors, and colleagues. While some individuals in your life can fulfill more than one specialized function, try to think of individuals who provide you with a special resource.

Function	People
Intimacy. People who provide me with closeness, warmth, and acceptance. People who allow me to express my feelings freely and without self-consciousness. People I trust who are readily accessible to me. People who provide nurturing and caring.	_____ _____ _____ _____
Sharing. People who share common interests or concerns because they are "in the same boat" or in similar situations. People who are striving for similar objectives. People with whom I share experiences, information, and ideas. People with whom I can exchange favors.	_____ _____ _____ _____

*Adapted from a Human Interaction Laboratory, Dr. Norma Jean Anderson, T-Group Leader and Facilitator. NTL Institute. Bethel, Maine, 1981. Used with permission.

Self-Worth. People who respect my
competence in my role as a student,
preservice teacher, teacher, or
administrator. People who understand
the difficulty or value of my work or
performance in that role. People I respect
who can recognize my skills, especially
when I may be unsure of myself.

Crisis/Overload. People who can be
depended upon during a crisis to provide
assistance. People who provide tangible
services or make resources available,
often experts in solving particular kinds
of problems and not necessarily the type
I would choose to have a close personal
relationship with.

Stimulation /Challenge. People who
can motivate me to explore new ways
of doing things. People who challenge
and stimulate me.

IDEAS TO EXTEND LEARNING

1. Make arrangements to visit and observe a classroom for very young children and another classroom for older children. Take notes on ways young children and older children approach and manipulate clay. Give children a small lump of earth clay and tell them that they can play with it, roll it around, make different shapes, or do anything they would like. Remind the children to keep the clay on the table. Place some objects such as craft sticks, scissors, or old toothbrushes near the clay so you can observe if and how the children choose to use the objects. Keep the introduction short. Move away from the group and take notes on the following behaviors: How do different children within the group approach the clay? How long do the children manipulate the clay? Which children use the objects and clay together? What kinds of interactions take place between the children (sharing, talking about the clay or objects)? Which children seem to want to make something from the clay? Which children seem to be more involved in the sensory process? Analyze your findings and make comparisons between the two age groups.

2. Make arrangements to work with an individual child over a period of three to four weeks and note changes that occur as the child becomes more familiar with clay and develops skills and techniques to meet his or her needs.

3. Collect a variety of small boxes of different shapes and sizes. Use glue or tape to arrange these boxes into a box sculpture. Pay attention to the processes you experience as you are making your sculpture. When you have completed your box sculpture, reflect on the experience and make notes about how the process

evolved. Be prepared to show your box sculpture to your colleagues and talk about your experience.

4. Plan and implement a three-dimensional art experience with young children.

5. Make a list of readily available objects that can be used for three-dimensional art projects.

6. Outline the section on "Conditions that Encourage Creative Expression" into a checklist. Observe a classroom teacher and use your checklist to analyze the classroom conditions. Make notes about things that you will do the same and things that you will do differently.

7. Review your "Support System People" form. Identify those people who are "overworked" and think about colleagues who are not a part of your current system but might be if you are willing to be more assertive.

ENDNOTES

1. de Saint Exupery, A. *The Little Prince.* New York: Minton and Balch, 1934.
2. Lowenfeld, V., and W. Brittain, *Creative and Mental Growth.* New York: Macmillan, 1970, p. 59.
3. Humphreys, Margaret W.
4. Buckley, Helen. Professor Emeritus, State University of New York at Oswego. *School Arts Magazine.* October 1961.

7
Literature

Throughout the many affective and creative experiences suggested in this book, you have been encouraged to flex, bend, and stretch your imaginative and creative potential. This approach to creative arts education implies that self-knowledge and self-understanding are important elements for being an effective and creative teacher. As you continue to grow as a professional, you will also continue to explore new dimensions of yourself and, equally as important, how these new dimensions have an impact on your effectiveness as a facilitator of the creative arts process in young children.

By now you know that this process of becoming a better teacher is very much like a journey. There are guidelines to follow and helpful people there to assist you, but the process of organizing the information you gather along the way is primarily your responsibility. *Organization,* on the continuum of affective development, involves bringing everything together. You must now begin resolving conflicts you may have between different ideas. You must determine the value of your new knowledge, forming a personal, professional, and consistent value system. This is not something that you or I can be "taught." Teachers, colleagues, peers, and friends can provide the basics, but only you can decide if the process of exploring your own affective development is worth your time and energy. The affective experiences in this chapter will help you explore this process more deeply as you spend some time identifying your professional and personal strengths and understanding your limitations. You will also learn

how to represent your present strengths into a creative and artistic form.

 This chapter presents a variety of ways to involve children in literature, including how best to arrange the environment. When young children listen to stories, they use their imaginations and creative abilities to form ideas and images about characters and story line. When children listen to poetry, they experience their feelings and emotions. Through literature children continue to explore all the possibilities the imagination holds. They transform what may appear to us to be ordinary happenings or characters into their own magical and personal experiences. Reading and sharing books with children is not enough. *You* must convey to your children your own appreciation and reverence for literature if you want them to develop the same excitement and joy that the written word or illustration can bring to their experiences. Flannel board stories, "quiz cards" (instructions included) and writing poetry are three ways to do so. Appendix 3 includes a bibliography in several categories of children's literature to assist you in selecting books for young children.

Objectives

This chapter will provide the information and opportunity for you to

- describe the steps involved in selecting and presenting literature to young children
- identify techniques for using the flannel board and quiz cards
- practice writing poetry
- identify and evaluate your personal and professional strengths and weaknesses.
- review specific categories of children's literature
- design and implement literature activities with young children

SELECTING LITERATURE FOR CHILDREN

Children's literature can serve as a mirror for children. Books, stories, and poems can help children take a look at the outside world in relation to their own inner, imaginary world and their unique feelings. Books, stories, and poems often reveal to children that their imaginative and affective states are not unlike those of other people (especially "grown-ups") and that their feelings and imaginary worlds must be okay and important since someone has actually written about them!

 Many years ago, Marjorie Farmer, a scholar, professor, and poet at Pembroke State University, shared a wonderful little poem with me that I have kept tucked away in my heart for over twenty years. She said, "With a poem in your pocket and a song in your head, you will never be alone at night, when you go to bed."[1] I don't know if Professor Farmer was the author or if she was quoting another poet, but since that time I have read countless poems to young children to keep in their pockets for rainy days or especially dark nights. Almost all young children enjoy

the magic of rhythm and rhyme in poetry, and even the simplest poems open windows to enchantment and delight.

Thousands of children's books are published each year, and it seems that there is a special book for each child and each child's experiences. Children must be introduced to a variety of literature, including picture books, Mother Goose, poetry, and concept books. Picture books, one of children's favorites, can be divided into two major categories: *wordless picture books*, which do not have a written text, and *picture books*, which use words and illustrations to tell the story. Your children can interpret the illustration of wordless picture books to make up their own story as they follow the sequence. Even when there is a written narrative, young children often use illustrations to understand the story. Illustrations add life and richness to the story experience and increase children's enjoyment of literature.

The Caldecott Medal, named for English illustrator Randolph Caldecott, is awarded each year to an outstanding picture book. If you spent some time looking at the illustrations in these award-winning books, you will discover that illustrators use a variety of techniques and media to create truly beautiful and appealing works of art. Your own experiences with Robert McCloskey's *Make Way for Ducklings* or Maurice Sendak's *Where the Wild Things Are* will help you learn to appreciate the importance of art in children's books. Take the following list with you when you visit the library.

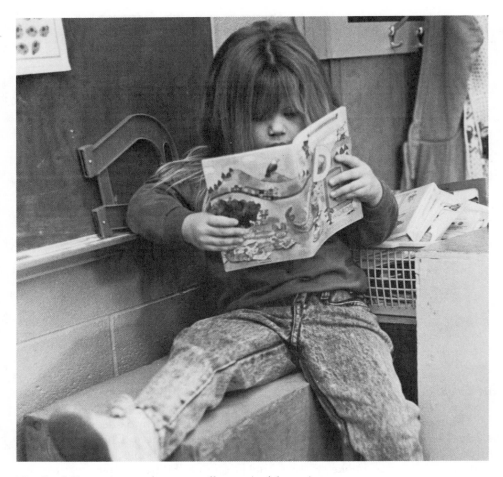

"Reading" illustrations can be a personally meaningful experience.

Caldecott Medal Award Winning Books

1989 *Song and Dance Man.* Stephen Gammell

1988 *Owl Moon.* John Schoenherr

1987 *Hey Al.* Richard Egielski

1986 *The Polar Express.* Chris Van Allsburg

1985 *Saint George and the Dragon: A Golden Legend.* Trina Schart Hyman

1984 *The Glorious Flight: Across the Channel with Louis Bleriot July 15, 1909.* Alice and Martin Provenson

1983 *Shadow.* Marcia Brown

1982 *Jumanji.* Chris Van Allsburg

1981 *Fables.* Arnold Lobel

1980 *Ox-Cart Man.* Barbara Cooney Hall

1979 *The Girl Who Loved Wild Horses.* Paul Gobel

1978 *Noah's Ark.* Peter Spier

1977 *Ashanti to Zulu: African Traditions.* Leo and Diane Dillon

1976 *Why Mosquitoes Buzz in People's Ears: A West African Folk Tale.* Leo and Diane Dillon

1975 *Arrow to the Sun.* George McDermott

1974 *Duffy and the Devil.* Margot Zemach

1973 *The Funny Little Woman.* Blair Lent

1972 *One Fine Day.* Nonny Hogrogian

1971 *A Story-A Story* Gail E. Haley

1970 *Sylvester and the Magic Pebble.* William Steig

1969 *The Fool of the World and the Flying Ship.* Uri Shulevitz

1968 *Drummer Hoff.* Ed Emberley

1967 *Sam, Bangs and Moonshine.* Evaline Ness

1966 *Always Room for One More.* Nonny Hogrogian

Gentle and caring teachers can open windows to the child's imagination during quiet moments of reading stories.

1965 *May I Bring a Friend?* Beni Montresor

1964 *Where the Wild Things Are.* Maurice Sendak

1963 *The Snowy Day.* Ezra Jack Keats

1962 *Once A Mouse.* Marcia Brown

1961 *Babouskka and Three Kings.* Nicolas Sidjakov

1960 *Nine Days to Christmas.* Marie Hall Ets

1959 *Chanticleer and the Fox.* Barbara Cooney

1958 *Time of Wonder.* Robert McCloskey

1957 *A Tree Is Nice.* Marc Simont

1956 *Frog Went A-courtin'.* Feodor Rojankovsky

1955 *Cinderella.* Marcia Brown

1954 *Madeline's Rescue.* Ludwig Bemelmans

1953 *The Biggest Bear.* Lynd K. Ward

1952 *Finders Keepers.* Nicolas Mordvinoff

1951 *The Egg Tree.* Katherine Milhous

1950 *Song of Swallows.* Leo Politi

1949 *The Big Snow.* Berta and Elmer Hader

1948 *White Snow, Bright Snow.* Roger Duvoisin

1947 *The Little Island.* Leonard Weisgard

1946 *The Rooster Crows.* Maud and Miska Petersham

1945 *Prayer for a Child.* Elizabeth Orton Jones

1944 *Many Moons.* Louis Solbodkin

1943 *The Little House.* Virginia Lee Burton

1942 *Make Way for Ducklings.* Robert McCloskey

1941 *They Were Strong and Good.* Robert Lawson

1940 *Abraham Lincoln.* Ingri and Edgar Parin d'Aulaire

1939 *Mel Li.* Thomas Handforth

1938 *Animals of the Bible.* Dorothy Lathrop

ARRANGING AN ENVIRONMENT FOR LITERATURE

Books and space for browsing and reading should be located in an area of the room that is quiet and away from the more active centers. If you have the resources, carpet the area or place small rugs on the floor. The book area must be a comfortable, attractive, and inviting place for your children. Arrange the books in a display at the child's eye level. Observe your children to determine which books seem to be favorites, and let these books form your basic book collection. These favorite

books can be left in the area indefinitely while new additions, such as concept books, books that relate to the needs of individual children, or books in response to or to encourage new enthusiasms can be circulated on a regular basis. Be sure that you read each book before placing it in the active collection. It is very important that you be thoroughly familiar with each book you present to your children and that you know the story line well enough in advance to read it at a moment's notice. Arrange your schedule so that *you* can spend some time in the book center each day. Sit with your children, read to them, and talk informally with them about the books they are interested in, the books you read together, and the books they want to know more about.

Selecting books for children and preparing for the presentation of a new book are two of your most important responsibilities. Books for young children should have

- A simple, definite plot. Children should have some idea about the outcome of the story
- Repetition of words, rhymes, or happenings that children can quickly become familiar with
- Direct conversation between story characters
- Language and vocabulary that children can understand
- Stories that present familiar and interesting situations and incidents
- A climax that leaves the children feeling resolved and satisfied
- Accurate and realistic information in concept books

- Accurate presentation of ethnic, cultural, and racial information. St͏ hould not portray sexual, cultural, racial, or ethnic stereotypes
- A limited number of main characters

STORYTELLING WITH THE FLANNEL BOARD

When good stories come to life on the flannel board, children receive immediate sensory impressions and use their own imaginations to make the story their own.

Storytelling is truly an art form—an enthusiastic teacher telling good stories with facial expressions, gestures, words, and eye contact can have children almost spellbound as they listen intently. As a beginning storyteller, you may not yet have the confidence to sit before a group of children and tell a story without the usual props or books. So it is perfectly legitimate for you to develop the expressive art of storytelling at a pace that will be enjoyable for your children and rewarding for you. Flannel board storytelling seems to fall about midpoint on the continuum from reading a book to children and the intimate, personal, and direct quality of storytelling. A good story, accompanied by flannel board figures, easily captures the attention of children. Children will shift positions and move around until they have a perfect view of the flannel board. All the while, they will be using their own imaginative power to interpret and understand the story. And you will be practicing the art of storytelling and developing confidence in your own potential for becoming a master storyteller.

Story characters and props for flannel board storytelling can be made in a variety of ways. I find medium weight interfacing especially useful because you can lay the interfacing over a book illustration and see the illustration through the transparent fabric. Use a pencil to trace the outline of the characters and props. Once you have the outline, use crayons or nontoxic markers to add color and dimension to your pieces. Flannel board pieces made with interfacing are strong and they don't tear like paper figures. They will adhere to almost any fabric or cloth surface. When I tell a flannel board story to a group of children, I often place

the flannel board characters and props on the children's clothes. They become very involved in the story, and before it is over, the children have "become" the character or prop I placed on the board! Keep the cut-out figures in a flat box or folder, and let the children use them for their own storytelling experiences.

Interfacing is not the only material that can be used to make flannel board activities. Felt and heavy paper are also durable, although flannel board characters made from heavy paper will not last as long as those made with fabric. Characters and props can be traced from coloring books (one of the few good uses for coloring books) onto fabric or paper, colored, and then cut out. These drawings are usually line drawings that are easily traced and colored. For embellishment, you can add pieces of other material, eyes (which can be purchased commercially), glitter, yarn, or contrasting fabric. Remember, though, that the more you add to your flannel board cut-outs, the heavier they will be. Heavy figures fall off the flannel board and disrupt the flow of the story. It can be very frustrating to both you and your children when the flannel board characters keep falling off the flannel board!

There are some general guidelines to follow when preparing a story for children. Let's look at these guidelines from two perspectives: the art of storytelling and procedures for using the flannel board. Once you have selected your story, you should consider the qualities of good storytelling.

1. Read the story several times until you are thoroughly familiar with the sequence, the main ideas, and the characters in the story.
2. Practice telling the story aloud. You don't have to know the story word for word, but you must know key words or phrases that are important to the storyline.
3. Practice telling the story in front of a mirror and be aware of your facial expressions, gestures, and voice intonation. See if you can maintain eye contact with yourself throughout the storytelling process.

4. Record yourself on a tape recorder as you tell the story. Try out different voices for different characters and change the intensity and pace of your words as you move from one part of the story to another.
5. Encourage the children to become involved in the story when there are repetitions or when the story calls for actions.
6. Before you start telling the story, make sure that the children have room to sit and that they can all see and hear.
7. If the children are clearly not interested in the story, end it very quickly and move to another activity. This last step seems to be the hardest for some teachers, especially after they have worked so long on making the flannel board figures. I know you may find it difficult to believe that your children don't like or appreciate all the effort you put into preparing for the story, but you *can* put the story away and present it at a later time or to a different group of children.

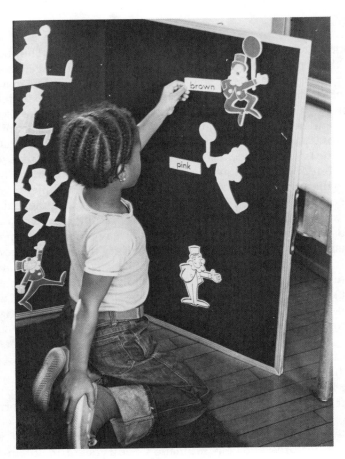

Flannel boards add interesting dimensions to favorite stories.

Besides being aware of how to tell a story well, you must also consider how best to use the flannel board.

1. Make sure the flannel board is located in a stable position. If the flannel board is placed on a table, bump the table or shake it slightly to make sure that the flannel board cannot fall or tip over.
2. Check to make sure that you have all of the flannel board characters and props. Place them on a flat surface out of the children's view and in the order you will place them on the flannel board.
3. Practice telling the story as you place the characters and props on the flannel board. Pay particular attention to placement, available space, and location of specific figures.

HOW TO MAKE AND USE QUIZ CARDS

Quiz cards are easy-to-make visual aids you and your children can use for fun. In addition to being a type of literary puzzle appropriate for young children, quiz cards can also be used to encourage children to use their imaginations. My own kindergarten children used to anticipate quiz card riddles and look forward to guessing the answer to a question. Quiz cards can be used by the children in a learning center or in teacher/child interactions.

Quiz cards can be made for many of the books you read to children. If you make just one quiz card every few weeks, at the end of the year you will have prepared some very special material that can be used by the children in your classroom for many years to come. Before you read a book or tell a story to your children, make a quiz card:

1. Cut tag board into a sheet 14 inches long by 7 inches wide. Then fold the sheet in book fashion so there is a 6-inch long overlay and a 2-inch margin on the underlay.
2. Select an illustration from the book you plan to read. Place a piece of pencil carbon paper on the tag board underlay and place the illustration you want to trace on top of the carbon paper. Carefully align the illustration so that when the quiz card is closed, part of the illustration will be visible on the right side of the underlay. This is especially important for nonreaders, as these children will use the picture clue to guess the title of the book or the answers to other questions you might decide to ask. Use a No. 3 lead pencil to draw over the outline of the book illustration. Be sure to press down firmly. When you have drawn over the outline of the book illustration, remove the pencil carbon paper and you will have the outline of the illustration on the underlay of the quiz card.
3. Use felt-tipped markers or crayons to color in the outline and make it more representational and similar to the book illustration.

What did their step-mother turn The Children of Lir into?

4. On the front of the card, write a simple question that you can ask your children or that they can ask each other. You might ask them to "guess" the name of the book, the identity of the characters, or other questions. When the quiz card is closed, your children will use the part of the illustration that is visible to decide the answer. For example, "Who were the Bremen Town Musicians?" would be a very simple question for very young children. A small part of the illustration representing the answer is showing on the underlay. In this case, the part of the illustration that your children see would be the legs, ears, tail, or other body parts of one or several of the animal characters described in the story.

5. When you have finished the illustration and have written the question on the front of the quiz card, cover the card with clear contact paper. Laminating also adds durability to the cards, but laminated material will crack or come apart after a few years.

I still have the original quiz cards that I made over fifteen years ago. They have been enjoyed by hundreds of children and are in as good a condition as they were when I made them. As the year progresses and more of your children are reading and thinking at higher levels, you can prepare quiz cards in which the illustration is not visible when the card is closed. You can also design questions that address more than memory and recall.

After you introduce quiz cards with the stories to which they refer, they can be placed in any number of centers for children to use just for fun. The following stories seem to lend themselves very well to quiz cards: *The Three Pigs, The Elves and the Shoemaker, The Bremen Town Musicians, The Fisherman and His Wife, Rapunzel, Rumpelstiltskin, Little Red Riding Hood, Jack and the Beanstalk, Peter and the Wolf, The Three Billy Goats Gruff, The Ugly Duckling,* and *Hansel and Gretel.*

POETRY FOR THE COLLEGE STUDENT AND CLASSROOM TEACHER

From the hundreds of poetic forms available, I have selected the *Cinquain, Haiku,* and *Cumulative Poetry* to introduce you to your own poetic potential. The Cinquain is governed by specific literary principles that serve as a basis for expressing thoughts and feelings. Cumulative poetry has a very simple style and few rules. Once you discover that you are indeed a poet and feel comfortable with your own poetry, you can use both of these forms with your children. When introducing poetry writing to your young children, you will want to serve as a recorder and write the words a child dictates. Another approach would be to write group poems where you would write the words or lines dictated by individual members of a group. When young children realize that you value their words and ideas and that they can indeed write a "real" poem, writing becomes a personal and meaningful process. At the same time, you will be giving your children something very special to carry with them, a poem for their pockets. As *you* practice writing poetry and become more secure in the knowledge that *you* have a poem in your pocket as well, you will have begun the process of making poetry writing a regular part of your classroom activities.

Writing a Cinquain

Group Size: Small group

Leader: Teacher

Objective: Participate in a poetry writing experience

Materials: The "guided fantasy for Cinquain." Literary principles and suggested form for writing a Cinquain, included in this section.

Procedure:
1. Review the following literary principles for writing a Cinquain. A Cinquain consists of five lines, usually unrhymed, that refer to a particular idea, observation, event, or feeling. A Cinquain does not make broad, sweeping statements about a particular subject, but rather describes one idea, one feeling, or one thing seen or observed in the poet's own experience. A modified variation that simplifies the Cinquain is particularly helpful for beginning

poets. The modified principles for writing a Cinquain are as follows:

1st line: One word that names the topic or indentifies the title
2nd line: Two words that describe the topic or title
3rd line: Three words expressing action related to the topic or title
4th line: Four words that express a feeling statement about the topic or title
5th line: One word that summarizes or serves as a synonym for the topic or title

2. Find a place in the room where you can sit comfortably or where you can lie down. When everyone is comfortable and quiet, a volunteer should read the guided fantasy.

Guided Fantasy for Cinquain

Find a place in the room where you can lie down or sit confortably without touching anyone else . . . Let your body move around a bit until each part finds a comfortable place, then let it settle down on that spot . . . Close your eyes and turn your attention inward . . . Be aware of whatever thoughts, words, or images are going through your mind and let them pass . . . When your mind and body are quiet and peaceful, imagine your-self projected into a wonderful, safe place . . . Use your mind's eye to watch this place unfold before you . . . a place that gives you a strong feel-ing of warm, comfortable, peaceful, relaxed safety.

Get a sense of what the area is like. Take time to allow all the details of this place to pass through your mind . . . Allow your awareness to feel the colors, textures, shapes, spaces, forms, sounds, and presence of your place. When you have noted the details of this inner sanctuary of your mind, allow your awareness to move from the here and now of this room to the here and now of your own special place.

Now imagine that in the distance you see a light, a radiant, blue-white glow shimmering before you. Begin to walk toward the light . . . As you approach it, it gradually becomes transparent . . . As you come closer and closer, the details of this form begin to take shape and you recognize it. It could be a person, an object, an animal, a leaf . . . Whatever it is at this moment, you are the only one who is aware of its identity. Reach out your hand and touch it . . . feel it . . . caress it . . . stroke it . . . get to know it with your hands. Let your awareness be in touch with the feelings you are having and take a few minutes to experience these feelings.

Now, stand back and capture this image in your mind's eye. In a mo-ment I will ask you to open your eyes and come back to the here and now of this room. When you are ready, gently open your eyes and, while still holding on to your image, take your pen in hand and recreate this mo-ment in Cinquain.

3. After the guided fantasy, each of you will use the images from the guided fantasy to write a Cinquain. The following form can help you create your Cinquain.

 _____ Name the topic or title.
 ___ ___ Descriptive words.
 ___ ___ ___ Action words.
 ___ ___ ___ ___ Feeling or emotion words.
 ___ Synonym for topic or title.

For example:

> Cat
> Grey, white
> Purring, looking, listening
> She comes to attention
> Sentry.

> Grass
> Brown, dry
> Waving, sighing, rustling
> There are creatures there
> Home.

> Creek
> Cold, clear
> Bubbling, falling, beckoning
> My thirst is quenched
> Water.

Cinquains can also be humorous so don't dismiss an idea or event as the subject of your Cinquain just because it reflects your sense of humor!

4. Write several Cinquains and then read them to someone sitting near you. When you have read your Cinquain to one person, consider reading it to the whole group. Reading aloud is voluntary, however, and depending on the personal nature of your Cinquaines, you may choose not to read your poems.

Haiku

I am including haiku in this section on poetry to encourage you to use this form as you continue to experiment with writing poetry. Haiku (pronounced "high-coo") is a Japanese poetic form that contains a reference to nature or to something happening in the present experience of the poet. The experience may be part of something going on around the poet or may relate to an internal emotion or

feeling. A haiku is an unrhymed poem with three lines and a total of seventeen syllables: five in the first line, seven in the second, and five in the third. For example, here is a haiku by the eighteenth-century Japanese poet Issa.

> If things were better
> for me, flies; I'd invite you
> to share my supper.
> —Issa (1763-1827)

You will note that the syllable count is off because of the translation from Japanese to English.

As a poetic form, haiku can be very abstract for young children. They will find the restrictive literary principles of writing haiku difficult and frustrating. There have been many well-meaning teachers who have introduced haiku to young children only to discover that instead of encouraging children to recreate an emotion through a poetic form, the children's emotions were directed (usually negatively) toward the process of trying to write a haiku! I have seen young children who didn't even know the meaning of the word *syllable* trying their best when their only goal was to please the teacher. Even though you and I may find the haiku to be an exciting and stimulating poetic form, we will all be well advised to leave the writing of haiku to older children and to use the cinquain and other simple poetic forms when introducing poetry *writing* to young children. We can, however, read haiku to young children. Reading poetry, even haiku, to young children can enrich and expand their experiences while providing a source of pleasure and aesthetic awareness. In preparation for reading haiku to your children, read and come to understand and appreciate the beauty and essence of this poetry form for itself. Five wonderful books that will introduce you to the truth and wisdom found in haiku are *A Few Flies and I: Haiku by Issa*, selected by Jean Merrill and Ronnie Solbert, from translations by R. H. Blyth and Nobuyuki Yuasa, illustrated by Ronnie Solbert, Pantheon Books, New York, 1969; *Cricket Songs*, Japanese haiku translated by Harry Behn, Harcourt, Brace and World, New York, 1964; *Don't tell the scarecrow and other Japanese poems by Issa, Yayu, Kikaku and other Japanese poets*, by Talivaldis Stubis, Four Winds Press, New York, 1969; *Of This World: A Poet's Life in Poetry* by Richard Lewis, photographs by Helen Buttfield, Dial Press, New York, 1968; and *In A Spring Garden*, edited by Richard Lewis, pictures by Ezra Jack Keats, Dial Press, New York, 1968.

Cumulative Poetry

Cumulative Poetry is a poetic form that allows a small group of people to compose a single poem. The process is easy, and the results often reflect the "collective unconscious" of the poets. I have used the process of writing cumulative poetry with children as young as first grade (they dictated the lines as I wrote them on chart paper) as well as with older children and adults. Cumulative poetry does not have to rhyme, there are no prescribed literary rules to follow, and each poet, in

turn, can determine the direction or nature of the poem. Guidelines for writing cumulative poetry are listed below.

Group Size: Small group

Leader: Teacher

Objective: Participate in a group poetry writing experience

Material: One piece of paper for each small group and a pencil for each poet

Procedure:
1. Form small groups of six to eight people. Sit close together in a circle.
2. Each one of you in the small group should try to think of an opening line for the poem. When one of you thinks of a beginning line, write it on the paper. Then pass the paper to the person sitting next to you. The second person reads the first line, thinks of a second line and writes it below the first sentence. When the second person has written the second line, that person should fold the paper so that only the second line, and not the first line, can be read.
3. The second person then passes the folded paper to someone else in the group. That person reads the second line, adds a third line, and folds the paper so that only the third line can be read. Pass the paper to another person and follow the same procedure. Each poet has only one line of the poem on which to base a contribution. When the poem is complete and everyone has added a line, one member of the group should read the poem aloud.

The following cumulative poems were written by preservice and professional teachers who were, like you, discovering their own poetic potential. When I read them, I am always amazed that they were written by a group. They express thoughts and feelings that one would envision coming from a single poet. As you read these poems, remember that the poets could read only one line, the one preceding their own before adding their own thoughts and ideas to the poem.

Bright, shining spiral
Winds an everlasting path
Toward me.
The children come running, laughing,
Singing, chanting all around,
I'm lost in the loveliness of the sound
And the joyful sight.
Dreams are at their fingertips,
Dreams that fly to the moon.
Where will these dreams land?

Spinning, I seem to go faster and farther,
I think I shall leave this earth.

Where will I go? What path will I follow?
Does my destiny lie beyond my reach?
Not at all, it's within my grasp,
My eyes are open, my mind is alert
I breathe, and it's the breath of spring.

I'm going to a land where war has been forgotten.
The air will be clean and fresh again.
The children will smile and be carefree
Like waves upon the sand.
The summer days came and went,
And I just hung around the drugstore
Staring blindly into the darkness
Until the lights came on again
And nighttime turned to day.

The mountain scene reminded me of when I was in Denver,
Rocky Mountain high.
The top looks just like a marshmallow cloud.
I jumped off the cloud into the sparkling waters below.
Cool, wet, refreshing. I meshed with the ripples.
Down to the water I went to find the wind,
Gentle wind, I knew you were there.
Fly me away to the sky!

Now try writing your own cumulative poems. Let your thoughts flow and be free with your imagination. I think you will be amazed at the results!

AFFECTIVE DOMAIN: ORGANIZING

In order to guide yourself in the process of becoming a teacher, you must first know where you are and where you want to go. And since you will be both the creator and the created, you should begin to think about your present level of development and generate some specific data about your personal and professional self. On the continuum of affective development, the process of *organization* is concerned with bringing together different values, resolving conflicts, and beginning to build an internally consistent value system.[2] One way to think about all the different parts of us that contribute to our being teachers is to understand and accept our own strengths, limitations, and weaknesses. The emphasis in this process will focus on accepting responsibility for utilizing your strengths and developing a plan to eliminate weaknesses or deficiencies. This will be done in a series of steps that will help you gather information from yourself (and others) about your strengths at this very moment. Then you will be able to describe your own personal and professional strengths with greater clarity and accuracy.

It is almost impossible to dig for strengths and competencies without an increased awareness of where our weaknesses are. We are often too hard on ourselves and spend more energy focusing on our weaknesses than on the very real strengths that have brought us to this point in our journey. Some of you probably have a harder time than others acknowledging or talking about your strengths and accomplishments. The old notion of "modesty" creeps into our view of self and causes us to downplay those strengths we know we possess. Talking with friends is reassuring; the very act of self-disclosure and sharing can help you understand the congruence between personal and professional strengths. Sharing also shows that weaknesses are only deficiencies that can and will be corrected; courses not taken, lack of experience in working with children, or skills that are not fully developed can all be remedied. Just as the children we teach are continually developing, so we as teachers should also continue to grow and develop both personally and professionally.

As you work through these activities, focus on your strengths, using creative expression to communicate them to others. These activities allow for a great deal of flexibility and originality in your own creative responses. As you participate in an environment that is supportive and personally secure, you will be learning more of the ingredients for establishing this same kind of trusting atmosphere in your classroom, which will in turn enable you to encourage your children to continue their journey into the creative process.

*Steps Toward Integration: The Personal "Me" and the Professional "Me".**

Group Size: Small groups

Leader: College instructor

Objectives:
Increase congruence between personal and professional strengths
Identify steps toward mastering weaknesses
Integrate personal creative expression into professional ideals

Materials:
One genuine Swiss army knife (with instructions if possible)
Two large envelopes for each group, one labeled STRENGTHS and one labeled
 WEAKNESSES
Ten small slips of paper for each participant
One letter-size piece of paper for each participant
Construction paper
Colored markers
Glue and tape

*Adapted with permission from L. Thayer, *50 Strategies for Experiential Learning: Book One.* San Diego, CA.: University Associates, Inc., 1976.

Procedure:
1. Form several small groups and sit together in a circle on the floor.
2. Take a few minutes and think of five personal or professional strengths you already possess that will be useful in your teaching career. These strengths may consist of skills, areas of knowledge, traits, experiences, values, and so forth. When you have thought of five strengths, list them on the large piece of paper. This will be your master list. Then, transfer this list of strengths to five of your small slips of paper. Don't put your names on the small slips of paper, just your strengths.
3. When each person has completed a master list and has transferred this list to the small slips of paper, each one of you should put all the small slips of paper (your strengths) into the large envelope labeled STRENGTHS. Keep the master list for yourself.
4. Next, take a few minutes and indentify five professional weaknesses, deficiencies that are *possible to correct* such as courses not yet taken, books not read, activities that have not been experienced, or desirable skills not yet mastered. Write these weaknesses on your master list and then write them on the small slips of paper.
5. Following the same procedure you did with your strengths, put any of the small slips of paper you wish to share into the large envelope labeled WEAK-NESSES. You do not have to disclose your weaknesses list if it makes you uncomfortable.
6. Choose one person in your groups to be a "reporter." Your group reporter then opens the large envelopes and reads the small slips of paper to the rest of you, starting with the WEAKNESSES envelope. Focusing on one weakness at a time or a group of weaknesses that seem to fit together, each of you can make suggestions or present alternatives that could eliminate these weaknesses. Pay attention to the deficiencies to be worked on, and don't try to figure out who wrote them!
7. The reporter then reads the slips of paper from the STRENGTHS envelope. I encourage you to indentify your strengths when you hear them read and to share your feelings about discussing these strengths with the group.
8. Each person should keep the master list. The list of weaknesses can be useful when selecting courses or deciding on practicum experiences. The

strengths list is excellent to refer to when you feel discouraged or professionally insecure.

9. As a final step toward integrating strengths and personal creative expression, you are invited to make a ''Swiss Army Knife for Teachers!''

A Swiss Army Knife For Teachers

Procedure:

1. If you have one available, examine all the components (gadgets) of a Swiss army knife. Concealed in the small knife are a variety of tools, blades, and implements that make this particular knife uniquely useful. It is many things, scissors, tweezers, can-opener, and much more. Think of all these components as being the *strengths* of this special knife.
2. Next, remember your own strengths, especially the ones you identified earlier. What strengths must a teacher have? How many components are there to a teacher? In what ways will these strengths and components fit together smoothly and functionally?
3. As a group, think of ways that you can integrate your strengths, imagery, and creativity to design and present a Swiss army knife for teachers. Presentations might include illustrations made with a variety of materials, skits, group improvisations, or other creative activities. Take some time to discuss how you will present your strengths, and then present your group renditon of your Swiss army knife for teachers to the whole class.

IDEAS TO EXTEND LEARNING

1. Read a minimum of fifty children's books. Choose at least five from each of the specific categories listed in the appendix.
2. Develop a card file for each book you read. Include on each card the author and illustrator, title, category, and a short summary of the content.

3. Examine the illustrations in several Caldecott Award winning books. Note the style, artistic medium, and general approach the illustrator uses.
4. Develop an annotated bibliography in one of the following areas: nonsexist books, multicultural books, concept books, wordless picture books, issues concerning children, or another area of your choosing.
5. Practice reading a story and recording yourself on tape. Review the tape and identify ways in which you can improve your skills in reading aloud.
6. Visit an early childhood classroom. Observe the activities that occur in the book center and record ways in which the children utilize the center and the materials.
7. Make a date with a good friend and discuss your strengths and weaknesses. Ask this freind to help you generate additional ideas for maximizing your strengths and eliminating weaknesses.
8. Look at all the college textbooks you are using this semester and identify those that you like the best and the least. Make a list of the reasons some have more appeal than others and discuss these reasons in class.
9. Identify personal and professional characteristics you believe are the most important for being a strong and effective teacher. Compare these characteristics with your own list of strengths.
10. Make flannel board characters from one of your favorite stories and implement a storytelling activity with a group of young children.

ENDNOTES

1. From a conversation with Professor Marjorie Farmer, Pembroke State University, 1973.
2. Krathwohl, D. R., B. S. Bloom, and B. B. Masia. *Taxonomy of Educational Objectives Handbook II: Affective Domain*. New York: David McKay Co., Inc., 1964.
3. Adapted from: Louis Thayer, *50 Strategies for Experiential Learning: Book One*. San Diego, CA: University Associates Inc., 1976. Used with permission.

8
Beginning a New Adventure

The activities in this book have focused your attention on experimenting with your imagination, discovering your own creative potential, and exploring the creative arts process with young children. This approach to creative arts education has stressed the importance of your potential for growth and creativity, of self-understanding and self-awareness, and of synthesizing all these elements into personally meaningful creative arts experiences. Included in this chapter is an experiential component designed to encourage you to examine your current belief system about the role of the creative arts in the education of young children. This activity will serve as a guide as you begin to develop a philosophy of creative arts education. Now you should be ready to enter freely and compassionately into the teaching process while you continue to stretch and expand the creative experiences of your children.

Your children are waiting for you. They are waiting for reassurances that there *is* more than one way to play a drum, that they can create magical rain sounds with their hands, and that their paintings are valued even if they *don't* look just like all the rest. They are waiting for you to sit back and give them time, lots of time, to bring their own personal feelings, experiences, sensory perceptions, and imaginations to the artistic process.

This last chapter is for you to write. I will provide the structure and then it will be up to you to weave the music, the colors, and the drama into the fabric of your experiences.

Objectives

This chapter will provide the information and opportunity for you to

- express and examine your attitudes, beliefs, and behaviors about creative arts education and teaching
- begin thinking about how creative arts education affects your professional "life-style"
- give gifts of good words to your colleagues and receive gifts from an imaginary wise man

CREATIVE ARTS: CARRY THEM ON!

It is not the number of activities you design or the methods of implementation you use that are the most important elements of creative arts education. What is most important is that you provide your children with a relaxed, informal, warm, and supportive learning environment in which children are encouraged to explore the creative arts *process*. Dimondstein describes the teacher who has a conscious interest in the creative arts process as one who "needs to see herself not as one who 'gives' art to students (as tourist 'do' the Louvre), but as one who can open up windows on the world to students as well as to herself."[1]

We know that creative arts education is vital to the total educational process. Education of the "whole child" cannot be accomplished unless the arts and creative expression are held high on our list of priorities. Without the inclusion of this very important content area, the needs, abilities, and potential of young children are simply not being addressed. You have discovered firsthand what it feels like to be in an environment that encourages creativity, and you have experienced an atmosphere that gives you time to enter the creative process. Now you are faced with a choice. You must decide, from your own experiences and for your own professional and personal reasons, how to introduce children to the process of creative arts exploration. You must also decide if you can or will give up coloring books, dittos, and red flowers with green stems and creatively change the familiar, traditional, product-oriented approach to creative arts production.

Imagine for just a moment that you are in your classroom. You have a handful of golden, magic fairy dust. With it you can design a creative arts curriculum that will have value and meaning for both you and your children. Beginning teachers, how will you structure the environment to give your children the time and freedom to become involved in the creative arts process? Experienced teachers, how will you break away from the old confines of having all the children draw, make, sculpt, or "create" the same thing at the same time? Directors and principals, how will you help your teachers to move away from the traditional and toward an innovative alternative approach to creative expression? College instructors, what experiences will you design to help your aspiring teachers to understand the affective nature of the creative arts and to use that understanding in the teaching/learning process? For all of you who are charged with enhancing the

creative quality of life for young children, how will you experience movement in dance, feel the imaginary force of the wind on your body, capture the rainbow's gold in painting, create a dream-image in sculpture, or recall intimate moments in a Cinquain? Think about these things and remember that you *don't* have to be innately talented to dance, sing, paint, sculpt, or orchestrate beautiful music. What you have to be is open to exploration. Give yourself and your children permission to give form to sensory perceptions, take risks with your fears and inhibitions, and respond to your own creative potential. Be sensitive and aware of your creative impulses and the creative efforts of your children. Joy and pleasure, for each of you, waits to be discovered.

AFFECTIVE DOMAIN: CHARACTERIZATION OF A VALUE OR VALUE COMPLEX

The last major category of the taxonomy of educational objectives in the affective domain is *characterization of a value or value complex*.[2] At this level of affective development, an individual's value system has a major influence on overall "life-style." In this case, life-style involves your own consistent and predictable behaviors in relation to the creative arts and creative arts education. You have been encouraged to develop an awareness of the value of creative arts education and the role you play in this process. Now it is time to come full circle, not ending a journey but beginning a new adventure with greater appreciation of your own role as a creative teacher who can facilitate the creative process in young children.

Development in the affective domain is an ongoing, lifelong process. It would be unreasonable, to think that, as a result of the few limited experiences you have explored while reading this book, we could be sure that we have reached this highest level of affective development. What we can be sure of, however, is that we have "tuned into" the realm of our own affective domain and can now make choices about ways of teaching the creative arts based on our clarified values. The activity "Teaching: Attitudes, Beliefs, and Behaviors" will help you end this part of your journey and begin your new adventure with greater insight, sensitivity, and awareness. In this nonevaluative setting, you will have the opportunity to talk about your feelings, ideas, beliefs, and values about teaching and facilitating the creative arts process. This dyadic encounter will serve as a guide for you to begin thinking about your philosophy of creative arts education and, at the same time, to assist you in clarifying your ideas in relation to your behavior.

DEVELOPING A PHILOSOPHY OF CREATIVE ARTS EDUCATION

You are an intelligent, sensitive, and creative person. Accordingly, this approach to creative arts has been structured to encourage a supportive learning environment in which you enter into the creative process in personally meaningful ways.

This is the basic foundation for creative arts exploration. Your willingness to trust and try, combined with the freedom to choose your own unique ways of expression will pay high dividends as you continue to learn ways to encourage children to develop their special modes of self-expression.

The question, "What is your philosophy of creative arts education?" can often produce anxiety and apprehension in preservice, or even experienced, teachers. Defining a philosophy of education is difficult enough, and now someone is asking you about a philosophy of creative arts education! Images of Sir Herbert Read and John Dewey stand before you as you try to remember which one talked about education as a culmination and which one discussed education as fostering growth! Was Tolstoy right when he called the arts a manifestation of emotion, or was Roberta Collard right when she said that the arts (music) are disciplined passion? Don't let these questions frighten you. At this point in your journey, I would hope that your philosophy is still in the developmental stage. However, it is not too early to begin thinking about your own views and beliefs about the creative arts and teaching.

The next activity, "Teaching: Attitudes, Beliefs, and Behaviors," will provide you with some time to ask yourself questions about the teaching field and your role as a teacher of the creative arts. In this nonevaluative setting, you will have the opportunity to talk about your feelings and ideas about teaching, specifically teaching the creative arts, with another person. This dyadic encounter can be a first step in defining your beliefs about creative arts education, clarifying your role as a teacher in relation to these beliefs, and developing your own philosophy of creative arts education.

As you continue to read through this chapter, you will begin to think about what your responses will be during the activity. One word of caution: what you decide to say as your read ahead right now might change moments before you enter the encounter. If that happens, it is a positive sign: it means that you are still giving your philosophy a chance to evolve, develop, and grow!

*Teaching: Attitudes, Beliefs, and Behaviors**

Group Size: Large group

Leader: College instructor

Objectives:
Express and examine attitudes, beliefs, and behaviors about creative arts education and teaching
Encourage openness in sharing ideas, desires, and fears about teaching
Strengthen listening skills
Give and receive feedback

*Adapted from: Louis Thayer, *50 Strategies for Experiential Learning, Book One*, San Diego, CA: University Associates, Inc. 1976. Used with permission.

Developing a philosophy of creative arts education requires a great deal of thought and reflection. It often helps to share ideas and feelings with a colleague.

Procedure:
1. Each one of you will have an opportunity to share feelings and ideas about the field of creative arts education with another person.
2. Pair up with another participant. If there are teachers and preservice teachers in your group, you should consider forming dyads together. Begin the dyadic encounter by reading the following text silently and then responding to the questions or statements.
3. At the completion of the encounter, each of you is encouraged to return to the large group and talk about the experience, examining additional questions about creative arts education.

Sharing ideas successfully with one another involves some basic skills and attitudes. The basic dimensions of a deep, sharing relationship are self-awareness, self-disclosure, trust, risk taking, empathic understanding, nonpossessive caring, acceptance, and feedback. In an understanding, warm, nonevaluative atmosphere, individuals confide significant information about themselves to someone else, who reciprocates when the roles are reversed. This "stretching" results in a greater feeling of trust, understanding, and acceptance, and the relationship becomes closer, allowing more significant self-disclosure and greater risk taking. As you continue to share your ideas and experiences authentically, you should come to know

and trust each other in ways that may enable you to become good resources for each other.

Note the ground rules for this experience:

1. You should be comfortably seated, directly facing your partner, in a location that is free from distractions. If these conditions are not met, find another setting before proceeding any further.
2. Remember what you were thinking when you first read this section.
3. All the information discussed is strictly confidential.
4. Each partner responds to each statement before continuing.
5. The statements are to be completed in the order in which they appear. Do not skip items.
6. The discussion items are open-ended statements and can be completed in whatever depth you wish. You may decline to answer any question simply by telling your partner that you choose not to respond.
7. Either partner can stop the exchange if he or she becomes obviously uncomfortable or anxious.

Look up. If your partner has finished reading begin your dialogue.

The name I like to go by is . . .
My teaching experience includes . . .
I want to teach because . . .
My primary objectives as a teacher are . . .
As a teacher, I know that the creative arts are important because . . .
Some creative arts methods I plan to use with children are . . .
The reasons I use these methods are . . .

Look at your partner while you respond to this item. (Also, try to use your partner's name occasionally when responding.)

Right now I am feeling . . .
As a prospective teacher, I believe that I can be (very) (reasonably) (not very) successful in facilitating children's creative expression . . .
Some evidence of my success (or lack of success) includes . . .
Creative arts methods that I would like to learn more about are . . .
Creative arts methods that I would be unhappy using are . . .

Checkup: Have a two- or three-minute discussion about this experience so far. Maintain eye contact as much as you can and try to cover the following points.

- How well are you listening?
- How open and honest have you been?
- How eager are you to continue this interchange?
- Do you believe that you are getting to know each other?

Some educational ideas about the creative arts that I would like to know more about are . . .

Ways in which I could improve myself to become a better creative arts teacher are . . .

Some of my real strengths as a creative arts teacher are . . .

Some of my real weaknesses as a creative arts teacher are . . .

I am (fulfilled/frustrated) in my ability to experience the creative arts in this class because . . .

So far, my philosophy of creative arts education is . . .

To become more creative and involved in the creative arts and a more creatively oriented teacher, I have to work on (name those that apply):

- philosophy
- skills such as . . .
- letting go and being uninhibited about . . .
- accepting my creative potential, especially in the areas of . . .
- recognizing the creative abilities and efforts of children
- other things such as . . .

Ideas of yours that have really interested me are . . .

Right now the experience is making me feel . . .

What I think you need to know is . . .

I get the feeling that you . . .

Gifts and Good Words*

Group Size: Small group, large group

Leader: College instructor, teacher

Objective: To give a gift to ourselves

Materials: Large sheets of drawing paper, crayons and colored markers, clay

Procedure:

1. Place art material in a convenient location. Select someone from the group to read the following guided fantasy.

The Wise Man

Find a good spot in the room where you can lie down without touching anyone else. Wiggle around a little until you find a way of lying down that is completely comfortable. Close your eyes and let your mind begin to relax. I want you to imagine that you are walking up a trail in the mountains at night. There is a full moon, which lets you see the trail easily, and

*Stevens, John O. *Awareness: Exploring, Experimenting, Experiencing.* Moab, Utah: Real People Press, 1971. Used with permission.

you can also see quite a lot of your surroundings . . . What is this trail like? . . . What else can you see around you? . . . How do you feel as you walk up this mountain trail? . . . Just ahead there is a small side trail that leads up higher to a cave that is the home of a very wise man who can tell you the answer to any question. Turn off onto this side trail and walk toward the wise man's cave . . . Notice how your surroundings change as you move up this trail and come closer to his cave . . .

When you arrive at the cave, you will see a small campfire in front of the cave, and you will be able to faintly see the silent wise man by the light of the dancing flames of the fire . . . Go up to the fire, put some more wood on it, and sit quietly . . . As the fire burns more brightly, you will be able to see the wise man more clearly. Take some time to really become aware of him . . . his clothes, his body, his face, his eyes . . .

Now ask the wise man some question that is important to you. As you ask this question, continue to watch the wise man and see how he reacts to what you say. He might answer you with words alone, he might answer you with a gesture or facial expression, or he might show you something . . . What kind of answer does he give you? . . . Pay attention to the answer and the way he gave it to you . . . You will soon have to say goodbye to the wise man . . . Say anything else you want to before you leave.

Just as you are about to say goodbye, the wise man turns, reaches into an old leather bag behind him, and searches in the bag for something very special to give to you . . . He takes it out of the bag and gives it to you to take home with you . . . Look at the gift he gives you . . . How do you feel toward the wise man now? . . .

Now turn away and start walking back down the mountain trail, carrying your gift with you . . . As you walk back down the trail, look at the trail carefully so that you will remember how to find your way back to the wise man when you want to visit him again . . . Be aware of your surroundings and how you feel . . .

Now keep your eyes closed and bring your gift with you as you return to this room . . . Take some time now to examine this gift in more detail . . . Take some time now to examine this gift in more detail . . . What did he give you? Really discover more about it. Touch it . . . smell it . . . turn it over in your hands and look at it carefully . . . When you are ready, put this gift away carefully and safely in your memory . . . and say goodbye to it for now.

2. At the end of the guided fantasy, each of you should select art materials (paper and colors or clay) and visually represent the gift the wise man gave you. You may choose to represent the entire journey, a special part of the journey, the wise man, or just the gift. Try to capture the essence or spirit of the gift rather than an exact representation.

3. When everyone has had time to complete their representation of their gifts, take some time to tell about your journey and the special gift the wise man gave you.

Creating Good Words

Group Size: Small group, large group

Leader: College instructor

Objective: To write positive comments and good words about each other

Materials:
One 8 1/2- by 11-inch sheet of paper for each person
Markers or felt-tipped pens
Masking tape

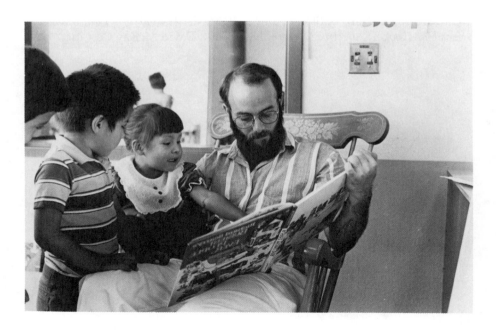

"With a poem in your pocket or a song in your head, you will never be alone at night when you go to bed."

Procedure:

1. Tape a sheet of paper to everyone's back. Move around the room and write positive comments or good words on each other's sheet of paper. Just write what you feel without signing your name. When everyone has finished writing comments and good words, take off your sheet of paper, read the comments, and take your "good words paper" home with you. Tape it up in a place where you can see it and read the positive things other people have said about *you*!

You have come to the end of this book but certainly not the end of your journey. I hope that your interaction with the creative arts has been filled with personal and professional meaning and that all your experiences will encourage you to continue this magnificent adventure, both for your own personal and creative growth and for the children who look to you for guidance. Acknowledge the talents and creative abilities of your children and open a pathway for *them* to begin their journey!

Now, promise yourself, this very moment, that you will always keep the magic and wonder of the creative process filled with joy and life!

ENDNOTES

1. Dimondstein, G. *Exploring the Arts with Children.* New York: Macmillan, 1974, p. 303.
2. Krathwohl, D. R., B. S. Bloom, and B. B. Masia. *Taxonomy of Educational Objectives Handbook II: Affective Domain.* New York: David McKay Co., Inc., 1964.

Appendix 1
Fingerplays

Open-Shut Them

Open, shut them
Open, shut them,
 (Open and close hands making a fist)
Let your hands go clap.
 (Clap hands together)
Open, shut them
Open, shut them,
Put them in your lap.
 (Put hands in lap)
Creep them, crawl them
Creep them, crawl them
Right up to your chin
 (Fingers creep toward chin)
Open up your little mouth,
But do not let them in.
 (Quickly put hands behind back)

Little Cabin in the Woods

Little cabin in the woods
 (Use index fingers to make imaginary square)
Little man at the window stood

(Index finger and thumb to make eyeglass shape)
Saw a rabbit hopping by
 (Extend index and middle finger in hopping motion)
Then, knocking at the door.
 (Fist in knocking motion)
"Help me, Help me, Help me," he said,
 (Shake hands above head)
"Or the hunter will shoot me dead."
 (Loud clapping sound)
"Little rabbit, come inside
 (Beckoning motion)
Safely, you'll abide."
 (Cradle index and middle finger in other arm)

Two Little Blackbirds

Two little blackbirds sitting on a hill.
 (Index finger on each hand fluttering motion)
One named Jack, and one named Jill
 (Raise one hand, then the other)
Fly away Jack, fly away Jill.
 (Right hand flies behind back, then left)
No little blackbirds sitting on the hill.
Come back Jack, come back Jill.
 (Right hand returns to front, then left)
Two little blackbirds sitting on a hill.
 (Both hands back to original position)

There Was a Little Turtle

There was a little turtle
 (Make fist with right hand)
Who lived in a box.
 (Cover fist with left hand)
He swam in a puddle
 (Swimming motions)
He climbed on a rock.
 (Climbing motion)
He snapped at a mosquito.
 (Make snapping motion with right hand, extending toward audience)
He snapped at a flea.
 (Repeat)
He snapped at a minnow.
 (Repeat)
And he snapped at me!
 (Point snapping motion toward self)

He caught the mosquito.
>(Catching motion, extending toward audience)

He caught the flea.
>(Repeat)

He caught the minnow.
>(Repeat)

But he didn't catch me!
>(Point toward self and shake head, "No!")

Let's Go on a Bear Hunt

The leader "lines" each phrase and the audience repeats. Everyone claps hands on thighs in walking rhythm.

Let's go on a bear hunt.
>(Clap hands on thighs in walking rhythm)

All righty.
Let's go.
Hey lookie,
There's a wheat field.
Can't go around it,
Can't go under it,
Let's go through it.
All righty,
Let's go.
Swish, swish, swish.
"Bugs!"
>(Rub hands and arms together in swishing motion, then shout "bugs!" and scratch arms and legs)

Hey lookie,
There's a river,
Can't go over it,
Can't go around it,
Let's swim across it.
All righty,
Let's go.
Side-stroke,
Back-stroke.
"Alligators!"
>(Make swimming motions, then shout "Alligator!" and speed up actions)

Hey lookie,
There's a bridge,
Can't go around it,
Can't go under it,
Lets walk across it.

All righty,
Let's go.
> (Stamp feet on floor to make loud sound)

Hey lookie,
There's a tree.
Can't go over it,
Can't go under it,
Let's climb up it.
All righty,
Let's go.
> (Make climbing motions with hands and arms)

See any bears?
> (Hand on forehead in looking motion)

No bears out there!
> (Climbing down motion)

Hey lookie,
There's a cave.
Can't go around it,
Can't go over it,
Let's go in it.
All righty,
Let's go.
> (Clap hands on thighs in slow motion)

I see two big eyes!
> (Use suspenseful voice and hold up two fingers)

I see two sharp teeth.
I feel some nice, soft fur.
> (Stroking motion with hand)

It's a BEAR!
> (Use loud, excited voice)

Repeat finger play backwards and very fast. After going back through the wheat field, make a big sighing sound and say . . . "Boy, it sure is good to be back home!"

Where Is Thumbkin?

Where is Thumbkin?
Where is Thumbkin?
> (Begin with hands behind back and bring out each finger as mentioned)

Here I am, here I am.
How are you today, sir?
Very well I say sir.
Run away, run away.
> (Fingers on each hand motion to the other, then return to behind back)

Where is Pointer?
Where is Pointer?
Here I am, here I am.
How are you today, sir?
Very well I say sir.
Run away, run away.
Where is Tall Man?
Where is Tall Man?
Here I am, here I am.
How are you today, sir?
Very well I say sir.
Run away, run away.
Where is Ring Man?
Where is Ring Man?
Here I am, here I am.
How are you today, sir?
Very well I say sir.
Run away, run away.
Where is Pinky?
Where is Pinky?
Here I am, here I am.
How are you today, sir?
Very well I say sir.
Run away, run away.

Eency Weency Spider

The eency weency spider climbed up the water spout.
(Touch index finger of right hand to thumb of left hand and vice
versa. Make climbing motion alternating fingers)
Down came the rain and washed the spider out.
(Wiggle fingers in downward motion)
Out came the sun and dried up all the rain.
(Arms in circle over head)
And the eency weency spider climbed up the spout again.
(Fingers repeat climbing motion)

The Bus Ride

The wheels on the bus go round and round
(Use arms to make circle motion)
Round and round, round and round.
The wheels on the bus go round and round,
All through the town.
The doors on the bus go open and close
(Bend and unbend arms at elbow)

Open and close, open and close.
The doors on the bus go open and close,
All through the town.
The wipers on the bus go swish, swish, swish,
 (Make swishing sound while waving arms)
The driver on the bus says "Move on back,"
 (Motion backward with arms)
The people on the bus go up and down,
 (Stand up and sit down)
The horn on the bus goes honk, honk, honk,
 (Pushing motion with hand and arm)
The wheels on the bus go round and round,
 (Repeat circle)
Round and round, round and round.
The wheel on the bus go round and round,
All through the town.

Clap, Clap, Clap Your Hands

Clap, clap, clap your hands,
Clap your hands together;
Clap, clap, clap your hands,
Clap your hands together.
 (Clap hands together)
Blink, blink, blink your eyes
Blink your eyes together;
Blink, blink, blink your eyes,
Blink your eyes together.
 (Blink eyes)
Rest, rest, rest your head
Rest your heads together;
Rest, rest, rest your head,
Rest your heads together.
 (Rest head on folded hands)

Five Little Squirrels

Five little squirrels sitting in a tree.
 (Hold up five fingers)
The first one said, "What do I see?"
 (Hand above eyes looking around)
The second one said, "I see a gun!"
 (Point index finger like a gun)
The third one said, "Then we'd better run!"
 (Fingers in running motion)
The fourth one said, "Oh, I'm not afraid!"
 (Hands on hips in boastful motion)

The fifth one said, "Let's hide in the shade."
　　　　　　(Crouch down in hiding position)
Then BANG! went the gun and how they did run!
　　　　　　(Loud clap; fingers in running motion to behind back)

Jack in the Box

Jack in the box all shut up tight.
　　　　　　(Make fist with right hand and cover with left hand)
Not a breath of air, not a ray of light.
How tired he must be all down in a heap,
We'll open the door, and out he'll peep.
　　　　　　(Raise left hand in opening motion and pop up thumb)

Teddy Bear

Teddy bear, teddy bear, turn around;
　　　　　　(Repeat actions as suggested in rhyme)
Teddy bear, teddy bear, touch the ground.
Teddy bear, teddy bear, shine your shoe;
Teddy bear, teddy bear, that will do.
Teddy bear, teddy bear, go upstairs;
Teddy bear, teddy bear, say your prayers.
Teddy bear, teddy bear, turn out the light;
Teddy bear, teddy bear, say, "Goodnight!"

　　To extend this fingerplay, the teacher can make a hand-cranking motion while humming the melody to "Pop Goes the Weasel." At the end of the melody, the leader says "Wake up" and children pop up!

Appendix 2
Music

Come Follow Me In A Line, In A Line

Traditional

Come fol - low me in a line, in a line, oh

Come fol - low me we will go this way.

The Mulberry Bush

Traditional

Here we go round the mul - ber - ry bush, the

mul - ber - ry bush, the mul - ber - ry bush,

Here we go round the mul - ber - ry bush, so

ear - ly in the morn - ing.

This is the way we walk to school.
This is the way we tie our shoes.
This is the way we brush our teeth.
This is the way we spin around.

A Song for Seasons

Words Linda C. Edwards
French Folk Melody

Grass is green - er, Grass is green - er Skies are blue,

Skies are blue, I'm in love with Spring - time,

I'm in love with Spring - time, How about you? How about you?

2. Leaves are golden, Leaves are golden,
 Breeze is cool, Breeze is cool,
 I'm in love with Autumn,
 I'm in love with Autumn,
 Back to school, Back to school.

3. Snow is falling, Snow is falling,
 Skies are grey, Skies are grey,
 I'm in love with Winter,
 I'm in love with Winter,
 What a great day!
 What a great day!

Hello Everybody

Traditional

Hel - lo ev - ery - bod - y, yes in - deed

yes in - deed, yes in - deed, Hel -

lo ev - ery - bod - y yes in - deed,

yes, in - deed my darl - ing.

Let's make music, yes indeed.
Let's sing softly, yes indeed.
Let's move quickly, yes indeed.
Let's come together, yes indeed.

Walk, Walk, Walk to School

G. C. Lockwood
Traditional

Walk, walk, walk to school, Walk to school to - geth - er,

Walk, walk, walk to school, walk to school to - geth - er.

Clap, clap, clap your hands.
Wiggle, wiggle, wiggle your nose.
Blink, blink, blink your eyes.
Tap, tap, tap your toes.

Children can create their own words and actions for this song: Pick, pick, pick up the blocks. Turn, turn, turn all around.

Appendix 3
Bibliography
of Children's
Literature

PICTURE BOOKS

Aardema, Verna. *Why Mosquitoes Buzz in Peoples Ears: A West African Tale*. Illus. Leo and Diane Dillon. New York: The Dial Press, 1975.

Andersen, Hans Christian. *Thumbelina*. Retold by Amy Ehrlich. Illus. Susan Jeffers. New York: The Dial Press, 1979.

Bemelmans, Ludwig. *Madeline*. New York: Viking Press, 1939.

Bishop, Claire Huchet and Kurt Wiese. *The Five Chinese Brothers*. Illus. Kurt Wiese. New York: Coward-McCann, 1938.

Brown, Margaret Wise. *Goodnight Moon*. Illus. Clement Hurd. New York: Harper & Row, 1947.

Brown, Margaret Wise. *The Runaway Bunny*. Illus. Clement Hurd. New York: Harper & Row, 1972.

Burningham, John. *Mr. Gumpy's Outing*. New York: Holt, Rinehart & Winston, 1971.

Burton, Virginia Lee. *The Little House*. Boston: Houghton Mifflin, 1942.

Burton, Virginia Lee. *Mike Mulligan and His Steam Shovel*. Boston: Houghton Mifflin, 1939.

Carle, Eric. *The Very Hungry Caterpillar*. New York: Philomel, 1969.

Cohen, Miriam. *Will I Have a Friend?* Illus. Lillian Hoban. New York: Macmillan, 1967.

Daugherty, James Henry. *Andy and the Lion*. New York: Viking Press, 1938.

De Regniers, Beatrice Schenk. *May I Bring a Friend?* Illus. Beni Montressor. New York: Atheneum Publishers, 1964.

Duvoisin, Roger Antoine. *Petunia.* New York: Alfred A. Knopf, Inc. 1950.

Emberley, Barbara. *Drummer Hoff.* Illus. Ed Emberley. Englewood Cliffs, NJ: Prentice-Hall, 1967.

Ets, Marie Hall. *Gilberto and the Wind.* New York: Viking Press, 1963.

Fatio, Louise. *The Happy Lion.* Illus. Roger Antoine Duvoisin. New York: McGraw-Hill, 1964.

Flack, Marjorie. *Ask Mr. Bear.* New York: Macmillan, 1932.

Flack, Marjorie. *The Story About Ping.* Illus. Kurt Wiese. New York: Viking Press, 1977.

Freeman, Don. *Corduroy.* New York: Viking Press, 1968.

Freeman, Don. *A Pocket for Corduroy.* New York: Viking Press, 1978.

Gag, Wanda. *Millions of Cats.* New York: Coward-McCann, 1928.

Gramatky, Hardie. *Little Toot.* New York: G.P. Putnam's Sons, 1939.

Hader, Berta Hoerner and Hader, Elmer Stanley. *The Big Snow.* New York: Macmillan, 1948.

Hoban, Russell Conwell. *Bread and Jam for Frances.* Illus. Lillian Hoban. New York: Harper & Row, 1964.

Hogrogian, Nonny, *One Fine Day.* New York: Macmillan, 1971.

Johnson, Crockett. *Harold and the Purple Crayon.* New York: Harper & Row, 1958.

Keats, Ezra Jack. *Peter's Chair.* New York: Harper & Row, 1967.

Keats, Ezra Jack. *The Snowy Day.* New York: Viking Press, 1962

Keats, Ezra Jack. *Whistle for Willie.* New York: Viking Press, 1964.

Kraus, Robert. *Whose Mouse Are You?* Illus. Jose Aruego. New York: Macmillan, 1970.

Krauss, Ruth. *The Carrot Seed.* Illus. Crockett Johnson. New York: Harper & Row, 1945.

Langstaff, John. *Over in the Meadow.* Illus. Feodor Rogankovsky. New York: Harcourt Brace Jovanovich, 1967.

Lionni, Leo. *Frederick.* New York: Pantheon Books, 1966.

McCloskey, Robert. *Blueberries for Sal.* New York: Viking Press, 1948.

McCloskey, Robert. *Make Way for Ducklings.* New York: Viking Press, 1941.

McDermott, G. *Arrow to the Sun: A Pueblo Indian Tale.* New York: Viking Press, 1974.

Mayer, Mercer. *There's a Nightmare in My Closet.* New York: The Dial Press, 1968.

Milne, A.A. *Winnie the Pooh.* Illus. Ernest H. Shepard. New York: E.P. Dutton, 1926.

Ness, Evaline. *Sam, Bangs and Moonshine.* New York: Holt, Rinehart & Winston, 1966.

Payne, Emmy. *Katy-No-Pocket.* Illus. Hans Augusto Rey. Boston: Houghton Mifflin, 1944.

Piper, Watty. *The Little Engine That Could.* Illus. George Hauman and Doris Hauman. Retold from *The Pony Engine* by Mabel C. Gragg. Platt & Munk, 1954.

Potter, Beatrix. *The Tale of Peter Rabbit*. New York: Warne, 1902.

Prokofieff, Serge. *Peter and the Wolf*. Illus. Frans Haacken. New York: Franklin Watts, 1961.

Rey, Hans Augusto. *Curious George*. Boston: Houghton Mifflin, 1941.

Sendak, Maurice. *In the Night Kitchen*. New York: Harper & Row, 1970.

Sendak, Maurice. *Where the Wild Things Are*. New York: Harper & Row, 1963.

Seuss, Dr. (Theodore Geisel). *And to Think That I Saw It on Mulberry Street*. Vanguard, 1937.

Seuss, Dr. (Theodore Geisel). *The 500 Hats of Bartholomew Cubbins*. New York: Vanguard, 1938.

Slobodkina, Esphyr. *Caps for Sale*. Reading, MA: Addison-Wesley Publishing, 1940.

Van Allsburg, Chris. *Jumanji*. Boston: Houghton Mifflin, 1981.

Viorst, Judith. *Alexander and the Terrible, Horrible, No Good, Very Bad Day*. Illus. Ray Cruz. New York: Atheneum Publishers, 1972.

Waber, Bernard. *Lyle, Lyle Crocodile*. Boston: Houghton Mifflin, 1965.

INFORMATIONAL BOOKS

Aliki. *My Five Senses*. New York: Harper & Row, 1962.

Anacona, George. *It's a Baby*. New York: E.P. Dutton, 1979

Anderson, Lucia. *The Smallest Life Around Us*. Illus. Leigh Grant. New York: Crown Publishers, 1978.

Asimov, Isaac. *How Did We Find Out about Energy?* Illus. David Wool. New York: Walker and Co. 1975.

Charlip, R. and B. Surpree. *Harlequin and the Gift of Many Colors*. New York: Parent's Magazine Press, 1973.

Cole, Joanna and Jerome Wexler. *A Chick Hatches*. New York: William Morrow and Co., 1976.

Cole, Joanna and Jerome Wexler. *My Puppy is Born*. New York: William Morrow and Co., 1973.

Holling, Holling C. *Pagoo*. Boston: Houghton Mifflin, 1957.

Metos, Thomas H. and Gary G. Bitter. *Exploring with Solar Energy*. Messner, 1978.

Milne, Lorus and Margery. *Gadabouts and Stick-at-Homes*. New York: Charles Scribner's Sons, 1980.

Rockwell, Harlow. *My Doctor*. New York: Macmillan, 1973.

Rockwell, Harlow. *My Dentist*. Greenwillow, 1975.

Sharp, David. *Looking Inside Exciting Places*. Skokie, IL: Rand McNally, 1976.

Showers, Paul and Kay S. *Before You Were A Baby*. Illus. Ingrid Fetz. New York: Crowell, 1968.

Simon, Seymour. *The Paper Airplane Book*. Illus. Byron Barton. New York: Viking Press, 1971

Simon, Seymour. *Pets in a Jar: Collecting and Caring for Small Animals*. Illus. Betty Fraser. New York: Viking Press, 1975.

FANTASY BOOKS

Andersen, Hans Christian. *The Fir Tree*. New York: Harper & Row, 1970.

Andersen, Hans Christian. *The Wild Swan*. New York: Charks Scribner's Sons, 1963.

Bailey, Carolyn. *Miss Hickory*. New York: Viking Press, 1962.

Bond, Michael. *The Tales of Olqa da Polga*. Illus. Hans Helweg. New York: Macmillan, 1971.

Cameron, Eleanor. *The Wonderful Flight to the Mushroom Planet*. Illus. Robert Henneberger. Boston: Little, Brown, 1954.

Cleary, Beverly. *The Mouse and the Motorcycle*. New York: William Morrow and Co., 1965.

Coombs, Patricia. *Dorrie and the Witch Doctor*. New York: Lothrop, Lee & Shepard Books, 1967.

Duvoisin, Roger. *Petunia*. New York: Alfred D. Knopf, 1950.

Howe, Deborah and James. *Bunnicula: A Rabbit Tale of Mystery*. Illus. Alan Daniel. New York: Atheneum Publishers, 1979.

LeGallienne, Eva (translator). *The Nightingale*. New York: Harper & Row, 1985.

Lawson, Robert. *Rabbit Hill*. New York: Viking Press 1944.

Lionni, Leo. *Pezzettino*. New York: Pantheon Books, 1975.

O'Connell, Jean S. *The Doll House Caper*. New York: Crowell, 1975.

Polushkin, Maria. *The Little Hen and the Giant*. Illus. Yuri Salzman. New York: Harper & Row, 1977.

Selden, George. *The Cricket in Times Square*. Illus. Garth Williams. New York: Farrar, Straus and Giroux, Inc., 1960.

Selden, George. *Tucker's Countryside*. Illus. Garth Williams. New York: Farrar, Straus & Giroux, Inc., 1969.

Slobodkin, Louis. *The Space Ship Under the Apple Tree*. New York: Macmillan, 1952.

Tompert, Ann. *Little Fox Goes to the End of the World*. Illus. John Wallner. New York: Crown Publishers, 1976.

White, E.B. *Charlotte's Web*. New York: Harper & Row, 1945.

Williams, Margery. *The Velveteen Rabbit, Or How Toys Become Real*. Garden City, N.Y.: Doubleday Publishing, 1969.

POETRY BOOKS

Adoff, Arnold. *Big Sister Tells Me That I'm Black*. Illus. Leorenzo Lynch. New York: Holt, Rinehart & Winston, 1976

Allen, M.A. *A Pocketbook of Poems*. Illus. S. Greenwald. New York: Harper & Row, 1957.

Chute, M. *Around and About*. New York: E.P. Dutton, 1957.

DeAngeli, Marguerite. *Book of Nursery and Mother Goose Rhymes*. Garden City, NY: Doubleday Publishing, 1954.

Faber, Norma. *Never Say Ugh to a Bug*. Illus. Jose Aruego. New York: Greenwillow, 1979

Fisher, Aileen. *Out in the Dark and Daylight*. Illus. Gail Owens. New York: Harper & Row, 1980.

Greenaway, Kate. *Under the Window*. New York: Frederick Warne, 1910.

Jacobs, Leland B. *Just Around the Corner*. New York: Holt, Rinehart, 1964.

Jacobs, Leland B. *Poetry for Chuckles and Grins*. Illus. Tomie de Paola. Garrard, 1968.

Katz, Bobbi. *Bedtime Bear's Book of Bedtime Poems*. New York: Random House, 1983.

Langstaff, John. *Over in the Meadow*. Harcourt Brace Jovanovich, 1967.

Livingston, Myra Cohn. *A Lollygag of Limericks*. New York: Atheneum Publishers, 1978.

De la Mare, Walter. *Peacock Pie*. New York: Holt, 1924.

Merriam, Eve. *Finding a Poem*. New York: Atheneum Publishers, 1970.

Millay, Edna St. Vincent. *Poems Selected for Young People*. New York: Harper & Row, 1979.

Miller, Mitchell. *One Misty Moisty Morning*. New York: Farrar, Straus and Giroux, Inc. 1971.

Milne, A. A. *Now We Are Six*. Illus. E. Shepard. New York: E. P. Dutton, 1927.

Pomerantz, Charlotte. *The Tamarindo Puppy and Other Poems*. Illus. Byron Barton. Greenwillow, 1980.

Russo, Susan. *The Moon's the North Wind's Cooky*. New York: Lothrop, Lee & Shepard, 1979.

Wallace, Daisy (ed.). *Fairy Poems*. Illus. Trina Schart Hyman. New York: Holiday House, Inc., 1980.

BOOKS ABOUT SEX ROLES

Bauer, C. *My Mom Travels a Lot*. New York: Warne, 1981.

Berenstain, S., and J. Berenstain. *He Bear, She Bear*. New York: Random House, 1974.

Brenner, B. *Bodies*. New York: E.P. Dutton, 1973.

Brownstone, C. *All Kinds of Mothers*. New York: McKay, 1969.

Burton, Virginia. *Katy and The Big Snow*. Boston: Houghton Mifflin, 1943.

Chapman, K. *The Magic Hat*. Chapel Hill: Lollipop Power, 1973.

Clifton, L. *Everett Anderson's Friend*. New York: Holt, Rinehart & Winston, 1976.

Cohen, M. *Will I Have a Friend?* New York: Macmillan, 1967.

Danish, M. *The Dragon and the Doctor*. New York: The Feminist Press, 1972.

Delton, J. *Two Good Friends*. Illus. G. Maestro. New York: Crown Publishers, 1974.

De Paola, T. *Oliver Button is a Sissy*. New York: Harcourt Brace Jovanovich, 1979.

Ehrlich, A. *Zeek Silver Moon*. New York: The Dial Press, 1972.

Felt, S. *Rosa-Too-Little*. Garden City, NY: Doubleday Publishing, 1950.

Gaeddert, L.A. *Noisy Nancy Norris*. Illus. S. Fiammenghi. Garden City, N.Y.: Doubleday Publishing, 1965.

Gauch, P. *Grandpa & Me*. New York: Coward, McCann and Goeghegan, 1972.

Goldreich, Gloria, and E. Goldreich. *What Can She Be?* New York: Lothrop, Lee and Shepard, 1972.

Heyward, D. and M. Zarssoni, *The Country Bunny and the Little Gold Shoes*. Illus.
 M. Flack. Boston: Houghton Mifflin, 1965.
Krasilovsky, P. *The Man Who Didn't Wash Dishes*. Illus. Ninon. Garden City, NY:
 Doubleday Publishing, 1950.
Leaf, M. *The Story of Ferdinand*. Illus. R. Lawson. New York: Viking Press, 1936.
Merriam, E. *Boys & Girls, Girls & Boys*. New York: Holt, Rinehart and Winston,
 1972.
Merriam, E. *Mommies at Work*. New York: Alfred A. Knopf, Inc., 1961.
Miles, B. *Just Think*. New York: Alfred A. Knopf, 1971.
Polushkin, M. *The Little Hen and the Giant*. New York: Harper & Row, 1977.
Reavin, S. *Hurrah for Captain Jane*. New York: Parents Magazine Press, 1971.
Schick, E. *City in the Winter*. New York: Macmillan, 1970.
Wabes, B. *Ira Sleeps Over*. Boston: Houghton Mifflin, 1972.
Yashima, Taro. *Crow Boy*. New York: Viking Press, 1955.
Zolotow, C. *It's Not Fair*. Illus. W.P. duBois. New York: Harper & Row, 1976.
Zolotow, C. *William's Doll*. Illus. G. Williams. New York: Harper & Row, 1972.

BOOKS ABOUT
CHILDREN'S CONCERNS

Alexander, Anne. *Nobody Asked Me If I Wanted a Baby Sister*. New York: Dell, 1971.
Anderson, Karen B. *What's the Matter, Sylvia, Can't Your Ride?* New York: The Dial
 Press, 1981.
Babbitt, N. *The Something*. New York: Farrar, Straus and Giroux, Inc., 1970.
Blaine, M. *The Terrible Thing That Happened at Our House*. Illus. J. Wallner. New
 York: Parents Magazine Press, 1975.
Bonsall, Crosby. *Who's Afraid of the Dark?* New York: Harper & Row, 1980.
Brown, M.W. *A Child's Goodnight Book*. Illus. J. Charlot. Reading, Mass.: Addison-
 Wesley Publishing, 1950.
Brown, Myra B. *First Night Away From Home*. Illus. D. Marino. New York: Franklin
 Watts, 1960.
Buckley, Helen Elizabeth. *Michael Is Brave*. Illus. E. McCully. New York: Lothrop,
 Lee & Shepard, 1971.
Chorao, K. *Lester's Overnight*. New York: E.P. Dutton, 1977.
Greenberg, B. *The Bravest Babysitter*. Illus. D. Paterson. New York: The Dial Press,
 1977.
Mayer, Mercer. *There's a Nightmare in My Closet*. New York: The Dial Press, 1968.
Mayer, Mercer. You're the Scaredy Cat. New York: Parents Magazine Press, 1974.
Memling, Carl. *What's in the Dark*. Illus. J.E. Johnson. New York: Parents Magazine
 Press, 1971.
Moskin, Marietta. *Toto*. Illus. Rocco Negri. New York: Coward, McCann and
 Geoghegan, 1971.
Viorst, J. *My Mamma Says There Aren't Any Zombies, Ghosts, Vampires, Creatures,
 Demons, Monsters, Fiends, Goblins, or Things*. Illus. K. Chovao. New York:
 Atheneum, 1973.

Vogel, Ilse. *Hello, Henry*. New York: *Parents Magazine Press, 1965.*
Waber, B. *Ira Sleeps Over*. Boston: Houghton Mifflin, 1972.
Watson, J., R. Switzer, and J. Hirschberg. *Sometimes I'm Afraid*. Illus. Hilde Hoffman. New York: Golden Press, 1971.
Welber, R. *The Train*. Illus. Deborah Ray. New York: Pantheon Books, 1972.
Wesley, Dennis. *Flip and the Cows*. New York: Viking Press, 1942.
Wolde, Gunilla. *Betsy and the Vacuum Cleaner*. New York: Random House, 1979.
Zolotow, C. *May I Visit?* Illus. Eric Blegvad. New York: Harper & Row, 1976.
Zolotow, Charlotte. *The Hating Book*. Illus. B. Shecter. New York: Harper & Row, 1969.
Zolotow, Charlotte. *The Storm Book*. Illus. Margaret Graham. New York: Harper & Row, 1952.

BOOKS ABOUT DEATH

Borack, Barbara. *Someone Small*. New York: Harper & Row, 1969.
Brown, Margaret Wise. *The Dead Bird*. Illus. Remy Charlip. New York: Young Scott Books, 1965.
Coutant, H. *First Snow*. Illus. Vo-Dinh. New York: Alfred A. Knopf, Inc., 1974.
DePaola, Thomas A. *Nana Upstairs and Nana Downstairs*. New York: G.P. Putnam's Sons, 1973.
Fassler, Joan. *My Grandpa Died Today*. Illus. S. Kranz. New York: Human Science Press, 1971.
Harris, Audrey. *Why Did He Die?* Illus. Susan Dalke. Minneapolis: Lerner Publications, 1965.
Lee, Virginia. *The Magic Moth*. New York: Seabury Press, 1972.
LeShan, Eda. *Learning to say Good-bye: When a Parent Dies*. Illus. P. Giovanopoulos. New York: Macmillan, 1976.
Miles, Miska. *Annie and the Old One*. Illus. Peter Parnall. Boston: Little, Brown, & Co., Inc., 1971.
Stein, Sarah B. *About Dying: An Open Family Book for Parents and Children Together*. Photos by Dick Frank. New York: Walker and Co., 1974.
Tresselt, A. *The Dead Tree*. Illus. Charles Robinson. New York: Parents Magazine Press, 1972.
Tresselt, A. *Johnny Mapleleaf*. New York: Lothrop, Lee & Shepard, 1948.
Smith, Doris B. *A Taste of Blackberries*. Illus. Charles Robinson. New York: Crowell, 1973.
Warburg, Sandol. *Growing Time*. Illus. Leonard Weisgard. Boston: Houghton Mifflin, 1969.

BOOKS ABOUT DIVORCE

Berger, Terry. *How Does It Feel When Your Parents Get Divorced?* Photos by Miriam Shapiro. Julian Messner, Inc. 1977.
Caines, Jeanette F. *Daddy*. Illus. Ronald Himler. New York: Harper & Row, 1977.

Hazen, Barbara. *Two Homes to Live In: A Child's Eye View of Divorce*. Illus. Peggy Luks. New York: Human Sciences Press, 1978.

Lexau, Joan. *Emily and the Klunky Baby and the Next Door Dog*. Illus. Martha Alexander. New York: The Dial Press, 1977.

Lisker, Sonja O. and Leigh Dean. *Two Special Cards*. Illus. Sonja O. Lisker. New York: Harcourt Brace Jovanovich, 1976.

Newfield, Marcia. *A Book for Jordan*. Illus. Diane deGroat. New York: Atheneum Publishers, 1975.

Perry, Patricia and Marietta Lynch. *Mommy and Daddy are Divorced*. New York: The Dial Press, 1978.

Pursell, Margaret. *A Look at Divorce*. Photos by Maria S. Forrai. Minneapolis: Lerner Publications. 1976.

Thomas, Isanthe. *Eliza's Daddy*. Illus. Maneta Barnett. New York: Harcourt Brace Jovanovich, 1976.

Zindel, Paul. *I Love My Mother*. Illus. John Melo. New York: Harper & Row, 1975.

BOOKS ABOUT SIBLING RIVALRY

Alexander, Martha. *I'll Be the Horse If You'll Play With Me*. New York: The Dial Press, 1975.

Alexander, Martha. *Nobody Asked Me If I Wanted a Baby Sister*. New York: The Dial Press, 1971.

Brenner, Barbara. *Nicky's Sister*. Illus. John Johnson. New York: Alfred A. Knopf, Inc., 1966.

Greenfield, Eloise. *She Came Bringing Me That Little Baby Girl*. Illus. John Steptoe. Philadelphia: J.B. Lippincott, 1974.

Holland, Vicki. *We Are Having a Baby*. New York: Charles Scribner's Sons, 1972.

Hazen, Barbara. *Gorilla Wants to be the Baby*. Illus. Jacqueline Smith. New York: Atheneum Publishers, 1978.

Hoban, Russell. *A Baby Sister for Frances*. New York: Harper & Row, 1964.

Iwasaki, C. *A New Baby is Coming to My House*. New York: McGraw-Hill, 1970.

Jarrell, Mary. *The Knee Baby*. Illus. Symeon Shimin. New York: Farrar, Straus and Giroux, Inc., 1973.

Keats, Ezra Jack. *On Mother's Lap*. New York: Harper & Row, 1967.

Lasker, Joe. *He's My Brother*. Albert Whitman & Co., 1974.

Zolotow, C. *Big Sister and Little Sister*. Illus. M. Alexander. New York: Harper & Row, 1966.

MULTICULTURAL LITERATURE

Aardema, Verna. *Why Mosquitoes Buzz in People's Ears: A West African Folk Tale, Retold*. Illus. Leo Dillon and Diane Dillon. New York: The Dial Press, 1975.

Adoff, Arnold. *Black is Brown is Tan*. Illus. Emily Arnold McCully. New York: Harper & Row, 1973.

Alexander, Martha. *Bobo's Dream*. New York: The Dial Press, 1970.

Bang, Molly. *The Grey Lady and the Strawberry Snatcher*. New York: Four Winds, 1980.

Baylor, Byrd. *Before You Came This Way*. Illus. Tom Bahti. New York: E.P. Dutton 1969.

Baylor, Byrd. *When Clay Sings*. Illus. Tom Bahti. New York: Charles Scribner's Sons, 1972.

Belpre, Pura. *Santiago*. Illus. Symeon Shimin. New York: Warne, 1969.

Bemelmans, Ludwig. *Madeline*. New York: Viking Press, 1939.

Beskow, Elsa. *Pelle's New Suit*. Harper & Row, 1929.

Ets, Marie Hall. *Gilberto and the Wind*. New York: Viking Press, 1963.

Feelings, Muriel. *Jambo Means Hello: Swahili Alphabet Books*. Illus. Tom Feelings. New York: The Dial Press, 1974.

Flack, Marjorie. *A Story About Ping*. Illus. Kurt Wiese. New York: Viking Press, 1933.

Gerson, Mary-Joan. *Why the Sky's Far Away: A Folktale From Nigeria*. Illus. Hope Meryman. New York: Harcourt Brace Jovanovich, 1974.

Goble, Paul (adapted and illustrated). *The Girl Who Loved Wild Horses*. New York: Bradbury Press. 1978.

Hailey, Gail. *A Story, A Story*. New York: Atheneum Publishers, 1970.

Isadora, Rachel. *Ben's Trumpet*. New York: Greenwillow Books, 1979.

Keats, Ezra Jack. *The Snowy Day*. New York: Viking Press, 1962.

Lester, Julius. *Long Journey Home*. New York: The Dial Press, 1972

Lexau, Joan. *I Should Have Stayed in Bed*. Illus. Syd Hoff. New York: Harper & Row, 1965.

Little, Lessie and Eloise Greenfield. *I Can Do It By Myself*. Illus. Carole Byard. New York: Crowell, 1978.

McDermott, Gerald (adapted and illustrated). *Arrow to the Sun: A Pueblo Indian Tale*. New York: Viking Press, 1975.

McDermott, Gerald (adapted and illustrated). *The Stonecutter: A Japanese Folktale*. New York: Viking Press, 1975.

Miles, Miska. *Annie and the Old One*. Illus. Peter Parnell. Boston: Little, Brown & Co., Inc., 1971.

Mosel, Arlene. *Tikki Tikki Tembo*. Illus. Blair Lent. New York: Holt, Rinehart & Winston, 1968.

Musgrove, Margaret. *Ashanti to Zulu: African Traditions*. Illus. Leo and Diane Dillon. New York: The Dial Press, 1976.

Politi, Leo. *Rosa*. New York: Charles Scribner's Sons, 1963.

Williams, Barbara. *Jeremy Isn't Hungry*. Illus. Martha Alexander. New York: E.P. Dutton, 1978.

About the Author

Linda Carol Edwards is Director of Graduate Programs in Early Childhood Education at The College of Charleston. Her teaching responsibilities encompass early childhood education, child development, creativity and fine arts for young children, and curriculum development and instruction. Prior to receiving her doctorate from the University of Massachusetts and completing a graduate studies program at the NTL Institute for Applied Behavioral Science, Dr. Edwards taught kindergarten in the public schools of North Carolina for ten years. She is an active participant in several early childhood education organizations and a frequent presenter at the annual conference of the National Association for the Education of Young Children. Because of Dr. Edwards' continuing interest in the relationship between the creative process and affective development, she consults with teachers and administrators, holds seminars and workshops, and continues her research in human resource development.